9783902782762

Cubierta:
Palacio Real, habitación de Ruggero,
detalle de la decoración mural, Palermo.

Preface

In the fall of 2006, I started traveling through India and Nepal for several months, exploring and touring this region, learning about the peoples and cultures and also working as a guide. I had always been interested in visiting this part of the world, known for its long history and for its spirituality. On one fateful day, as I was about to sail down the Ganges River for three days with a group of travellers, I received an email from my spiritual brother. The email announced to me that an opportunity had appeared for us to travel together to China the following year to study with a spiritual master. I was so excited at this news that accessed a state of ecstasy and spontaneously chanted words of power. My friend later joined me in 2006 to travel through much of Northern India and Nepal before he returned home. We travelled to China the following year to study with a group of aspirants from around the world who David Verdesi had assembled in order to meet with and study from the late Buddhist-Daoist master Jiang Feng. Jiang Feng was one of the masters of an ancient spiritual tradition which has been written about by the author Kostas Danaos in the book *The Magus of Java*. This trip to China was the beginning of my foray into Daoism, learning from different masters including my main Daoist teacher, Wang Liping.

I begin the preface in this manner because I would like to draw the reader's attention to an interest in learning ancient knowledge from spiritual masters. I have met spiritual masters on each of the continents I have travelled to. However, in India and in China, there was the opportunity to learn a spiritual methodology that could lead to empowerment and liberation. Up until this point, I had been aware of the immense power and immense potential for transformation that can come about by working with spirits. The opportunity to go to China was different. This was a chance to study with some of those ancient masters. Here, the opportunity presenting itself was one that promised to provide training that could lead to become a realized human being. Some would call it becoming superhuman, or a god-man (or god-woman). This was the same kind of training that Buddhist, Daoist, and Hindu adepts have realized over the ages. So, it was a very big deal.

This book is about the influence that members of what I call the serpent brotherhood, or the serpent sect, have had in teaching humanity a specific kind of knowledge. The story in this book is of the serpent sect and in particular of nagas, of internal alchemy, tantra and interactions with human adepts, not only in Asia but surprisingly (perhaps revealed for the first time) also very much so in Africa. I refer to a set of spiritual methodologies that can lead to physical and spiritual empowerment. This story is revealed in detail in the book. In the strange world we live in, where the truth of certain things tends to be reversed, we learn in the book of Genesis of the Christian bible that the serpent was evil. As with many truths, we may resort to the saying, the 'devil' lies in the details! While I have come to learn of the existence of Reptilians (the beings that the late Zulu high shaman Credo Mutwa taught us are called 'the Chitauri' in Africa, as told in his 1999 interview with Rick Martin), and while it can be said that many of these beings are extremely brutal and what can be termed downright "evil", there are others too among the Reptilians that do not resonate only with the negative polarity and that have aided humans on our journey of becoming. Just like humans, some are positive, some are negative, and many are somewhere in between. Well, back to the serpent sect that chose to act as guardians. There are likely other guardian groups beside the serpent cult that taught this knowledge to humanity. I argue that this faction called the serpent cult, who have played the role of guardians, and who were themselves aligned with the guardian group, taught spiritual technologies to humans that lived in Lemuria. Lemuria was probably the first place that the current surface Earth human lived over long periods of time. I argue that since Lemurian times, this knowledge has found its way to other places across the globe. There are records of it existing in Atlantis, in the Yu/Uighur empires, in India, in Kemet and Kush, and also in the Maya/Yucatan regions.

I begin this book by tracing accounts of the serpent cult in Lemuria, and following this cult, through Asia into Africa. The cult has gone by several names, however I use the name "nagas" to follow the migrations of the serpent cult. This is because there has been a record of this name, nagas, in Lemuria, and across various parts of Asia. The nagas are a human people, but also a Reptilian race. The impetus to trace the appearances of these people since the time Lemuria in other places on the globe began when I noticed an oddity in Africa. It is that in West Africa, there was a story of a seven-headed snake whose legend is tied to the

history of the Ghana empire, an early empire of black people. This seven-headed snake is the symbol of the nagas from the most ancient times. It has been their symbol as they migrated from place to place. Based on this symbol, I make a case that the serpent cult of the ancient times also found its way to Africa. The forms of spirituality that the naga people practiced since ancient times is also found on the African continent.

It is with great joy that I have this privilege to write about these spiritual technologies in the instance of Africa. In writing this book, I am fulfilling a promise I once made to David Verdesi, the one who first opened the door for me to study with different Daoist adepts in Asia, that if I ever found an internal alchemy tradition in Africa, that I would tell him about it, as he indicated that he would be interested in learning about it as well. Well David, it turns out that Africa indeed does have a tradition in internal alchemy and tantra. The first foundation training I took to study with a Daoist adept of a living lineage was organized by David Verdesi. After I started serious internal alchemy training in 2007, I put my travels on hold.

This book is neither a purely academic work nor is it a purely spiritual work. It is at once both academic and spiritual. However, of the two orientations, I would say that the orientation of this book tilts slightly toward the spiritual more so than toward the academic. This is because the academic approach adopted in the presentation of material is ultimately aimed at speaking to matters spiritual. It is a book about the esoteric practice of alchemy and tantra, versions of which have been practiced among different people of the Earth, especially in Asia, for millennia, and also, heretofore virtually unknown, very much also practiced for millennia on the continent of Africa.

In order to delve into Africa's traditions of meditation and tantra, then, at levels comparable to what I have experienced is practiced in Asia (in China, India, Mongolia, Nepal, Tibet, etc.), I shall delve into the works of two black adepts who have contributed immensely to spreading this knowledge. Of these two adepts, the first, who is a contemporary writer and whose work in my estimation are very well known, much better than the other, is Dr. Muata Ashby. Dr. Muata Ashby has written extensively on Kemetic lore, culture, language and spirituality and even has a school, the Sema Institute of Yoga, that teaches Ancient Egyptian (Kemetic) spirituality. The second adept, arguably less well known in contemporary times, but still very well known among

esoteric circles, is Dr. Paschal Beverly Randolph. This second individual lived in the 19th century. The work he obtained while traveling in Luxor, Upper Egypt, is known as *A Treatise on Sexual Thaumaturgy And the Practice thereof*. Luxor, the reader will find later on in this book, is the site of the ancient dwelling known as Thebes, or Waset, its Kemetic name. I shall comment on the works of both Muata Ashby and Paschal Beverly Randolph, informing my commentary and additions with knowledge and experiences I have gained from my training in Daoist internal alchemy, as well as my knowledge of Buddhism, having studied and also received a number of empowerments of the Kalachakra tantra.

Dedication

This book is dedicated to all spiritually oriented humans on Earth especially those continent and diaspora Africans whose spiritual heritage and practice has fallen short due to lack of knowledge.

Table of Contents

1. **INTRODUCTION** 4

PART I

2. **THE NAGAS** 10
 - 2.1 Nagas as people, as semi-divine beings, and as Reptilians
 - 2.2 Different source texts on the Nagas
 - 2.3 Similarities between descriptions of nagas in Asia
 - 2.4 Reptilians teaching humans in ancient times
 - 2.5 Yoga, the yoga sutras of Patanjali, the nagas, and tantra
 - 2.6 Buddhism, the nagas, Nagarjuna and tantra

3. **REVIVING KEMETIC INTERNAL ALCHEMY & TANTRA** 29
 - 3.1 Internal and external alchemy
 - 3.2 Why anyone would want to practice internal alchemy
 - 3.3 Paschal Beverly Randolph, an African-American adept
 - 3.4 A treatise on sexual thaumaturgy and the practice thereof
 - 3.5 Corrections to earlier commentaries of the original text
 - 3.6 Inner knowledge informing interpretation of the original text
 - 3.7 Muata Ashby's work on Kemetic tantric yoga
 - 3.8 Inner knowledge on Kemetic meditation and enlightenment

PART II

4. THE SEVEN-HEADED SERPENT CULT..109

 4.1 How it is I began the investigation
 4.2 The Ghana empire
 4.3 Comparing accounts of the legend of biida the snake
 4.4 The seven-headed serpent in Lemuria
 4.5 The seven-headed serpent in Cambodia
 4.6 Narayana the seven-headed intellect, and the supreme creator
 4.7 The seven-headed serpent in India
 4.8 The seven-headed serpent in the Yucatan
 4.9 The seven-headed serpent in Canaan and Mesopotamia
 4.10 The six-headed serpent in Greece and Rome
 4.11 Snake deities in Kemet and the Ethiopian naga king Arwe/Wainaba
 4.12 The ancient city of Naga'a in Nubia-Meroë and the temple of Amun

5. AKAN LORE CONCERNING THE NUMBER SEVEN ..198

 5.1 Divine kingship (Asar-Aset) and Sacred State (Amun-Mut) of the Akan
 5.2 The number seven in Akan religious and secular life
 5.3 Occurrences of the number seven in *Religion and Art of the Ashanti*
 5.4 Occurrences of the number seven in *Ashanti*
 5.5 Occurrences of the number seven in *Ashanti Law and Constitution*
 5.6 Occurrences of the number seven in *Divine Kingship in Ghana and Ancient Egypt*
 5.7 Occurrences of the number seven in *At the Court of an African king*

SOURCES .. 222

APPENDIX 1: A brief note on extraterrestrials.................................... 228

APPENDIX 2: 22 ET groups that created Earth's human races 237

APPENDIX 3: A Map of African peoples connected to Kemet & Kush .. 248

APPENDIX 4: The Dogon account of first contact with the Nommo 260

ABOUT THE AUTHOR 262

1

INTRODUCTION

This book presents a number of spectacular results that were initially unintended aims but that emerged as I attempted to solve a mystery. The mystery involves the apparent disparity of a serpent cult, well known in Asia, that also has an equally long history but virtually unacknowledged presence among African people across Africa. What surprised me greatly, was that starting with an odd observation that an instance of naga presence in West Africa ought to imply much more about the influence of the nagas led to what amounts to a massive discovery and a widely unknown truth: that Africans have had a history of alchemy and tantra going back at least as far as the times of Ancient Egypt. Alchemy of the spiritual kind, and Tantra, were certainly practiced in Kemet and Nubia. Here, the virtually unknown fact is that similar to the case of the supposed lack of a writing culture in Africa, which activity happened in secret societies, it was also within the secret schools and secret initiations of African societies that the internal alchemy, tantra and sexual education have occurred in Africa. Thus, in Africa, internal alchemy and tantra remained in the realm of the esoteric and the sacred, only to be accessed during initiations, and not open to or widely available to the general public. Of course, in the modern world of the current time, across the world there has been an opening into the public arena of information that was once

held secret and that was once only the purview of the initiated. The contents in Part I of this book pertaining to the practices of internal alchemy and tantra within the Theban tradition of Ancient Egypt fall into this category.

The original aim of this book however was to investigate the existence of nagas in Africa as they appeared to be so far away from where nagas are often associated with in Asia. In that regard, this book succeeds in solving the "naga mystery" as it pertains to Africa by proving that nagas with the characteristics of those spoken of in Asia have in fact had a presence on the African continent for centuries. In the course of solving this naga mystery, the "greater Sirius mystery" as it pertains to Africa and its black people is also finally solved, providing in explicit detail the connections of many African groups and tribes to each other, to Kemet (Ancient Egypt), to Kush (Nubia), to Kanaan and Mesopotamia, to Lemuria and ultimately to beings associated with the Sirius star system. This is because while the original intention was to solve the original naga mystery within West Africa, it emerged during the course of research that an often benevolent serpent sect has had a strong influence in the esoteric traditions of Kemet and Kush, where the Sirius tradition is also fundamental. Perhaps the most surprising and consequential result of the research in this book is also being able to prove that the esoteric Kemetic internal alchemy and tantra methods commented on in this book were the intimate practices of the black peoples in Kemet and Kush of the sects of Asar (Osiris) and Amun. This shows that the Sirius tradition of spirituality as it existed in Kemet also had the same degree or more of those esoteric, tantric yogic-like practices carried out by Daoists in Asia. The system of internal alchemy and tantra practiced by the initiates of the temples of Amun is very ancient, harkening back to the ancient world.

Another significant outcome of the research that led to this book is demonstrating that the Dogon and the Akan people both of West Africa are last among the very few peoples remaining in the entire sub-Saharan Africa to have still

maintained the matrilineal system of governance, inheritance clan structures etc. Akan and Dogon culture are virtually identical. A further result demonstrated in this book is that not only does the Akan system of governance involving divine kingship mirror that of Ancient Egypt (in particular the Asar-Aset-Heru tradition), other African groups within southern Africa such as the Baluba, Mongo and even the Monomotapa kings also practiced surviving elements of the Ancient Egyptian system of divine kingship. The surprises do not end there. In this book, I prove perhaps for the very first time ever, drawing on available ancient texts, that the current system of the Akan Sacred State is identical (this means, it is the same) to that of the spirituality practiced in the Ancient Egyptian temples of Amun, particularly that of Waset/Thebes, and those of Nubia/Kush/Meroe. Relying on an ancient text that involves an eye witness account, I do this by showing an isometric relationship (i.e., a one-to-one correspondence) of the spirituality of the Amun-Mut-Khonsu sect (which, together with the Asar-Aset-Heru sect have been the cornerstones of black culture and spirituality for millennia) with practices of the Akan Sacred State that are still current even to this very day. The implications of this are significant indeed. It means that, among other respects, the Tano oracle and system of worship of the Akan of present-day Ghana and Ivory Coast was the _same_ system practiced in the temple of Amun at Thebes in Upper Egypt, as well as all over Nubia and further afield wherever the temple of Amun went to in the ancient world, such as at the Ancient Greek oracles of Delphi and Dodona. This means that not only has the Ancient Egyptian system of government survived intact in the Akan system of government, the very heart and soul of the religious and spiritual life of the black people of the ancient world has also survived intact among the Akan people. The Akan (and their Dogon brothers and sisters and many other African peoples who are named in this book) are by consequence also the Ancient Egyptians and the Ancient Kushites, or one could more correctly say are the direct descendants of these ancient people. And I prove that in this book.

The implications of the last paragraph are also important inasmuch as they imply that the ancient manuscript for internal alchemy and tantra that came out of the Theban temples of Waset/Thebes is also another heritage of the temples of Amun and by consequence of the black peoples who are direct descendants of the ancient peoples of those regions. In fact, it is not only as an implication. I also prove it in this book that this is the case.

So, there are a lot of new discoveries in this one book (not least the fact that there is an actual ancient naga settlement in Nubia/Kush which goes by the name Naga'a) which left me repeatedly surprised, sometimes unbelievably so, as I followed the research trail which began with the original intent to unravel the naga mystery of West Africa. The historical content in this book alone is immense to be a book by itself, exploring in extreme detail the histories and traditions not only of Africa and particularly of Asia, but also of Lemuria, Kaanan, Mesopotamia, Europe and the Yucatan. There are even explorations that foray into Native American traditions. Last of all, the most unique and extensive explorations are relegated to four Appendices. Certainly, some readers may gravitate or resonate more in the direction of the history, and the connections made. They are stupendous. However, being a spiritually oriented intellectual, it is also the spiritual content of this book (which, by itself, could have also been another book on its own) that I deem to be of real and lasting importance to black peoples of Africa and around the world. This is because while it is empowering to connect with our roots, it is the spiritual life of Africa that must be maintained and continued in order to continue African culture at its very heart. To that end, I provide other spiritual content in this book pertaining to Africa and its people, beyond the discovery of the ancient manuscript for internal alchemy and tantra with its importance to black peoples of African descent the world over (and including those that have gone beyond Earth to live on other planets). It is certain that the practices outlined in

the ancient manuscript that I extensively comment on were practiced on the continent of Atlantis. Together with the Kemetic book of Enlightenment (the *Rau nu Prt m Hru*, or the *Book of the Dead/Coming forth into the Light*) we learn that the people of Kemet had an extremely advanced system of spirituality, equal to and in some respects even more advanced than current day comparable practices.

PART I

2

THE NAGAS

2.1 Nagas as people, as semi-divine beings, and as Reptilians

One of the most fascinating names associated with peoples is the name 'naga'. This name has brought about some confusion because it refers both to serpents and in particular the cobra, king of serpents, and it also refers to human groups or tribes. There is an entire grouping of people today in the country India known as Nagas. They live in Nagaland, part of the state of Assam, in the easternmost part of India. Assam is a cultural melting pot, consisting of Tibetan peoples, Cambodian peoples, Indo-Aryans, and others. Urban (2010) breaks down the groups in Assam as such:

"The people of the region are no less diverse, representing a complex mixture of ethnic and linguistic groups that include Mon-Khmer, Tibeto-Burman, Indo-Aryan, and Tai-Shan. Today, the state of Assam alone contains twenty-three recognized tribal groups, including the Bodo Kacharis, Rabhas, Lalungs, Mikirs, Khasis, Jaintias, Garos, and Nagas, each with their own unique cultures, dialects, and religious histories." (p. 8)

Assam thus represents a meeting place of different cultures who must have arrived there from different places. What is common among these people in the region is a strong adherence to the spiritual practices of tantra. The word 'tantra' has been over the ages to mean different things. In this current age, and especially among the 'new age'

tradition, tantra very often has a reference to techniques employed during sexual intercourse. Although this association with sex is not arbitrary (as, for instance, there are esoteric sexual rites performed in Assam at temples devoted to the goddess Kamakhya), the word tantra has not always referred to sex. Rather, it connotes a framework, or a consistent paradigm, a method (the image sometimes given is that of weaving). Tantra, when spoken of in the context of spirituality, is more about transformation. Through spiritual tantra, we can become whole again. We can transcend the mundane.

The connection of tantra with spirituality is strong, especially in regard to nagas. Here, the conversation about nagas veers away from them as a human people or group, to the more sublime level of nagas as a race onto themselves. Although this race of nagas, an ancient race, has human attributes and heritage, they also have a serpentine or reptilian attribute. In fact, their reptilian attribute is what defines and distinguishes them more than their human attribute. In this way, the race of nagas have attained the rank of 'semi-divine' status, positioned somewhere along the spectrum of mortals at one end and 'the gods' at the other end. This classification is also not arbitrary because, as we shall see in sections that follow, there are accounts around the world of a Reptilian race of beings that live for hundreds of years and that have at different points in history also served as rulers of human nations and groups. In fact, if we tap into the extraterrestrial paradigm, then there is at least one work (Deane, 2002) that asserts that about a million years ago, Reptilians from another star system came to Earth and created a new hybrid race that mixed humans at the time with their own Reptilian genetics. This race, which became the nagas, has since claimed to be indigenous to Earth because of their human heritage. Another work (Danaan, 2020) actually uses the term 'nagas' when associating this hybrid group with other (full blood) Reptilians that are operating on Earth.

And so, the nagas, those 'semi-divine' beings (and not the groups and tribes of human people who go by the same name), are not quite human. Yet they are not quite Reptilian either. They are both, which would be the reason why they interact with both parties. For this book, nagas are important because in the past, they have given humans some very advanced spiritual information that can contribute to spiritual transformation and eventually to enlightenment. This is why they have a central role in the story told in this book. There is the idea that from an early time of humanity, humans learned alchemy and tantra from the nagas, and that this relationship has continued over the ages (c.f. Patanjali, and Nagarjuna, who would be spoken of in greater detail in sections 2.5 and 2.6). As we shall see in the section on Yoga, the ancient sage Patanjali, the supposed author of the Yoga Sutras of Patanjali, has an association with the nagas. Patanjali's influence on and importance in Yoga and its dissemination cannot be overstated. After Patanjali, this time within Buddhism, we also find nagas affiliated with Nagarjuna. So, we find that the nagas have had an important role to play when it came to the spirituality of the people of Asia.

In this book, perhaps for the first time ever, I shall make the case that the nagas (as they are known of, and described in Asia) have also had an influence on spirituality in Africa, specific not only to Kemet (Ancient Egypt) and to Kush (Nubia), but also more widely across the African continent.

2.2 Different source texts on the nagas

In studying the presence of nagas in Asia, I consulted a number of texts from conventional sources in order to become grounded on historical views of nagas. These source texts pertain to India and its environs that give various views on the nagas as they appeared in the histories. Often, the nagas would appear in the context of a specific religious or

spiritual tradition, but not always. For example, there are Hindu, Buddhist, Jain, and Puranic histories and traditions that integrate accounts of nagas. In this section, I shall sample a number of these source texts. The purpose of this endeavour is to place nagas within the context of Asian lives, especially in the spiritual context, as that context is the major focus of this book.

One source text, titled *Nagarjuna in Context*, is replete with accounts of nagas from the histories and traditions of Buddhism, Jainism and Kashmiri Shaivism. In particular, the focus is on Nagarjuna, a character who was immensely important in advancing Buddhist thought and practice. In Buddhist texts chronicling their history, Nagarjuna is said to interact with nagas to receive favours, religious texts (sutras), among them the Prajñápáramitá Sutras which subsequently influenced Nagarjuna in his writing of the Mulamadhyamakakarika. This latter work is still arguably the most important work in Mahayana Buddhism. Of Nagarjuna, Walsh (2005) says:

"Every story related to Nágárjuna contains recurring elements, though some elements recur infrequently. The discussion below examines two of these elements—nágas and alchemy—in relation to his association with particular kings and place names. Every account of Nágárjuna has some etiological myth related to his name, that is, relating to nágas, or snakes." (Walser, 2005, p. 73)

And so from Nagarjuna's influences and interactions, we learn that humans and nagas have interacted at length. In certain of these accounts, it is even the humans that convert nagas. So, in India, humans and nagas appear to have interacted at length and many of those times in the context of religion and spirituality. Another source text that focuses entirely on nagas and their history is the book titled *The Nagas, the Ancient Rulers of India, their Origin and History*. This book points out among other things that there are naga temples still existing today in India, in the region of the Kashmir valley:

"Takshila is very close to the Kashmir valley which was the residence of Karkota Naga. Loharas (who claim their origin from Sàtavàhanas) Karkota, Gonanda, Nagpal (Bhadravaha) Naga Royal families have been ruling in Kashmir during historical period. Still today, there are countless temples of Nagas in Kashmir, such as temple of Basuki Nag, in the little town of Bhadarvah and in two villages." (Viyogi, 2002, p. 6)

In following sources on nagas in India, one scarcely reads far before encountering the name 'Takshila', said to be an ancient abode of the naga people. This is a reference to the serpent race people of the very ancient time, not the human tribes that go by the name Naga. That they survived to the present time and that there are still temples built for them is significant on many levels.

To learn more about what has been written about the nagas from source texts, we shall next consult the *Markandeya Purana*. Now, this text is ancient. The Puranas are ancient even in comparison with the Hindu Vedas, and this particular Purana is said to be the most ancient of the Puranas. In this book, nagas are everywhere, functioning in ways that humans are written about in ancient Hindu texts like the Mahabharata. The ways that humans are written about in the legends in the Vedas is the way that nagas are written about in this Purana. To cite one example, there is one section in this ancient text where a naga is having a conversation with S'iva, one of the deities of the Hindus. I have never read a text where a human was having a casual conversation with S'iva. The conversation between S'iva and the naga goes as such:

"Hearken also to this, O Naga. But when the sraddha is reached, thou shouldst eat the middle pinda by thyself, most noble Naga, being pure, and having thy mind subdued; and then, when that is eaten, the happy lady shall rise out of thy middle hood, the same in form as when she died. And having pondered on this thy desire, do thou perform the libation to the pitris; immediately she, the fine-browed, the auspicious, shall rise out of the breathing middle hood, the same in form as when she died"

This quote above appears to be some form of spiritual instruction from S'iva to the Naga. Mention of the happy lady and the middle hood causes me to surmise that this is a very ancient transmission of tantra involving the central channel (the middle hood).

2.3 Similarities between descriptions of nagas in Asia and in African

While the naga presence in Asia is very well known and studied, the same cannot be said of the Naga presence in Africa. In fact, the naga presence in Africa is almost unheard of. It was because I head learned about the naga presence in Asia and also in Lemuria that I was able to recognize that the legend of the snake in the history of the ancient Ghana empire in West Africa was a story about nagas. This is because the snake in that legend has the same characteristics as nagas described in Asia and in Lemuria. The story of the snake associated with the Ghana empire and how this disparity of having nagas that are ordinarily known to be located in Asia this time be in Africa, a question that begged for an explanation, and the investigative journey I undertook to confirm the existence of nagas in Africa's past, is told in chapter four of this book. For now, let us examine similarities between descriptions of nagas in Asia and in Africa.

First and foremost is the association with seven heads. As we all know, seven headed serpents are not found in nature. At least, not as physical animals. That lore on seven-headed snakes are to be found in Africa as well as in Asia highly unusual to be a coincidence, therefore it is significant. The seven heads are symbolic of the importance of the number seven. Seven is a very important number in esoteric or occult teachings. For this reason, I attempt to detail correspondences and connections with this number seven in chapter four, for cultures in Africa, in Asia, and elsewhere in the world.

Secondly, the nagas in Asia were known to be powerful magicians. Their feats were legendary, especially when it came to influencing the weather. In regard to being able to perform magical feats, there is a very clear connection between the lore concerning nagas in Asia and in Africa. The nagas in Asia were said to be able to cause changes in the weather, in ways that affected those who they were not happy with. Consider the case of nagas in Kashmir, whom, upon the humans in their region ceasing to perform ancient brahmanic rites, resorted to attack them with weather magic, sparing those humans who continued with the rites and eliminating the rest:

"In this work, Nágárjuna and his Maháyána followers are credited with leading good brahmins away from the rites of the Nila[mata]purána, with the result that the nágas sent the snows to destroy the people. Those who did not adhere to Buddhism and still performed the rites were magically spared, whereas all the Buddhists were destroyed. The snows only abated when a certain brahmin, Candradeva, practiced austerities to please Nila, "lord of the [Kashmir] nágas and protector of the land." (Walser, 2005, pp. 74 - 75)

Here, we find that the nagas, having immense occult power, were able to draw on their magic to instill their hold on the humans within their sphere of influence to continue practicing traditional rites. Those Buddhists who had converted from traditional brahmanic Hinduism and had thus ceased to observe the rights were obliterated by the naga king Nila. Nagarjuna is a personality that is enormously important to this story about nagas especially in his connection with Mahayana Buddhism. He shall resurface in the section below on Buddhism.

Similarly, the nagas in Wagadu, the Ghana empire, had the ability to bring bad weather on the Soninke people after they broke their pact with them. The legend of the seven-headed snake in the Ghana empire ends with the slain snake cursing the people of the land there at the time with a drought. According to Islamic sources, the area, which had previously

had stable weather, did in fact suffer a drought so severe that the settlements in the Ghana empire had to be abandoned. An account of the curse of the snake as given in the section below titled *The Ghana Empire* and also repeated here is as follows:

"When the snake took out his last head, the one in silver, the night became clear like the day. The snake said, "I swear by the lord of seven head, during seven years and seven bad years, and during seven months and seven bad months, during seven days and seven bad days, Wagadu will not receive any rain and any piece of gold"."

The third and most relevant similarity between the nagas of Africa and those of Asia is in their connections with spirituality, spiritual centers, and with the practices of internal alchemy and tantra. The reptilians practice sexual tantra, as I show later in this book. If the reptilians have a history of practicing sexual tantra, then the nagas, those that are hybrids of reptilians and humans, would almost certainly also practice tantra. Being intermediaries between reptilians and humans, the nagas would then have been teachers of tantra to humans. This has in fact been the case in at least one "highest yoga tantra" tradition known as the kalachakratantra, one that I have trained in. In this tradition of tantra, nagas are revered as ancestors and benefactors of the tradition. We should not also forget Patanjali, an ancient proponent of Hindu Yoga who was associated with the nagas, as well as Nagarjuna, a major proponent of Buddhism, who has already been mentioned in this section.

In Africa, the naga city of Naga'a that was in Nubia in ancient times and that is discussed in the last section of chapter 4 had a strong presence of the sect of the Ancient Egyptian deity Amun. It is from the temples of Amun in Waset/Thebes in Upper Egypt (a city that is now called Luxor) that we get the ancient internal alchemy and sexual tantra manuscript of the Ancient Egyptian priesthood and which is the subject of my extensive commentaries in chapter 4.

2.4 Reptilians teaching humans in ancient times

In Africa, we have a long and well-known history of indigenous people knowing about or interacting with extraterrestrials. At the level of indigenous African knowledge, this subject is not taboo. Perhaps the most well-known example of Africans encountering ETs is given in the story of the Dogon people meeting with the Nommo, this amphibian race from the Sirius star system that the interacted with. The Dogon 'first contact' story with the Nommos is given in Appendix 4. What is also now well-known are some of the African knowledge traditions regarding the reptilian race. Much of this knowledge from African traditions was revealed by late Zulu high shaman Credo Mutwa.

What is barely known is that there has been a race of human-reptilian hybrids known as the nagas who have interacted with humanity since the most ancient times until the present. They interacted with black people in Asia and as this book will prove, they have also interacted with black people in Africa. The nagas, having both human and reptilian heritage, can hold one or the other form depending on the circumstances they are in, and on the degree to which they have human or reptilian genetics. These nagas have been seen as 'demi-gods' in the ancient world, some having been worshiped, served as kings of their own people and also of humans, and have had cordial as well as hostile interactions with humans. The 50-50 (human-reptilian) hybrid Nagas can live for hundreds of years.

There has perhaps not been a better depiction of nagas that I have come across than the character played by James Earl Jones in the 1982 movie *Conan the Barbarian*. In this movie, Jones plays the character Thulsa Doom, a negative polarity Naga king who oppresses men, and who can use his hypnotic reptilian eyes to hypnotize and to subsequently control humans. In a stunning display of the real, there is an episode in the movie where, during an orgy ritual, Thulsa Doom (by

himself and not part of the orgy) shape-shifts into his reptilian form. Being a Naga and having both human and reptilian heritage, this was possible for the naga king. Below is James Earl Jones, in his character as Thulsa Doom from the 1982 movie. Notice his eyes:

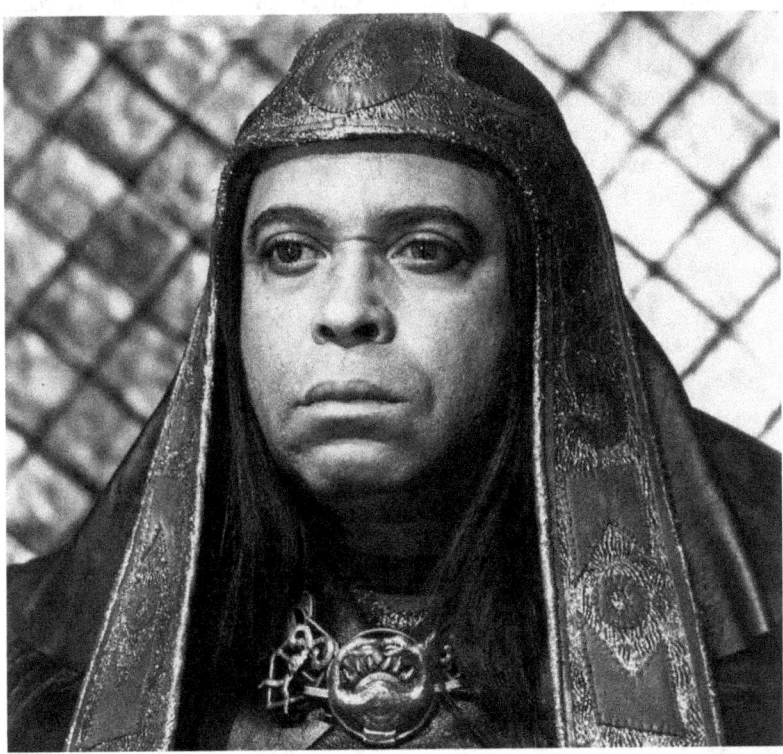

This movie was the standard for fantasy movies back in the day, for a long time until movies such as Tolkien's *Lord of the Rings*, *Game of Thrones* and other similar movies of more recent times came around. The purpose of showing these images is to impress upon the reader the reality of the naga presence in the memory of humanity. It is more than a memory. There are actual historical accounts to verify their existence, as show in section 2.2 above.

The story regarding nagas is not all about plunder and doom, such as was the case with Thulsa Doom in Conan the Barbarian. There were in fact nagas who served as benefactors to humanity. These, together with Reptilians and with Sirian-Reptilians have been part of a serpent sect that has taught humanity since the dawn of the age of current Earth humans. A portion of nagas and their Reptilian allies have aided humanity in its quest for spiritual growth and enlightenment, and that is one of the significant stories in this book. More on Reptilians can and their influences on current Earth humans is elaborated upon in Part II of this book, as well as in Appendices 1, 2, and 3.

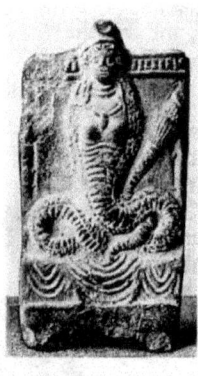
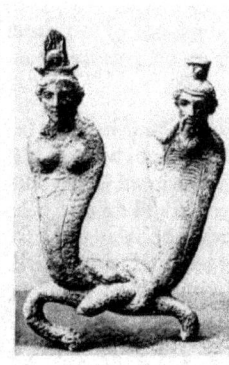

31. These two cult objects from the worship of the goddess Isis during the Graeco-Roman era were excavated at the Greek city of Cyzicus, in ancient Phrygia, opposite Byzantium. Both show the goddess Isis with a serpent's tail, and the bronze statue on the right shows her with her tail entwined with that of her husband Serapis (a later name for Osiris). See Notes to the Plates.

(Source: Temple, 1998, p.462)

2.5 Yoga, the Yoga Sutras of Patanjali, the Nagas, and Tantra

Yoga is a very old system that has been practiced in India and elsewhere for millennia. There are said to be four different kinds of yoga (Eliade, 1958), which are Hatha Yoga, Laya Yoga, Mantra Yoga, and Raja Yoga. Let us define each of these, leaving Hatha Yoga last, because it is going to be a subject of more in-depth discussion. Laya Yoga, also called "the yoga of dissolution" in a translation of Dattatreya's

Discourse on Yoga. The Dattātreyayogaśāstra is sometimes said to be the earliest text providing a complete system for practicing Hatha Yoga. At any rate, Laya Yoga refers to yogic techniques of which the practitioner contemplates emptiness. Through such contemplation, the body-mind can eventually attain dissolution in a state of deep absorption on emptiness. To elaborate further on these techniques, such as contemplation on emptiness goes beyond the scope of this book. Here, I only seek to introduce ideas to a certain degree for which the reader might already be familiar. Mantra Yoga, as the name implies, entails chanting of mantras as part of the yogic practice.

Raja Yoga, also known as the "King of the Yogas" (Bailey, 2012) is described as the practice of Yoga for which the individual achieves union of the personality self or the ego with the Soul, or the Higher Self. In the Yoga-Sutras, a complete system is given for achieving union (Bailey, 2012), becoming whole again (Busia, 1984) or achieving concentration and samadhi (Hariharananda, 1983). According to Hariharananda (1983):

"Yoga is one of the six systems of Indian Philosophy, and Patañjali's Yoga-sutra is one of the earliest treatises amongst them. His Yoga aphorisms deal with the mind and its fluctuations, showing the way how they can be controlled and how complete mastery over the mind can lead to cessation of misery and attainment of peace leading to salvation. " (p. vii).

In place of salvation, one may also think of liberation. Liberation from the conditions of confusion while incarnated with consciousness stationed at the level of the ego. The Yoga Sutras of Patanjali appear to combine techniques of meditation with postulates from Samkhya (Eliade, 1958). Samkhya is an ancient Indian system of logical deduction. Combined with the mystical methods of meditation, the Yoga-Sutras of Patanjali bring together both the mystical and the rational but then goes beyond just these two. Very little is known for certain about the exact time period that Patanjali (the personality that composed the Yoga Sutras) lived.

Conventional accounts appear not to go too far back (around 800 B.C), however esoteric accounts place the work in really ancient times. What is known is that Patanjali was not the author of the system. Rather, he appears to have compiled teachings that are more ancient than his time. Bailey (2012) places the system that Patanjali's Yoga Sutras is based on as ancient as 10,000 B.C., citing Hindu sources. Bailey (2012) also gives us some insight by stating that "[t]he Yoga Sutras are the basic teaching of the Trans-Himalayan School to which many of the Masters of the Wisdom belong" (n.p.). From Churchward, we learn that the nagas/naacals relocated to the Himalayas, so the naacal mystery school from Lemuria/Mu could very well be one of the schools that originated components that ended up becoming systematized as the Yoga Sutras of Patanjali. This could also be the reason why Patanjali is depicted in images as being wrapped around by a serpent with seven serpent heads. As the reader will find out in chapter four, the seven-headed serpent is the very symbol of the naga/serpent cult.

2.6 Buddhism, the Nagas, Nagarjuna, and Tantra

Buddhism is a system of spiritual practice that was founded by Gautama, a prince in Ancient India who left his family to seek enlightenment. It is a vast system that has taken centuries to develop, from the time it was gifted to the world. In this book, my purpose is not so much to delve into all of Buddhism, which is beyond the scope of what I hope to achieve. Rather, I aim to emphasize the importance of naga influence on Buddhism, and the possible implications of that. That the nagas influenced Buddhism is a very well-known fact amongst Buddhist scholars. Their influence comes in the form of a text that a Buddhist personage known as Nagarjuna revealed.

Now, Nagarjuna was no ordinary Buddhist personage. Some accounts claim that after the Sakyamuni Buddha, the historical Buddha who was once known as Gautama the

prince, that Nagarjuna is quite easily the second most important figure in Buddhism. Nagarjuna was one of the major figures responsible for revealing one of two main traditions of Buddhism known as Mahayana. The other tradition is known as Theravada. While Theravada is known as the "Lesser Vehicle", Mahayana is known as the "Great Vehicle". "Lesser" and "Greater" do not mean that one is better than the other. Rather, these are orientations of practice that can lead to enlightenment. In Theravada, the older of the two traditions, achievement of enlightenment aimed primarily at the individual level. Remember that Gautama forsook his family to roam the world in pursuit of individual enlightenment. Practitioners of Theravada seek to emulate the Buddha, not necessarily by also going into the wilderness to practice, but rather to observe their Buddhist faith and practice on an individual level, in order to work at achieving enlightenment. So here, "Lesser" means focusing more on the individual.

With Mahayana, on the other hand, individual achievement of enlightenment is contingent on assisting many other individuals on their paths. In Mahayana, there is individual effort, in terms of following Buddhist practices. There is also the effort to raise others on their own efforts to achieve the goal.

So, that is a very basic attempt at delineating what is a complex tapestry of traditions and practices. To that end, I shall ask the Buddhist scholars and specialists to forgive the basic treatment, in view of the limited scope of the section, focusing on Nagarjuna and on naga influence. As mentioned earlier, stories about Nagarjuna's life are replete with encounters with Nagas. Walser (2005) tells us that:

"Nágárjuna's connection to nágas usually involves his receiving some gift or boon from a nága king. In the Harsa-Carita, this is an antidote to all poisons, a gift from the moon. In Kumárajiva's Biography and in the Tibetan historical tradition, the gift is the Prajñápáramitá Sutras. These myths demonstrate an attempt to tie the character of Nágárjuna to some other element desirable to the

hagiographer (such as alchemy or Maháyána Buddhism) through the instrument of his name." (pp. 73 –74)

On examining Nagarjuna's life, we learn many things. We learn that he was from Dravidian from Southern India, and that in addition to getting the hundred thousand verse Prajñápáramitá Sutras from the nagas who had kept it in their realm after the Buddha taught it (see a link to The Life of Nagarjuna by Alexander Berzin, in the references section), that he was instrumental in the development of tantra in India. The Prajñápáramitá Sutras has itself been influential on Mahayana Buddhism, but my interest here is primarily in tantra. Eliade (1959) tells us that "According to Buddhist tradition, tantrism was introduced by Asanga (c. 400), the eminent Yogacara master, and by Nagarjuna (second century A. D.), the brilliant representative of the Madhyamika and one of the most famous and mysterious figures in medieval Buddhism." (p. 201). Here, this is a reference to the The Guhyasamaja Tantra, one of the "highest yoga tantras", and the one that is historically the oldest in terms of being revealed publicly to the world. In addition to Theravada and Mahayana, the "highest yoga tantras" deal with a third branch of Buddhism known as Vajrayana. Vajra is a Buddhist symbol associated with the thunderbolt, and with the "Diamond Vehicle", an indestructible "merkaba" vehicle with which the adept can ascension and immortality.

So, let us stop here for a moment and take account. First, Nagarjuna was associated with the nagas. That much is well-known and publicly acknowledged even by conventional academics. Second, Nagarjuna is said to have received knowledge from the nagas. We have read earlier from Melchizedek (1999) that black people were practitioners of tantra in Lemuria a very long time ago, and from that we can surmise that those black people must have learned tantra from the nagas (just as Buddhists learn tantra from nagas in this age), and even to the extent of adopting the name naga. We have also surmised from Bailey (2012)'s assertion that Hatha Yoga was practiced in Lemuria, and also from Eliade

(1958) that there is a strong link between Hatha Yoga and tantra. Now, we are learning that Nagarjuna, a major Buddhist figure, studied the The Guhyasamaja Tantra (according to Alexander Berzin, and others), which means that Nagarjuna was a Vajra holder. Guhyasamaja Tantra belongs to the class of "highest yoga tantras", along with other examples such as Chakrasamvara, Hevajra, Kalachakra are among the most advanced tantric yoga systems that can lead to the ultimate goal of yoga practice, which is completion, union, or becoming whole again. In addition to all of this, Nagarjuna is said to have been Dravidian, or a member of the "swarthy" or dark-skinned people of India. All of this seems to be pointing to the notion that the nagas, blacks of Asia, and one of their protegés, Nagarjuna, himself a Dravidian and black, were influential in the development of Buddhism after it was revealed by Gautama Buddha's realization.

Eliade (1958) unequivocally writes that, "according to Tibetan tradition, Nagarjuna was a native of Andhra, in southern India - that is, in the heart of the Dravidian region." (p. 201). It is also from Eliade (1958) that I will argue we learn more about the origin of tantra from the nagas. We have Eliade (1958) to thank, for the following assertions:

"... we may conclude that, especially at first, tantrism developed in provinces that had been but little Hinduized, where the spiritual counteroffensive of the aboriginal inhabitants was in full force. For the fact is that tantrism served as the vehicle by which a large number of foreign and exotic elements made their way into Hinduism; it is full of names and myths of peripheral divinities (Assamese, Burmese, Himalayan, Tibetan, to say nothing of the Dravidian gods), and exotic rites and beliefs are clearly discernible in it. In this respect, tantrism continues and intensifies the process of Hinduization that began in the post-Vedic period. But this time the assimilation extends not to aboriginal Indian elements alone, but also to elements outside of India proper; the "tantric country" par excellence is Kamarupa, Assam. " (pp. 201 – 202)

Eliade thus provided the evidence, and the signs, that tantra has origins outside of Hindu culture. The origins point to more aboriginal cultures that predate the Hindu Aryan culture. It is significant that he points to Assamese, Burmese, and Dravidian culture and in particular that Kamarupa (the first kingdom of Assam) was "tantric country". Nagaland is in the same region bordering Assam, and in fact both present-day Assam and present-day Nagaland were part of the historical kingdom of Kamarupa, which existed between 350 CE, and 1140 CE. So, whether or not Eliade realized it, I am of the opinion that his evidence and his signs point strongly toward an origin of tantra with the nagas.

Urban (2010) appears to confirm Eliade (1958) in suggesting that although there are forms of tantra in both northern and southern India, there are also non-Vedic forms tantra which include elements from many cultures indigenous to Asia but peripheral to or outside of India proper. The implication here is that tantra may have entered into India from some of these peripheral cultures, or it may have a source altogether different from both Indian and indigenous Asian cultures, with each side now having elements of tantra. If both sides were influenced by nagas and if those nagas came from someplace else (that place possibly being Lemuria – see chapter four) then different places (Assam, Kashmir, Dravidia) can have renditions of tantra, with each having a rendition with elements more unique to their root culture. Urban (2010) is of the following opinion:

"it is true that the form of Tantra that we find in Assam is very different from the elite, highly philosophical, and brāhmanic Tantra of traditions like Kashmir Śaivism or South Indian Śrīvidyā. In contrast to the sophisticated philosophical discourses of Abhinavagupta or Bhaskararāya, the Assamese Tantric tradition is heavily infused with non-Hindu and often highly un-Vedic elements drawn from the many indigenous religions of the northeast. And yet, as we will see in the chapters that follow, the Assamese tradition is by no means a simple veneer of Hinduism slapped onto a deeper tribal substratum. Instead, it is the result of a far more complex negotiation between the many indigenous

traditions of the northeast and the Sanskritic, brāhmanic traditions coming from north India that resulted in what is among the oldest and most powerful forms of Tantra in South Asia." (p. 10)

The single thread that unites Buddhism, Nagarjuna, and the various expressions of Tantra (Assamese/Kamarupa, Kashmir Shaivism, South Indian Srividya) is the naga element. These serpent beings are ubiquitous in the spiritual traditions of the region. They have been benevolent to humans, such as in those cases where personalities like Nagarjuna received gifts (in the form of sutras) from them. They have also punished humans for failure to follow tradition, such as in the case of the naga king Nila of the Kashmir region (whom we encountered in an earlier section) eliminating locals for converting to Buddhism instead of staying true to the teachings and the rites of the puranas. At the top of it all, we have an episode where a naga receives teachings directly from S'iva (i.e., Shiva), the equivalent of a deity (or perhaps an ET), and one who is also sometimes associated with serpents. Thus, serpents play a central role in the spiritual traditions of these said Asian cultures.

The same will be seen in the African case, where it will be shown in chapter four that there is a serpent cult that was based in Kemet (Ancient Egypt), Kush (Nubia), Abyssinia (today's Ethiopia), and Wagadu (i.e., the ancient Ghana empire). We can take for granted that the teachings on internal alchemy and meditation that are discussed in chapter three ultimately got to African initiates in these regions in Africa through the serpent cult. In chapter three, this will be shown conclusively in the case of Kemet and Kush, where the most esoteric initiation teachings of both the internal alchemy and tantra paths and the enlightenment paths of African spirituality are guided by beings having strong associations with serpents. To learn more about their history and the ways I took to arrive at the above conclusion regarding the esoteric traditions of Africa, the reader would have to refer to chapter four however, to learn more about

the nagas and the serpent cult in relation to Africa and to the rest of the world.

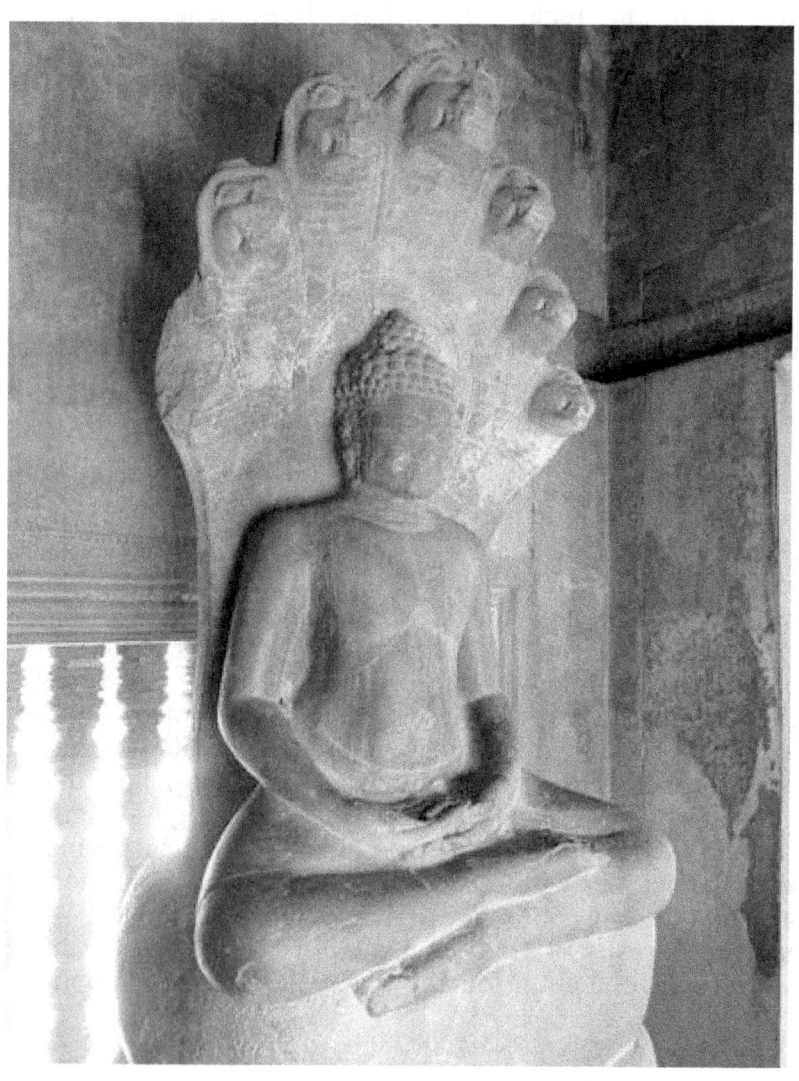

3

REVIVING KEMETIC INTERNAL ALCHEMY & TANTRA

3.1 Internal and External Alchemy

Alchemy is a term that means "of Khem". The word itself is Arabic in nature, referring to practices of the black peoples. Khem being the land of the blacks which in ancient times was Ancient Egypt. In particular, the word was referred to esoteric or secret knowledge of the black people in Khem that brought about the transformation of elements. The adepts of Khem would for instance take mercury and then combine it with cinnabar, firing the combination using specific knowledge and formulas, all with the purpose of transforming the mercury into other elements such as gold. This is the conventional understanding of alchemy, from which the modern-day scientific study known as chemistry derives. Chemistry, or we could write it as "Khemistry", has Khem in it, or the knowledge of the black people of Khem, which entails adding elements together based on knowledge and of principles to bring about transformation.

Now, as one would imagine, the practice of alchemy has existed for thousands of years. During that time, there have been successes and failures. The principles that bring about transformation, however, have remained the same during this time. These principles can be applied in a physical

context as well as in a non-physical context. The non-physical context involves understanding with non-physical 'elements' can be combined, and how to apply 'firing processes' to them to bring about non-physical kinds of transformations. In Khem/Kemet, the form of alchemy that bring about transformation using physical elements and the form of element that brings about transformation through non-physical elements were both practiced. The first form of alchemy can be termed external alchemy. That is the form that involves physical substances. In the Daoist traditions of Asia (who have also practiced alchemy for millennia), external alchemy is known by the term 'wai dan', which means 'external cultivation'. There are historical accounts of individuals having succeeded in creating external 'alchemical pills' that then caused them to live forever as immortals. Not all external alchemical products lead to immortality. Some can also bring about deep and fundamental healing. There are also accounts of many failures. I should mention that I have come across a substance produced through external alchemy and that has incredible healing qualities. It heals the physical body at a fundamental level. I came across this substance which was produced by a Daoist adept and his students who were among my first Daoist teachers. This happened in China. It took several weeks of constant 'firing' to make it. I did not need to ingest this substance, however, as upon consultation, my physical body and energy did not require it.

The second form of alchemy can be termed internal alchemy. Where external alchemy brings together physical substances, transforming them into stable physical substances, internal alchemy brings together energetic substances that bring about transformations of one's energy when the principles of internal alchemy are correctly followed. In Daoist traditions, internal alchemy is known by the term 'nei dan', which means 'internal cultivation'. This book, especially the first part, is about internal alchemy. The transformations that are brought about through the practices of different schools of

tantra and yoga fall under this second category. Tantric spiritual methods are forms of internal alchemy in that they bring about transformation of the self through meditative practices.

3.2 Why anyone would want to practice internal alchemy

Internal alchemy, unlike external alchemy is immediately accessible to all who are aware of its principles and methods. This is because the energetic substances that are required for carrying out internal alchemy are available to everyone. There is no need to go searching for rare physical elements and materials to undertake internal alchemy. Any person on Earth with a physical body and with the interest, intent and will can engage in this practice. That is the first reason why anyone would want to practice internal alchemy – it is fun, as well as accessible to all, and the materials are all essentially free of charge. The difficult parts are finding authentic teachings and also of dedicating oneself to put effort into the practices.

Beside it being fun, the potential result of correctly practiced internal alchemy is the second and more important reason why anyone should practice it. With the correct practice of internal alchemy, there are immediate health benefits that can help sustain one's health, which is arguably our greatest wealth. Correct practice of internal alchemy strengthens our energies that in turn repairs our physical bodies and our DNA. It is even possible to begin to activate certain aspects of one's DNA to become stronger, more powerful, more psychic, more spiritual, more intuitive and in tune with higher vibrations and with fellow people. Each of these potential outcomes depends on the interests, on the direction and also on the extent of correct dedicated practice. In essence, where external alchemy or 'wai dan' would be your conventional technology solution which you have to pay for, like plugging your devices into a physical socket for power,

internal alchemy or 'nei dan' is like the ultimate 'free energy device' solution for our physical bodies. The energies come from the universe. They are ever-present. It only takes effort, dedication and correct practice to access the benefits of this second approach.

There is also the question of life, death and rebirth into the human condition. For those who want benefits beyond mere health or even of power, a certain direction of the practice of internal alchemy can lead to an extension of one's physical life, while some other directions can lead to a permanent repair of one's light body, to the extent that it no longer becomes necessary to have to lose consciousness with the death of one's physical body only to have to be born again in another physical body, at another time to begin the process all over again of learning who you are, why you are here on this planet (or on some other planet for that matter, if you end up or have already ended up there).

In chapter 5 of my book The *Guardians, Earth Humans, and Ascension*, I describe the magnificent human that one branch of the ancestors of humanity was. This human was in all aspects and respects what we can term 'angelic'. It was a being that was activated multidimensionally. A being that was not limited by time or space. It was 'fully ascended', which means that it could transition states from physical to spiritual or the other way around. In short, this being did not have the limitations that present Earth humans have. Our current Earth human physical bodies are very much limited, compared with this ancestor of humanity. This being represented our beginning, and it can also represent our end. Humans on Earth today have the DNA of this being and as such we have the potential to reclaim our spiritual heritage. The ultimate purpose of internal alchemy practice, for those who desire it, would be to completely repair the human multidimensional vehicle with the view of completing one's tour on the human journey in order to escape the cycle of birth and death.

That then is the ultimate reason anyone would want to practice internal alchemy. Internal alchemy offers us a route to become whole again. What does 'whole' mean? It means connecting with our spiritual selves, to our Higher Selves. It means building a body that can allow us to ascend, to consciously transition beyond this physical world and not have to come back by being reborn again, either on Earth or elsewhere in the physical or etheric.

Again, not every Soul is ready for this, or needs this ultimate purpose at this time. Meanwhile, it is possible to have a lot of fun while also getting a lot of health and other benefits with correct practice and effort. The reason why black people have a high vibration today is because a lot of their ancestors practiced advanced spirituality in the past.

3.3 Paschal Beverly Randolph, an African American Adept

It is not often that one meets a remarkable adept such as Paschal Beverly Randolph (PBR). PBR was an African-American doctor from Ohio, who also had English, French, German, Native American and Malagasy ancestry. He was a self-taught genius, a doctor of medicine, and a spiritualist who is said to have set up the first Rosicrucian order in the US. Having the good fortune of traveling to Europe and to Africa due to his work aboard ships, PBR was able to go to Egypt during his travels. According to Hall (2019), on one of those occasions in 1856 on a visit to Luxor, Upper Egypt, the site of old Waset or what subsequently known as Thebes, PBR had an encounter with a man who appeared as a merchant of Ancient Egyptian antiques. As fate would have it, PBR was less interested in the antiques the man had, so the man presented him with an ancient manuscript. The manuscript had ancient teachings on a form of sexual spiritual practice. To make matters even more interesting, on the night that PBR received the ancient manuscript, the daughter of the man joined him in bed to initiate him. It is

this ancient manuscript, *A treatise on sexual thaumaturgy and the practice thereof*, called in Hall (2019) The Alchemy of Night Enchiridion, that PBR brought back to the US, and that is said to be the basis of the practices in a secret society in the US known as the Hermetic Brotherhood of Luxor.

3.4 A treatise on sexual thaumaturgy and the practice thereof

We are fortunate in this time to have laid hands on an ancient internal alchemy text on sexual yoga. The title of the ancient text as given in Hall (2019) is:

"The Alchemy of Night Enchiridion - A Treatise on Sexual Thaumaturgy And the Practice thereof
The Prince Khem Yar Khepher'set,
Supreme Ruler of Khemit and the Two Lands
Being a true and accurate account of the Finding and Transcription of an authentic papyrus from Ancient Egypt" (p. 45)

There are two very interesting and glaring clues in the title of this ancient text that in my viewpoint beyond all doubt in my mind to the truth that this was a text originated with the black peoples of Ancient Egypt and to the periods when their leadership and civilization flourished.

The first clue is in the word "Yar Kheper'set". Specifically, it is in the addition of the suffix 'set to the end of the name. Here, 'set is short for or stands for Waset, also

I usually tend to avoid going into the debates about whether Ancient Egypt was black or not. However, facts are facts, and so I like to stick with the facts, and then work my way up from there, to draw conclusions. The facts, as I understand them, are that in the pre-dynastic and early dynastic period (dynasties three to five, for sure), Ancient Egypt was ruled by black pharaohs. This was also a time when the "Two Lands", Lower and Upper Kemet, were united. Unity first came in the first dynasty with the efforts of Menes, a black pharaoh. The

two lands became disunited once again by the seventh dynasty, or the first intermediate period. It was not until the eleventh dynasty that once again the Two Lands were united. Again, unity was brought about by a black pharaoh, named Mentuhotep II. This time, the power of Egypt came out of Waset/Thebes, an ancient center of black civilization, a place where ancient temples stood then, with ruins still standing today. The third and final time that the two lands of Ancient Egypt were united was in the twenty-fifth dynasty. Again, it was a black dynasty that brought about unity, with the first pharaoh of this dynasty being Piye. Of these three periods of unity, the twenty-fifth dynasty is beyond any doubt a black dynasty, so even the most mainstream Egyptologists will agree to that.

I bring up these periods of unity in Ancient Egypt, led by black dynasties because that is the second clue in the title of the ancient text. The second clue in the name of the text is that it was given by an ancient prince who was the supreme ruler of Kemet and the Two Lands. Therefore, this ruler was from a black dynasty during one of the periods when the lower and upper territories of Ancient Kemet were united. Of the three periods where there was strong black rule during the two lands being united (i.e., third to fifth dynasties of the Old Kingdom, eleventh to thirteenth dynasties of the Middle Kingdom, and the twenty-fifth dynasty of the New Kingdom), I posit that the ancient prince, Yar Kheper'set, would have likely reigned at some point between the eleventh and the thirteenth dynasties. This is because the surge of power that supported the black pharaohs of the unified Kemet in the early period of the Middle Kingdom came strongly from Waset/Thebes, which was their capital city during this period (unification started in Man-Nefer (Memphis), at the start of the Old Kingdom period). This is not to say that the practice of the contents of this ancient text began in the eleventh to thirteenth dynasties when the ancient prince ascribed his name to the manual. It may have been practiced in Waset as well as in the territories of lower and upper Kemet for millennia before that. Waset has for tens of millennia being

a major center of the black priesthood of Kemet, perhaps their most important center, one that was seen as such both in lower and in upper Kemet, as well as in the lands of Kush. Therefore, it would more easily follow that the black pharaoh, being in a city of spiritual enlightenment of the black people of ancient times in Kemet would also be influenced to the extent that he would practice internal alchemy and spiritual tantra. It would follow then also, that the black priesthood at Waset would have practiced this form of sexual practice among their tantric and internal alchemy methods. Let us also not forget that it was at Luxor (the current name of what was in ancient times Waset/Thebes) that PBR was given this ancient manuscript. The reader can by themselves connect this last dot with the others given in this section.

This ancient text is part of the spiritual heritage of black people. It should therefore come as no surprise then, that it was perhaps fated that a black man would be secretly entrusted with the manuscript in order to bring this knowledge back out into the world once again.

A final point I would like to make about the title of this ancient text has to do with the word thaumaturgy. Thaumaturgy is a Greek word that means the working of wonders, miracles or magic. In this context, rather than think of magic in the sense of 'hoodoo tricks', the meaning here in relation to sexual tantra is more akin to the development of spiritual abilities that result from correct practice of the sexual tantra. These abilities can be thought of as being 'supernatural powers' but they are really a side effect of the transformations that can be brought about by engaging in tantra.

3.5 Corrections to earlier commentaries of the original text

In writing this section, I would like to begin by emphasizing that I offer my interpretations not in a condescending manner but rather in the spirit of considering that we are all students of this Kemetic manuscript handed down to us which I believe to be authentic. And so, just as I offer what I perceive to be corrections (and in some cases, additions) needed to do justice to the original text, I invite others to also examine my work critically, and to point out where they may deem that I have made a mistake in my interpretation of this work. The original text is important in that it is the first manual of Kemetic origin that at least I have come across that discusses the energy centers of humans in a practical way that can be compared with the knowledge we have of them from the Eastern traditions. Being myself an adept of a certain level of attainment, I believe myself to have the practical and theoretical background to be qualified to comment on this text, especially where there might be what I perceive as errors in the commentary that others have given. So, let us get into it.

One aspect of correction I offer here pertains to the commentaries on the section of the original text about the "central suns". These, I believe, have been correctly associated with chakras by Paschal Beverly Randolph, who gives the original commentary for each section, and then by E.A.W.B., who I suppose is E. A. Wallis Budge, the famous British Egyptologist who also worked on the original text. In chapter 5 of the original text, titled *Opening the Central Suns*, the original text gives nine central suns. If we think of these central suns as chakras, then it may be curious that there should nine of them, not the seven we are often accustomed with from the Hindu/Vedic system. However, the clue as to each of what the central suns is, its function, are clearly stated in the original text. From my understanding of these descriptions (each of these nine central suns will be discussed later on in this chapter) these nine central suns, or chakras if you will, do not map perfectly to the seven commonly known from the Hindu/Vedic system of chakras. It is not uncommon to find different numbers of chakras

highlighted or foregrounded in different systems. For example, in my practice of the Kalachakra tantra, a system practiced extensively among Mongolian and Tibetan peoples (and others), six chakras tend to be emphasized. In truth, there are actually many chakras throughout the bioenergetic system. Some are seen as major and others are seen as minor. It can be argued that there are seven major chakras, from the Hindu/Vedic system's point of view, and several minor chakras. In the Daoist system for instance, there are many chakras, some in the palms, some under the feet, by the spleen and so on. So, the point here, is that the number of chakras emphasized differs from system to system. In my view, it is a description of the function of each chakra that can give us a clue as to whether the same chakra is being referenced across different systems.

It is in this vein that I think that there is a big error in the commentary in this section of the book. Again, I attempt to point this out not in a one-up-man style of "I am right and you are wrong", but rather considering that today's practitioners are this age's generation of adepts who together contribute to the body of knowledge that is available to us. My Daoist teacher, Wang Liping, always encourages those who learn from him to consider their contributions to the body of teachings that are presented to them. This way, we all add to it. It is also the reason why the Daoist cannon exists to begin with. However, back to the topic at hand. I think the big error in this section, first in the commentary that Paschal Beverly Randolph gives (his is perhaps more of an omission, but there is an error therein as well), but more so I believe in E. A. Wallis Budge's commentary, and then carried further in Judy Hall's elaboration of that commentary. So, the error is basically this. I believe that Paschal Randolph attempted to comment on the central suns in terms of knowledge of seven major chakras as is known from the Hindu system. Paschal Beverly Randolph wrote:

"Lying along the axis of the spinal column and positioned in the Body of Light, the seven Central Suns correspond to the seven-

centered chakric system outlined in Rosicrucian and Theosophical doctrine as taught to the Highest Adepts in my Brotherhood of Eulis."

This is actually not an error, in my view, because within the nine central suns or chakras that the original Kemetic text gives, one could point out seven of those, which would map onto the seven chakras of the Hindu/Vedic system. I see it more as an omission. It is a subtle point of comment, really, but an important one. Important because by ignoring the fact that the original text gives nine, and focusing on seven, because that is what is known and discussed in the esoteric orders mentioned in the quote above (themselves likely influenced by the Hindu/Vedic system, especially the Theosophical doctrine which we know was), it does an injustice to the Kemetic system. Had Paschal Beverly Randolph commented instead by saying something like the nine central suns have a similarity with the seven chakras of the Hindu/Vedic system, then we would understand that what they have in common is that they are all chakras. But Paschal Beverly Randolph wrote "the seven Central Suns correspond..." What happened to the other two central suns?

Now, I will get more specific as to why this slight error (or omission, if you will) can lead to a higher order error. After writing that commentary, E. A. Wallis Budge then attempts to map the Hindu/Vedic chakras to the Kemetic ones, only that he maps them incorrectly! Next, building on Budge's mapping, Judy Hall further elaborates on Budge's commentary, adding correspondences, including crystals and such. These crystals would be the correct ones if we were dealing with the Hindu/Vedic system, but because the mappings are incorrect to begin with, the crystals are associated with the incorrect central suns. Again, perhaps not such a big deal, if a reader is learning about this material from an intellectual standpoint and is perhaps not looking to delve deeply into the material from a spiritual practice standpoint. To the cursory intellectual, chakras in the Kemetic system, chakras in the Hindu/Vedic system. Okay,

they are all chakras. Both systems have similar concepts. Not a very big deal, if there are some differences in the details. And at times, it is or should not be a very big deal when minor details are omitted or overlaid, if the point is to get a big picture view of things. But it can be a big deal when little details can make a difference in a spiritual practice. I would not write here which of the mappings Budge did correctly or incorrectly. If you are a true student of the occult, and you really want to know, then I suggest you best get Judy Hall's book and study it for yourself to find out more. She has truly done us a great and inestimable service by making the original text available to a wider audience through her work. In fact, to use this system, the practitioner would have to get this book, as it is the only place I know of that the original text is available in its entirety. In the current book I am writing, I shall only comment on selected sections of the work.

To cut a long story short, the Kemetic system of central suns or chakras is rather unique onto its own. I find it fascinating because the nine central suns or chakras, from the descriptions of the functions of the central suns, appear to me to include aspects of both the Daoist and Vedic systems. For example, the function of what is known as the 'dan tian' (or in many cases of practitioners, it is actually a 'xia tian' and not yet a 'dan tian') has a place (or at least an understanding of its function) in the energetic anatomy of the Kemetic system. This excites me a great deal, because it suggests that the Ancient Kemetic people practiced or understood the role of inner alchemy (what is known in the Daoist system as neigong, inner power) in their spiritual practice. Internal alchemy is also what this Kemetic manual is especially designed for. I shall elaborate more on that later in this chapter, as well as my understanding of each of the nine central suns, or chakras, and which of these nine map onto the seven chakras commonly known from yoga, and that derive from the Hindu/Vedic system.

3.6 Inner knowledge informing interpretation of the original text

Before I present commentaries on the ancient Kemet text from the standpoint of insider knowledge of inner alchemy and tantric spiritual practices from related traditions, I think it is fair to place boundaries on what the commentaries I am about to present are not, and what they are. So, let us begin with what they are not.

The commentaries given in this section are not the product of an individual who has specific experience in the particular internal alchemy and tantric flavour of this Kemetic spiritual tradition. In other words, even though I am conversant with the underlying principles of the tradition, I have not received initiation by accomplished instructors in the methods I shall be commenting on. So, the commentaries shall not reflect my personal experience of this Kemetic tradition.

If I have not been initiated in this particular tradition and as such do not have personal experience in it, then what qualifies me to comment on it? Well, it is within the right of anyone to offer intellectual commentaries on a text, be it ancient or modern, and some of the content of the commentaries below would be of an intellectual nature. I however happen to be an individual who although not having yet experienced ancient Kemetic tantric initiation, has been fortunate to study under accomplished teachers of inner alchemy and tantric spiritual practices of other systems akin to this Kemetic one. It is on that basis that I offer these commentaries.

As a serious practitioner of inner alchemy, I can recognize an authentic system when I encounter one. This is because I hold the view that the authentic systems all have a common root. That common root is reflected in the universal laws and in the principles that undergird the systems. On several occasions in my training, I would study some principles in an Eastern spiritual tradition only to find the exact same

principles repeated in Western and in African traditions, right down to foundational exercises in some cases. This is why in ancient times, a premium was put on preserving and on teaching universal law first, then principle second, then method third. If you know the universal laws, and then the principles underlying practice, it is straightforward for those at a high level of attainment to come up with new methods which may not even have been part of the routine practice in previous times. Similarly, as cycles of humanity came and went, that which remained more or less constant were the universal laws and the principles of practice. Details of actual methods change from age to age, and/or even from school to school. Slight variations in method can be reconciled by deeper understanding of laws and principles that govern practice, so that people from different schools of an overall tradition can have conversations with one another, even where the details of their methods leading to attainment differ slightly or even a little more so.

Let us take the example of use of the English language. Over a thousand years, this language has evolved and changed in spoken form, so that the English that was spoken by William the Conquerer and his contemporaries in the British Isles in 1066 is different from the English that is spoken in the UK and around the world today. The features of the English language however may not have changed as drastically as the sound of the words or even the spellings of some words that evolve over time. Here, I speak of the grammar of the language, as well as the alphabet in which it is written. Grammar can be likened to the laws and the principles governing the language. Diction, however, may be relegated to method, and that method would have a representation in the alphabet, which literally spells out the manner in which the language is spoken. Once the principles of the language are demonstrated through the alphabet, one who understands the language, meaning they can read the alphabet and understand what is going on, would be able to decipher the written language would be able to decipher the language to a complete or a large degree even in the case

where the language has evolved over centuries. Even if it has been hundreds of years with some changes to the language such as spelling differences, they would stand a better chance at deciphering the language than perhaps one who is a complete novice or another who has only studied the language ab initio.

So, the idea here is to use similar enough principles and related practices as a proxy for providing useful commentaries that penetrate the content of this ancient Kemetic text so as to open it up and make it more accessible first and foremost to Africans for whom this can be a heritage practice and then also for all other peoples around the world. These commentaries then, can be thought of as coming from one who has reached expert level in contemporary English but who is veering into work written in medieval English. Now, there are probably those out here in Africa who have been initiated into an esoteric school or order with accomplished living lineage teachers that both practice and teach contemporary versions of the spiritual paradigm outlined in the ancient Kemetic text and that would be willing to share their insights into its theory and methods in a publication as I am doing. If there are such as those out there, I would be more than glad to obtain their points of view in order to learn from them. Before deciding to do these commentaries, I first did a search online but could not find such people. I recognize the value of this ancient text, which I deem to be authentic based on my appraisal of the principles shared in the content. This text could serve as a revival of an interest in inner alchemy from a Kemetic standpoint.

The time of secrets is coming to an end. In this twenty-first century, all over the world, many previously secret orders that did the work for centuries (and in some cases for millennia) of preserving teachings for posterity are now sharing their spiritual methods, insights and tools for those alive today to access and to learn from. There is a great opportunity for many beings incarnated today to advance

spiritually as a result of this opening up if they choose to do so. I have benefited much from teachings and practices previously secret that have now opened to wider audiences than were not allowed in the past. The little effort of mine here to provide some commentaries on the ancient Kemetic text is in this very spirit of sharing, and of opening up.

Having said all that, I also deem it requisite to explain the method I shall rely on to provide the commentaries. Upon examining the Kemetic text, I realized that its methods described therein are most similar to teachings of the Daoist paradigm. In other words, although there are tantric traditions for instance in Buddhism and in Hinduism (as only two examples), I judged that the practice of the Dao is the most similar (if not identical) to the principles and to the presentation of the practice material in the ancient Kemetic text. Not only that. The beginning part of the text that explains the nature of reality has an uncanny similarity to the explanation of the Dao as given at the beginning of Lao Tzu's *Tao Te Jing*. I would however opine that the ancient Kemetic text presents the ideas in an arguably more profound fashion, which I shall get to shortly in the commentaries.

There is one book on Earth in particular that contains extremely advanced spiritual information. Beyond even the Daoist texts I have encountered. The manuscript is known as *The Magic Bag*, and in it are opinions of realized beings. One of those beings, Yada Di Shi'ite, a Sirian black man of the very ancient time, was incarnated on Earth 500,000 years ago, before even the Sirian-Reptilian Annunaki arrived here (although the Nagas and full-blood Reptilians had already been here for at least half a million years by then), and who fully ascended (i.e., his merkaba/light body allows him to come and go at will when he interacts with humans, not ever needing to be born again). Yada di Shi'ite has stupendously amazing information on the creation of reality, so I shall draw from his knowledge where the Daoist texts fall short as I analyze and comment on manuscript of the Kemetic Prince Yar Kheper'set.

Otherwise, since the content of the ancient Kemetic text appears to be most similar in orientation to Daoist texts I have encountered, it is with Daoist texts and with ideas from the Daoist tradition that I shall frame the analysis in the commentaries. I shall draw on three texts for the endeavour. The texts I shall use, are the *Tao Te Jing*, the *Tao of Health, Longevity and Immortality – The Teachings of Immortals Chung and Lu*, and *Ling Bao Tong Zhi Neng Nei Gong Shu*. I shall supplement these three with some of what I have been personally taught in Daoism. Of the three, the *Tao Te Jing*, an ancient text explaining the universe and life in it, is arguably the most well-known Daoist text. It is included here because from it, we can compare a presentation of universal laws there with those in the Kemetic text. The second book, the *Tao of Health, Longevity and Immortality – The Teachings of Immortals Chung and Lu* (colloquially known as the "the Chung-Lu") is a manual that delineates principles of internal alchemy practice that has been in continuous use by living lineages of Daoist practitioners at least from medieval times to the present day. The third text, the most recently written text and a translation of a contemporary practice manual is a book about actual practice. It is based specifically on content found in the first two books. It is one that I have used within the lineage I have practiced in. From it, I shall draw on theory and will also make comparisons with practices in the ancient Kemetic text.

As a result of the very technical nature of the coverage in this section, it may be of greater interest to individuals who are already practicing internal alchemy, already practicing tantra, or otherwise serious students of esoteric knowledge. I am not offering anyone advice on how to practice this particular Kemetic spiritual tradition. Rather, I am sharing thoughts, insights, and experiences as a student of esoteric knowledge and also as a practitioner.

Before getting right into the commentaries, let us frame the diverse paths that African spirituality has taken. This

framing will give us a view on where this content on inner alchemy and tantra fit into the overall landscape of paths taken to practice African spirituality. By practice, I mean to say that the individuals engaged in these paths take an active role, one way or another. As things stand at the present time, after reflecting on various ways and traditions embodying African spirituality, I have come up with seven paths of practice: **(1) the path of internal alchemy and tantra, (2) the path of enlightenment, (3) the path of the seer, (4) the path of medicine and magic, (5) the path of prayer and of giving offerings, (6) the path of being led by spirits,** and **(7) the path to spirituality through a mundane profession**. What one may find is that African peoples typically did not pick just one of these paths. Rather, among many African peoples, one or more of these paths were combined or practiced in tandem among the people. Systems of African spirituality would integrate one or more of these paths into a tradition. Now, let us unpack these paths, in this attempt to review African spirituality.

The path of internal alchemy and tantra

For this approach, the adept learns methods based on universal laws and principles. Internal alchemy and tantra are about transformation. Just as in 'regular' (outer) alchemy, base metals can be changed into gold, with internal alchemy and tantra, we transform ourselves. This is an ancient path that has existed on Earth for a long time. The tantra manual that is to be the subject of commentaries in this section is one rendition of this practice that has been kept secret and practiced in secret societies in Africa. Could the methods in this book be a basis for the 'lost book' of the Oromo people, for their native spiritual practice known as Waaqeffanna? I have wondered about that. To date, I have yet to come across a complete internal alchemy or tantra manual for African people such as the Alchemy of Night Enchiridion. There are indications in Kemet of such practices existing, as we have seen with the Glorious Light meditation,

a method that is an essential part of many approaches to internal alchemy. We know that the peoples of Atlantis and of Kemet knew about yoga, tantra, about energy meridians about the flow of energy within and around our physical bodies because this knowledge is clearly outlined in the final chapter (titled the secret of secrets) of the book *The Emerald Tablets of Thoth the Atlantean*, where Thoth (i.e., Djehuti) teaches about the energy systems of the body, and the flow of energy through the meridians.

This book by Djehuti is evidence that there is knowledge in Africa of the use of inner alchemy and tantra knowledge to transform our physical and light bodies. For most people, the transformations brought about by internal alchemy and tantra primarily lead to greater physical and spiritual health and strength. However, one possible result of such internal alchemy and tantra transformation, depending on the nature of the training, is that when done correctly, physical life can be extended indefinitely. So here, we hear of African individuals such as the epic Lumukanda in Credo Mutwa's book *Indaba my Children* who began as a regular mortal but then after wandering the wilderness and encountering Watamaraka (a reptilian 'deity', so we can think priestess), he becomes immortal. Presumably, he learns some form of inner alchemy/tantra from her that results in him fixing his energy body in order to become physically immortal. Thereafter, he hangs out with different African tribes over generations, having become 'the undying one', with immortal daughters and with knowledge that allows him to create immortals. The kinds of abilities that Lumukanda and his group possess, such as discharging a blast of pure energy from their foreheads (3rd eye chakra) is reminiscent of the abilities one can develop as they practice certain forms of inner alchemy and tantra. We also learn from Mutwa in another source that he was initiated in a version of the sexual tantra (the subject of the Alchemy of Night Enchiridion) at a secret initiation in Rhodesia (today's Zimbabwe). So, from these accounts, we can tell that the knowledge of inner

alchemy and tantra has been in Africa for a long time, just not commonly available outside secret initiations.

The path of enlightenment

Another path that has a history in Africa from ancient times, this is a spiritual path wherein the initiate comes into the knowing that they one with all. It is the path where the inner divine nature gets unveiled and revealed to the initiate. This inner aspect is one we all share. Its nature is of the light, and of love. Light and love are aspects of the One Infinite Creator. The initiate becomes enlightened by becoming one with the initiate's own inner light. This path is in my view the highest or the most advanced of all the spiritual paths discussed here. The only source material I can refer to here from African sources is *The Kemetic Book of Coming Forth into the Light* (alternatively referred to as the 'Egyptian Book of the Dead'). This path did not originate with the serpent cult, even if they may have played a role in teaching aspects of it. It has its source with the creator forces and their guardian races. We shall delve into material pertaining to this path in the section on Muata Ashby's work below.

The path of the seer

In this approach to African spirituality, the initiate is trained to hone their skills for direct perception of the spiritual world. They perceive the spiritual world with their own spiritual faculties, and they learn to perceive beyond the physical either through their own efforts or with some assistance from a mentor. A classic example of this African path are the accounts that Malidoma Some gave in his book *Of Water and the Spirit*, detailing his own initiation. In this book, the reader will learn that arriving at the ability to perceive beyond the five physical senses may not be so easy for most of us, seeing as we spend so much time locking our perceptions in the realm of the five physical senses. Another account of training to become a seer that is perhaps not as well-known as that of Malidoma Some, although much older,

is the training that Mutwa alludes to in book four of his epic tome *Indaba, my Children*. In this second example, Mutwa is assisted to get to perception of the spiritual realms by a powerful female mentor, while being initiated in a circle of Chosen Ones. While the methods are different, the outcome is identical. In each case, the initiate learns to perceive phenomena beyond the physical by using their own spiritual faculties. Where in Mutwa's case the focus of the initiation was on a single individual, in Some's case, the of-age children of an entire tribe were initiated to become seers. Amazing.

The seer path is also very old, going back at least to Lemurian times. Another example of the seer path, this time from a Toltec tradition of Central America is the one given by Carlos Castaneda recounting his training with Don Juan, a Native American of the Yaqui people of Sonora and Mexico. Again, the training differs but the outcome is the same – the aim is to be able to perceive spiritual phenomena under normal physical conditions, using one's own spiritual faculties.

The path of medicine and magic

Across Africa, we have very powerful medicine folk. Here, I use the term 'medicine' not to mean going to a pharmacy and taking pills under prescription to get better. That is not the case. In Africa and in several places around the world, 'medicine' is a term that refers to physical and spiritual solutions to ails. Medicine fixes ails, be they physical or spiritual. For that reason, in Africa, medicine can refer to remedies for physical ails such as the application of herbs. Medicine can also refer to remedies for spiritual ails, such as herbs, or the use of talismans or the use of divination to come up with specific formulas for an individual. There are bone setters who have their medicine.

And so, a medicine man or woman in Africa is a technician or a specialist of spiritual knowledge. Some of the medicine that can be obtained from the medicine folk that attend to physical ails can be compared with the parts of Ayurvedic,

Chinese or Western medicine that involves ingesting some substance. Other medicine involves working with spirits to bring about spiritual solution in both the physical and the spiritual world. So here, medicine could be special objects that have unique qualities so that when they are brought together, they constitute the medicine of a particular spiritual entity. When it comes to putting together a medicine bag or pouch, this is one aspect that some African traditions share with some Native American traditions. The medicine folk who deal with spiritual medicine are experts at applying their knowledge of the spiritual realm. They may consult with spirits and negotiate with them; however, they are in charge. The spirits work on their behalf. The unseen effects of spiritual medicine can be given the name 'spiritual magic', which is what those who witness the workings of spirit without knowledge of the underlying mechanics and principles may think. Among the Akan, a herbalist is known as a 'dunsini', while a medicine man is known as a 'sumankwafo' (i.e., a fashioner of talismans). These are but two examples of 'spiritual experts and technicians' among these people.

In Africa, there are hundreds of peoples that have traditions involving medicine and magic. I shall offer a few examples here of cases where a reader may learn about the medicine traditions of a given African people. The first example can be found in the book *In Sorcery's Shadow – A Memoir of Apprenticeship among the Songhai of Niger*. It showcases medicine traditions of the Songhai people. The second example can be found in *The Way of the Elders – West African Spirituality & Tradition*. This second example sheds light on traditions of the Mande people. Additionally, the 1987 Malian movie *Yeelen* shows some of the highest levels of magical knowledge and ability of the Mande. The third and final example is titled *Jungle Magic – My Life among the Witch Doctors of West Africa*. This third example sheds light on spiritual practices especially of peoples in what is today the Eastern, the Northern and the Volta regions of Ghana. In each of these books, the reader will read experiences that are

fantastic from the point of view of five sense perceptual reality. Much of the effects are brought about by knowledge of dealing with spirits. Later in Part II of this book, there is also an account of the magic of ancestors of the Soninke people, which I have called Solomonic magic. It is a form of ceremonial magic wherein knowledge of how to summon spirits and put them to task is applied.

The path of prayer and of giving offerings

Throughout the world, among just about every indigenous group, there is a tradition of prayer. By prayer, it is meant communing with the divine. There is an understanding that there are consciousnesses and entities that hold space in the environment beyond just the humans. This is the idea that has come to be known by some as animism. These consciousnesses are in spirit form. With an understanding that spirits inhabit not only humans but also various living and non-living objects in nature (e.g., animals, clouds, trees, rocks, water bodies etc.), as well as in the non-physical worlds, prayer becomes a way to commune with spirits, those that are in the physical world and those that are not. When indigenous people pray, the aim is to reach the One Infinite Creator. And so, prayer by indigenous peoples entails knowledge of how to send the message from the consciousness of the individual into the wider environment in order to bring about a desired change. The prayer can for instance be sent through intermediaries, such as ancestors, or via different entities of the spirit worlds. For this, one way that indigenous peoples take to pray is to make offerings. Offerings can be made, depending on the situation, the tradition and the circumstances, with a variety of gases (e.g., incense, pipe smoke), liquids during libations (e.g., alcohol, blood, milk, water), and solids (e.g., eggs, mashed potatoes). The offering follows a protocol that effects communication between individual offering the prayer and the beings to which the prayers and the offerings are being made. The prayer and the offerings can be made at an altar or shrine or

out in nature. Prayers can be carried out by individuals in a personal capacity, by family or clan elders, by state linguists or by medicine folk. I suspect that this aspect of traditional spiritual practice is one of the reasons why many black people have been drawn to Christianity in particular. The form of prayer described in this paragraph is very common in West Africa and in fact it is a central part of the spirituality of Akan people, not only at the individual level, but also at the levels of the family, the clan and the state. Among the Akan people, the oracle is known as 'abisa' (literally means "the asking"). These practices of prayer and of making offerings are common among the Akan, the Ewe, the Ga, and many other peoples in West Africa and beyond. A reader interested in getting some very detailed information on how one Akan group interacts with water spirits at the state level, check out *The Sacred State of the Akan*.

I learned another form of prayer from Zulu shaman Credo Mutwa and his lineage. This form of prayer occurs without offerings. It can be done from a high place like a hill or a mountain. The prayer is directed at the Most High. There is also an example of it given at the beginning of the book *Indaba my Children*. I think this is a form of prayer used by the guardians, and human groups that are aligned with them.

The path of being led by spirits

Where in the case of the path of medicine and magic the practitioner contracts with spirits to work for her or him in order to bring about a given outcome, in the path of being led by spirits, as the phrase implies, the practitioner follows the guidance and direction of spirits of nature. These are often spirits with some attainment in spiritual knowledge and the occult. In other words, these spirits who teach or work through humans are 'magicians' and 'masters' in their own spiritual realms. In addition, they know how to cross dimensional divides to get to the human realm to get to interact with humans.

There are at least three categories of contexts in which spirits direct the activities of humans for spiritual ends. The first of those is where the spirits start to work with a person, usually a child, after repeatedly appearing to them or after taking them into their own spiritual realm for a time, to train the child into becoming a shaman who is led by the spirit. In Africa, it sometimes happens that those known as the "little people" (i.e., the dwarves, elves, gnomes) take children away to teach them. They always bring them back. Once the children return, they are different. They are now trained to be intermediaries between the human world and the spirit world. Other times, different spirits can possess or take hold of a child or an individual. They will not let go until either certain rites are done or that the child agrees to become a traditional priest for that spirit. This is the second category. In this second category, the individual called into a priesthood, after the initial possession experiences, must still go through formal initiation during which the attendant apprentices under more experienced priests. The initiation can take anywhere from several months to several years. Over the course of the initiation, the priest or priestess in training must strictly observe the taboos of the nature spirit deity that they serve. The training may include aspects of seeing, divination, use of herbs for healing and performing rites and rituals. Among the Akan people, the Guan people, and other related peoples, this spiritual path is known as Akom, and the priest who becomes trained in this path becomes on Okomfo. The Okomfo dances to the tune of the nature spirit that is its benefactor. The nature spirit benefactor can in most cases possess the Okomfo. While the Okomfo is possessed, the possessing nature spirit can act through the physical body of the Okomfo. One work that goes into great detail about this path that is common to Akan and Guan peoples, but also other related people such as the Ga and the Ewe of Ghana is the PhD thesis titled *Nana Oparebea and the Akonnedi Shrine: Cultural, Religious and Global Agents,* by Okomfo Ama Boakyewa. In all of this, the one characteristic that distinguishes the Okomfo of a nature

spirit from a sumankwafo (talisman maker/ magician) is the possession element.

The third category of the path of being led by spirits is pursued by those who have been derogatorily called witches. The word 'witch' in fact comes from the Old English word 'Wicca', which means 'wise'. Witches in the old times in England were among the wisdom keepers. In Africa today, and in other places around the world, this word is often used to refer to a malevolent or negative polarity form of spiritual action by individuals under the influence of *animal spirits*. Through their association with these animal spirits, the witch gains power. It is a problem when witches are unconsciously under the influence of these animal spirits, because they then cannot always control what they do under the influence of the spirits. The power from these animal spirits can also be passed down the bloodline. The classic study of witchcraft in an individual (albeit, of the unconscious kind) can be found in the book *Don't cry! My baby, don't cry! Autobiography of an African Witch* by Gabriel Bannerman-Richter. His other books are also very interesting and related to this phenomenon.

The path to spirituality through a mundane profession

Among the peoples of Africa, there are many mundane professions that nevertheless infuse knowledge of spirit in their doings. This is because the mundane culture of many sub-Saharan African people is integrated with spirit. Spirit is not some abstract, far-removed notion that is theorized. Rather, spirit has real and tangible effects. For this reason, people of many traditional African societies encounter the force and the influence of spirit in their lives not only when they pray or when they visit a medicine man or woman but also in numerous cases as they go to work or learn a new trade. Five examples of these professions are the traditional blacksmith, hunter, weaver, drummer, and farmer. In each of these professions, there are encounters with spirits, some

of whom aid and others that may be malevolent. The spirits could take unseen form or they could inhabit animals, or trees, or be in rocks or in the water. To increase the situational awareness of the professional, it often helps for them to be aware of the spirits that can enhance or mar their work. Among traditional blacksmiths in Africa, there is deep, intimate knowledge of fire spirits and their helpful role in the work they do, which not only had to do with crafting metal implements but also had to do with creating weapons of war. We can even call this group "applied magicians". Their intimate knowledge of spirituality as is has to do with talismans is well-known across West Africa. Another group of professionals who need sound knowledge of spirits as well as have spiritual protection are the traditional hunters of Africa. These hunters frequently spend extended periods of time in the wilderness, often encountering spirits in the wild, and creatures that may embody spiritual beings. Hunters also doubled up as warriors in the past, and in that role, they also needed spiritual protection. Families with ancestors who were hunters may have a variety of talismans they inherited for protection. After the blacksmith and the hunter, it may surprise some to learn that in some African cultures, weavers perform spiritual rituals to consecrate their looms as well as usher them into their work. The book *Cloth as Metaphor* (Arthur, 1999) recounts a scenario where weavers consecrate their looms before work. This is true of some drum societies too, where there are master drummers who know how to perform rituals connected with their work of drumming. The list can go on. Dancers, wrestlers, griots, executioners and so on and so forth. Traditional African societies are replete with peoples and with contexts that draw on the power of spiritual rituals to include spirits and the spirit world in the work of their daily lives.

Now that we have covered what has been the norm in the secular lives of most traditional African societies, let us focus attention once again on the subject of this section. I shall now proceed to give commentaries on the ancient manuscript of prince Khem Yar Kheper'set. It is my hope that there would

be a revival of interest in and practice of internal alchemy and meditation practices of Kemet among today's people, and certainly among Africans on the continent and around the world today, whose heritage these concepts reflect.

Igniting the flames of Mut and Min

For this section, I will start with the words of the of the prince, and then comment on them:

"In the beginning was Quema. Consciousness Was. Indivisible and divine. Within that Flame of Pure Consciousness, a young God played alone. Bored with singularity, Min made seti and brought the Cosmos into manifestation and duality took form. In that manifestation, two polarities were created: neither could exist without the other or the Universe would collapse into chaos.

Out of One was born the Other. All that is found in the Cosmos may be found within each individual human being, and the same principles that apply to the universe apply in the case of the individual being. Humanity was created with two sexes by the Eternal One expressly that it might commingle its masculine and feminine natures to feed the Soul. The Soul requires love in the same way as the body requires food. Each sex finds its resting place in the other. But the souls must rise above that unrest which men miscall delight.
Mere sensual gratification is not the aim of the Eternal Ones. Harmony of the body reflects the heightened ecstasy and rapturous union that exists beyond the stars. Equilibrium of the Spirit Eternal arises out of mutual affinities and ecstatic meetings of Adepts with a truly spiritualised Body of Light. Erotic fulfilment without limitation is possible for such souls. But they may pay the ultimate price if separated in future lives.

Love-starvation, which is the nostalgia or homesickness of the Soul, the longing for the beloved, is the most terrible evil that can oppress the Soul. The ennui sucks the life from the Soul and thwarts humanity in its return to the stars from whence it came. Each Soul needs its complement at the Highest Level of Being. Each must seek out that which completes it and unite with the Absolute above and with the Beloved below."

Commentary

At the very beginning of the prince Khem Yar Kheper'set's book, we find this most profound statement, "In the beginning was Quema. Consciousness Was". In the Kemetic initiation, we can therefore attribute consciousness with Quema. This was an all-pervading consciousness, because we are told it was "indivisible and divine". Next, we are given the idea of a Creator. This Creator played alone, and there is a reference to Min (Ammon/Amun). "Min made seti, and brought the Cosmos into manifestation", wherein we had duality.

This is an amazing account of the creation of manifest reality from pure consciousness. This is even beyond the level of the Dao (Dao and Tao are interchangeable spellings, used by different authors and practitioners). In Lao Tzu's Dao De Jing, we are told that:

"The Tao that can be told is not the eternal Tao.
The name that can be named is not the eternal name.

The nameless is the beginning of heaven and Earth.
The named is the mother of the ten thousand things."
(Feng, 1986, n.p.)

The Dao can be likened to the Cosmos, before duality appears. In other words, "The Tao that can be told" is the Cosmos of the prince's description. The Daoist immortal Chung Li Chu'an, while teaching his student Lu Tung Pin, another Daoist immortal (these two were two of the eight immorts of Daoist lore. They are basically 'celestial

immortals' or ascended beings) said to Lu Tung Pin, "The workings of heaven and Earth are the ways in which the Great Tao is manifested in the universe...The Great Tao takes on a form when it is manifested in heaven and earth" (Wong, p. 37). "The Tao that can be told" represents emptiness, potentiality, before it manifests into actuality. Quema represents the "eternal Tao", the silence, before potentiality.

Thus, in order to understand Quema, and the line from the commentary such as "in that manifestation, two polarities were created", we must resort to an even more extensive teaching about creation. That teaching comes from what Yada di Shi'ite shares at the beginning of the book *The Magic Bag*. In this book, we learn how the creator forces created two polarities, which, once they merged, brought forth an infinitely powerful cosmic explosion which led to birth within the Cosmos. I have not found this process of creation at the cosmic level described anywhere else except in *The Magic Bag*, and now, a mention of it in this ancient manuscript. In this book, there are creator forces, and helpers. For anyone interested in reading the work that the helpers do, at the turn of every cosmic creative cycle, they may check out the book titled *Starcraft*, written by a high-ranking adept called Vee Van Dam.

Back to the ancient manuscript of Khem Yar Kheper'set. One main reason why I believe this manuscript to be legit, and at a super serious level, is in this subtle explanation of creation at the cosmic level, which is given at the beginning of the manuscript, which I have heretofore only found at close to this level in the teachings of Yada di Shi'te in *The Magic Bag*. Ancient Kemetic philosophy teaches us that 'as above, so below'. This is true, from creation at the cosmic level (i.e., what brought about manifest reality) to creation at the level of man. It is also true for creation of a state (the creation of Akan/Kemetic statehood practices these principles), creation of solar systems, and creation of galaxies. It involves the bringing together of two polarities. The ancient manuscript calls these two polarities Min and Mut. Min here

stands for Amun, with Mut being his consort. More of which is discussed in Part II of this book. Min is the masculine principle, Mut is the feminine principle. In Daoism, the equivalent would be Kan and Li, where Kan is the masculine principle (tiger) which has feminine in it, and Li is the feminine principle (dragon) which has masculine in it. It is these two forces, Kan and Li, that interact in internal alchemy to create the 'alchemical pill'. Again, it is like creating a baby, creating a state, creating a solar system, creating a galaxy, or even creating the entire manifestation within the cosmos. The context changes, however, the principles remain the same across board. As above, so below.

Which is why the ancient manuscript goes on to say that "All that is found in the Cosmos may be found within each individual human being, and the same principles that apply to the universe apply in the case of the individual being." This is to say that the human being is a microcosm of the macrocosm that is the cosmos. The implications of realizing this, cannot be stated enough. And then the ancient manuscript tells us:

"The Soul requires love in the same way as the body requires food...But the souls must rise above that unrest which men miscall delight. Mere sensual gratification is not the aim of the Eternal Ones."

What does this mean? Well, if you, me, and everyone is a microcosm of the macrocosm, then you are the cosmos, just as I am the cosmos. You are the Creator, just as I am the Creator. The nature of the Creator is love, and light. Love is the force that creates. Light is the awareness that creates. It is in our very nature to be love, and to radiate our light. The second line in the quote above, speaks of the affliction of a light being (Akhu), as we are, caught up in the distractions of physical matter reality, thereby paying less attention to (or in most cases) forgetting our nature as an eternal light being. The next line I would like to comment on is "Equilibrium of the Spirit Eternal arises out of mutual affinities and ecstatic meetings of Adepts with a truly spiritualised Body of Light."

In other words, when two Adepts that are truly within their natures as light beings share their love (physically, as well as non-physically) in an ecstatic union, they become capable of achieving the harmony and balance of their eternal (Spirit) natures.

"Initiation commences with the mastery of the Fires within. The opening of the Central Suns and the raising of the Fires of Min and Mut opens the Soul and unites it with The Eternal One. Even when the Beloved, the Twinflame, has been identified every Initiate must complete each section of the work separately but in unison. One Initiate cannot move forward until the other has simultaneously completed each stage of the Great Work. No step can be circumvented, nothing can move out of its appointed place. The Act of Will must accompany the Initiation. Desire must be controlled until the appointed time. Only then may two Adepts, recognised from birth, be conjoined in the Great Marriage and move forward in the sapient knowledge that their Souls were created to transcend Manifest Creation and return to Absolute Oneness."

Commentary

Here, we shall begin with the sentence "The opening of the Central Suns and the raising of the Fires of Min and Mut 2 opens the Soul and unites it with The Eternal One". The "Central Suns" here refer to what has come to be known as chakras, a term that denotes "wheel", and that derives from the Hindu/Vedic tradition. These Central Suns are energy centers that interpenetrate the physical body and its aura. Being energy centers, they are not physical, however the major (and minor) centers can be associated with specific regions of the human physical body. For the major energy centers associated with the specific regions of the human physical body, there are seven of them. For the major energy centers associated with both the physical body and its energy body/aura, there are twelve of them. Raising the fires of Min and Mut entails circulating the energy of the cosmos and the bio-energetic human body, first by raising it in a particular sequence (that will be discussed later in another portion of the ancient text and the commentary I give on it), and then by allowing the energy to fall back, so it can be raised again.

By activating the Central Suns and raising the fires, the microcosm of each Adept progressively connects with the fires of the macrocosm, allowing the Soul (Akhu) to progressively connect with the greater extent of the macrocosm. Once the central sun associated with the top of our heads is activated, the Soul can connect with what the Law of One/RA teachings call 'Intelligent Energy', and 'Intelligent Infinity'. Intelligent Infinity is at the level of Quema, Pure Consciousness or the Eternal One.

Next, we are taught that "Even when the Beloved, the Twin flame, has been identified every Initiate must complete each section of the work separately but in unison". This means that in this practice, both Adepts must open their respective Central Suns and must raise their respective fires. For both Adepts to succeed in uniting with the Eternal One, each must succeed in both opening their respective Central Suns and also raising their respective fires. This is why the ancient manuscript states that "One Initiate cannot move forward until the other has simultaneously completed each stage of the Great Work." I shall quote the final lines below, since they shall be commented on together:

"The Act of Will must accompany the Initiation. Desire must be controlled until the appointed time. Only then may two Adepts, recognised from birth, be conjoined in the Great Marriage and move forward in the sapient knowledge that their Souls were created to transcend Manifest Creation and return to Absolute Oneness."

The first point of note here is that the primary purpose of this form of sexual tantra is for two Adepts to unite with one another and with the Eternal One. Therefore, the primary purpose of this practice is not merely for carnal enjoyment. The sexual act is a means to an end, which is to transcend the consciousness of manifest reality. So, the focus of each Adept should primarily be on the goal of transcending Manifest Creation to return to Absolute Oneness, and hence the steps that are given to reach that goal must be part of the focus of the procedure. Focus requires Will. Will here is not only

mental Will but more importantly, spiritual Will. Spiritual Will is intent, unbending intent. The enjoyment (mutual orgasmic physical and spiritual ecstasy) comes about as a byproduct of success, where both Adepts succeed in successively opening their respective Central Suns and raising their respective fires so as to open their respective Souls to share in the union of each other with the Eternal One. The result is both Adepts attaining the level of Pure Consciousness, beyond Manifest Creation. This level of consciousness is what the Akan people call Odomankoma. Divine Providence. Infinite Grace. Beyond ego, matter, and form. Oneness.

"The Flames of Min and Mut are the Internal Fire that ignites the sacred Flame of the Ba, the Soul-bird, and leads to the Soul Unity that is Sakhu or sacerdotal union. The Flames of Min and Mut are the Soul's Love made physical. It is the love that the Soul has for the vehicle which carries it, and for its twinflame: the Soul of the Heart of the Beloved. Without the Flames of Min and Mut there can be no penetration of the veil, no merging with the Eternal One. The sacred Flames rise up the spine like entwined serpents passing through each of the Great Central Suns flowering at the crown of Min, the Great Cause of Light. One Serpent, Mut, is female and soulful, an unmanifested consciousness that has the power to Be and to Manifest. The complementary Serpent, Min, is male and corporeal, dynamic, energetic and directive. It was Min, a child of the Eternal One, who single-handedly brought the physical world into being. It was Min who raised up Creation out of the primal waters of the Mother's Womb. From this Flame all form was born when the Eternal One divided into male and female. The Flames are equal and opposite, polarities meeting in complementarity. As it is Above, so it is Below.

Nonetheless, the Soul in its myriad incarnations experienced masculine and feminine in all its forms. It partakes of the nature of each and Adepts must unite these two forces within their own being before making the outer marriage: sacred or profane. That unrest which men miscall delight must be eschewed until the sacred joining is made. This is the Mystical Secret of the Ages. As it is Within, So it is Without, As it is Above, So it is Below. This is the only means to accomplish the miracles of the One Thing. As all things were by contemplation of the One, so all things arose from this One Thing by a Single Act of Adaptation."

Commentary

In Kemetic lore, the term 'Ba' refers to the soul or the astral shell which also carries the Spirit consciousness. We are taught that "The Flames of Min and Mut are the Internal Fire that ignites the sacred Flame of the Ba". This refers to how the flames of Min and Mut activate the heart center, which is a gateway to reaching the Eternal One. The next line I shall comment on in regard to the flames of Min and Mut is crucial. The line says, "Without the Flames of Min and Mut there can be no penetration of the veil, no merging with the Eternal One". Why is this? It is because in our current mundane states, we are no longer ascended beings. When before, to merge with the Eternal One we (the very ancient human on Earth) would simply activate our light bodies and 'wink out', now we cannot do that. However, our energy/etheric bodies still have the ability to connect our Souls to the Eternal One. Thus, by activating our fires, we switch on that part of ourselves that allows us to extend beyond our microcosms and back into those energy streams (Infinite Energy) emanating from the Eternal One. This spiritual path is not for everyone, only those that are ready to merge with the Eternal One. Once we connect with those energy streams, we can connect back with the Eternal One since the Eternal One is of the same nature as ourselves.

The next part of the commentary is about the two serpents:

"One Serpent, Mut, is female and soulful, an unmanifested consciousness that has the power to Be and to Manifest. The complementary Serpent, Min, is male and corporeal, dynamic, energetic and directive."

First, let us notice the use of the term 'serpent' and let us connect use of this term with the serpent cult. These terms could have been called anything else (such as simply, 'principles') but instead they have come to be associated with serpents. I think this is because humanity, which includes the black peoples of the Amun sect, were taught these secrets by the serpent cult. This is the same story in India, where the

term 'Kundalini' is associated with the movement of a 'coiled serpent'. It is likely that this knowledge held by both the Ammonite and Hindu traditions has the same source. Beyond the use of the serpent term, the descriptions of the qualities of the feminine and masculine principles is crucial to our understanding of how they work together. At the level of the cosmos, the purely feminine principle is pure emptiness. Potentiality. This principle in the Daoist tradition is known as pure yin. Purely receptive. The purely masculine principle is pure consciousness. Awareness. In the Daoist tradition, this is known as pure yang. Feminine and masculine engage together, leading to the feminine receiving and manifesting the concrete dynamic input of the masculine. This initiates the life-creating process. It is well to reiterate that here we speak of principles that adhere at the level of the macrocosm as well as of the microcosm. One principle is not greater, weaker, better, or worse than the other. In fact, both polarities come from the same source, and are the opposite to one another. This is the meaning of the line in the ancient text, "The Flames are equal and opposite, polarities meeting in complementarity."

In regard to the two polarities, feminine and masculine, the Adept would have ideally experienced various expressions of each polarity. These are experiences obtained during life interactions and even in the selection of female and male physical bodies to incarnate in. On Earth, most Adepts have had numerous lives both as male and as female incarnations. In order to complete the initiation into polarity-dominated life in physical and other closer realities, the Adept will need to integrate both feminine and masculine polarities back into an integrated whole. This is because such is the nature of the Eternal One, with which the Adepts would be looking to merge. This does not mean that the physical bodies of the Adepts will change. Rather, it is the Soul awareness that gets stronger, because the Souls of each Adept, be they in a female body or in a male body, is already of the nature of the Eternal One. The Soul is already integrated and whole, in regard to the two polarities. Always has been, and always will be. It is

therefore up to the Adepts to regain awareness of themselves, of their own Souls, as being that of the nature of the Eternal One. This is the meaning of the line "It partakes of the nature of each and Adepts must unite these two forces within their own being before making the outer marriage: sacred or profane."

This ancient manuscript is truly something. Next, we encounter the lines:

"That unrest which men miscall delight 6 must be eschewed until the sacred joining is made. This is the Mystical Secret of the Ages. As it is Within, So it is Without, As it is Above, So it is Below. This is the only means to accomplish the miracles of the One Thing."

Here, the Adept is being primed to strive for achieving the balance and harmony of becoming one with themselves within. Prior to that, the distractions of the polarities pull the Adept one direction or another, out of balance. Those distractions lead to the chaos of life. The distractions can be brought about by emotional attachments centered on seeing the self as the personality or ego and rather as the Eternal One within, which is always calm, always serene, ever watchful, and allowing of all. The goal is to reach the Eternal One within. As within, so without. As above, so below. Once the Adept reaches the Eternal One within, the Adept reaches Eternal One without. Once the Adept manages to become the Eternal One below, the Adept becomes the Eternal One above. Then, every and all experiences are one, without distortions and chaos.

Opening the Secret Chambers

"Within the Subtle Bodies of the Sakhu, Great Suns and Secret Chambers whirl around the Central Sun of the Seat of the Heart as do the Great Divinities rotate around the Central Being of the Eternal One. The Adept who masters each of the Central Suns and activates the Secret Chambers unites the Sakhu and the Seven Soul Bodies with the Khat and shall have good health and eternal life with the Gods above and on Earth below. He will illuminate his Body of Light, so essential

for survival throughout eternity. Each of the Suns and the Secret Chambers is opened by many weeks of concentrated practice with the breath, stimulating each to rotate and spiral out to join in the Great Unity Grid of Consciousness following the Celestial Starry Road of the Great Cow to join the...
.. in this way does Below reflect Above, the miracle of the One Thing is brought forth on the Earth through the Great Central Suns and their Secret Chambers and their illuminating effect on the Body of Light."

Commentary

Before commenting on this section of the ancient text, it should be pointed out that part of the text is missing in the papyrus that survived and was given to Dr. Paschal Beverley Randolph. That is the section in the text that ends as "to join the..." and that begins again as "...in the way". In any case, I shall begin by commenting on this section of the ancient text:

"The Adept who masters each of the Central Suns and activates the Secret Chambers unites the Sakhu and the Seven Soul Bodies with the Khat and shall have good health and eternal life with the Gods above and on Earth below."

We have already encountered the Central Suns earlier in the ancient text. What are the Secret Chambers? They are portions within the energy body of human beings that can hold enormous amounts of energy. There are three of them. The most well-known one, referencing Daoist terminology, is commonly called the "dan tian". The term dan tian stands for 'field of the elixir'. It is a region of the etheric body that when associated with the physical body, is one to two inches below the navel and three to five inches within the belley. In actual fact, the dan tian exists only in potentially. It must be created, and it is not easy to achieve. In Daoist practices (e.g., tai chi, chi gong, neigong, etc.) most people refer to 'sending energy to the dan tian' when in reality they are referring to something else. Before the dan tian comes into existence, what most people have when they send or process energy in the region described is something known as a 'xia tian'. Xia tian means container of the field. This means that the energy is contained within the region. At this stage, we can think of

the xia tian as comparable to the dust and gas clouds that exists before a star is created. Those dust and gas clouds are *not* the star. Alternatively, we can think of the dan tian as when the star is born (out of those dust and gas clouds) and when the star begins to live, 'breathe', take in energy, and release energy. In fact, these analogies are apt. It takes a lot of work to 'ignite the star' in order to arrive at a dan tian.

So, that is one of the three Secret Chambers. It is the lowest of the three, in terms of associating the Secret Chambers with regions of the physical body. Moving upward, the second of the three Secret Chambers is known in Daoist terminology as the 'zhong tian', the 'middle field'. This field is within and around the region of the physical heart, slightly lower than the organ. Of these three chambers, the heart chamber is the most important, for those wanting to reach the highest levels in the practice of internal alchemy. The third Secret Chamber (located a few inches inside the head on the line of the 'third eye' Central Sun, in front of the pineal gland, and directly above the central channel) is known in Daoist terminology as the 'san tian', which means 'third chamber'. In the Chinese (and many other languages, especially in Africa and Asia), the number 3 is 'san/saa'. I suspect that this 'coincidence' has to do with the three stars of the Orion belt. One of those three stars is home to the Reptilian queen of the Orion empire. But I digress. Speaking of both the Central Suns and the Secret Chambers is another reason I think both think that the ancient text is authentic and that the content appears to be more similar to the teachings in the Daoist tradition than to those of the Hindu/Vedic and the Buddhist traditions. In the former, Daoism, there are both 'chakras and tians'. In the latter, there is much said about chakras but not an explicit mention of tians. To train in the correct practice and use of these three Secret Chambers requires correct guidance and authentic practices. They are best not randomly experimented with, especially the middle Secret Chamber.

Moving on, the ancient text says, "He will illuminate his Body of Light, so essential for survival throughout eternity." This

is the entire story put into one line. The Body of Light is the 'ascension body', the Sakhu, within which consciousness as a light being (Akhu) travels. The practice given in the ancient text is aimed at illuminating the Body of Light. With it, consciousness can experience life within the entire manifest reality, including the physical parts of manifest reality, without needing to be born into a physical body for expression. This means that the illuminated Body of Light can physically appear for the consciousness within to interact with consciousness in a physical body on the level of the five physical senses. Moving on, the text says:

"Each of the Suns and the Secret Chambers is opened by many weeks of concentrated practice with the breath, stimulating each to rotate and spiral out to join in the Great Unity Grid of Consciousness following the Celestial Starry Road of the Great Cow to join the…"

I suspect that someone intentionally removed this part of the papyrus. Perhaps they did not want others to know about it. It will be well then if I reveal it. "the Great Unity Grid of Consciousness following the Celestial Starry Road of the Great Cow to join the Great Emitter". The Great Emitter is the central creative force of every existence that emits its love, through light, to create. The Great Emitter is the outer expression of the Eternal One.

"The Anchor: Governed by the Great Sage of Wisdom Hermes and Geb the God of Earth who opens his jaws imprisoning those who are not worthy. The Anchor unites Above with Below forming a Great Chain of Being, so that the Gods may be made manifest on the Earth and the work of the Adept be brought into manifestation on the physical plane. God's Plenty Below: Governed by the Great Green God Asar the Lord of Silence and the Sky who Rose Again, He Who is Permanently Benign and Youthful, who travels eternally with Ra amongst the Stars, and his wife the Mistress Aset, She of the Throne, Protector of the Dead whose home is in Sophet, Guardian of the Dreams and Healers, the God's Plenty Below is the source of survival for the Khat. It is where the soul bodies meet physicality. The power of this Sun must not be squandered by the unrest which men miscall delight nor may the common Will be turned towards satisfaction of mere lust. The God's Plenty Below is the

source of all creativity, the primal mound of creation and the waters out of which all arose.

The Magic Eye of the Belly: Governed by the Great Mother Goddess Mut from whom the cosmos was formed in the female form, bearer of the Womb of Life, and the Great God Min the maker of Gods and men who Came Forth and for whom Pharaoh commits Seti. In the male form, this is the seat of Sekhem, soul power, and the generative force. When this Central Sun is activated the Adept may bring all being into manifestation.

The Eye of the Will: Governed by the Great God Khonsu, He Who Travels With the Moon, Watcher through the Night and Source of All Virility, where the Ka, the etheric double, takes on identify, in this Central Sun the unique personality of the incarnate being is developed through feelings, power and control. Here lies the source of the Common Will which must be mastered so that the Spiritual Will can be called forth from the Higher Realms to work in cooperation with the Divine Directive Intelligence of the Universe and manifested Below.

The Seed of the Heart: Governed by the Great Goddess Maat, Begetter of Cosmic Harmony who brought forth the Order of the Universe from chaos at the moment of creation, who holds the Point of Balance. Here, the ability to determine your destiny becomes a reality. The Seed of the Heart absorbs energy from the Sun to stimulate the Ba's intention and drains away the noxious substances of the Khat to restore the purity of the primal waters from which creation arose.

The Seat of the Soul: Governed by The Lady Hathor the Mistress of the West and of Jubilation, Queen of the Dance, Music and Wreath Weaving, Inebriety Without End. Home of the Ba, the soulbird, and site of the identity of the soul and source of Absolute divine love.

The Voice of Divine Intelligence: Governed by The Great God Djehuti, One, Self-begotten, and Self-produced, who established the heavens, the stars, Earth and everything in them, who directs the motions of the heavenly bodies and without Whom the Gods could not exist, Knower of All, Measurer of Time, home of the Khu, the spiritual intelligence of the soul and joining place for the Body of Light.

The All Seeing Eye: Governed by The Great Lady of Wisdom Neith, mysterious and great who came to be in the beginning and caused everything to come to be. The divine mother of Ra, who shines on the horizon. The eternal virgin, indivisible, One in Herself, Personification of the primal waters and Mother of the Created World. It was the Lady Neith who wove this world into being on her loom, who told us: I am the things that are, that shall be, and that have been. No one has ever laid open the garment by which I am concealed. The fruit which I brought forth was the Sun. This Central
Sun is the home of the Akhar, the divine spark, and of spiritual perspective. When this Sun opens all is revealed. The Adept can see

through the veil of creation into the true being of matter, Spirit and Gods.

<u>The Great Cause of Light</u>: Governed by He Who Was Before All Was, Aten-Min, Director of the motions of the heavenly bodies, First before All, home of the Sakhu, unity consciousness and the perception of The Eternal One. When this gateway is open Nuit, the Goddess of the Starry Heaven reveals herself and her milk nourishes the Earth Below. Only when the Central Suns have come under the control of the initiate may the Body of Light be opened. Without integration into this Body the soul will wander...

... and the Body of Light is illuminated."

Commentary

And now to speak on the Great Suns. 'The Anchor' is the Central Sun at the root of the system, known otherwise as the root chakra. It is in the region of the perinium. 'Gods Plenty Below' is the Central Sun associated with the genitals. It is associated with the region slightly above the genitals of each respective gender. It has also been called the 'sacral chakra' and it plays a role in creation, not only of physical life, but also of any creative effort. 'The Magic Eye of the Belly' is the Central Sun that can be associated with the solar plexus region of the physical body. This is also the seat of Sekhem, power, life, chi, nyama, because the lowest Secret Chamber (the xia tian/dian tian) is closeby. 'The Eye of the Will' is the Central Sun associated with the region of the physical body known as the spleen. It has otherwise been referred to (especially in Daoist traditions) as the spleen chakra. 'The Seed of the Heart' is the Central Sun associated with the tip of the sternum. Behind this location (roughly), is the location of the Middle Secret Chamber. 'The Seat of the Soul' is the Central Sun associated with the region of the physical heart. It has otherwise been known as the heart chakra. 'The Voice of Divine Intelligence' is the Central Sun associated the throat area of the physical body. It is elsewhere known as the throat chakra. 'The All Seeing Eye' is the Central Sun associated with the area of the physical body between the eyes and slightly above it (between one and two inches).

Behind this Central Sun and within the physical space of the head can be found the third Secret Chamber.

One other point of utmost importance that we can glean from the descriptions of these Central Suns as given by the ancient text are the deities associated with each Central Sun. They all point strongly to the Asar-Aset-Heru cult and the Amun-Mut-Khonsu cult. As the reader shall see in Part II of this book (see *The ancient city of Naga'a in Nubia-Meroë and the temple of Amun* and especially *Divine Kingship (Asar-Aset) and Sacred State (Amun-Mut) of the Akan*, both in Part II), these two sects have been the corner stone of black spirituality on the continent of Africa for millennia, from the ancient time to this very day (in August 2022) that I am writing this book. This for me is one of the strongest confirmations that the Alchemy of Night Enchiridion, this ancient text by Khem Yar Kheper'set, was a spiritual practice text for black people. Black people of both sects were the ones practicing the contents of this ancient manual. It has been lost to the public for ages. It is time that black people, especially descendants of the people of Kemet (see Appendix 3 to learn who many of them are) to claim this practice as their own, and to once again practice internal alchemy and tantra en masse. I have been practicing internal alchemy and tantra now for decades, and I can speak from personal experience that this approach to spirituality can have great benefits to those for whom it is well suited.

Now, allow me to show why I claim that the deities associated with the Central Suns are of the Asar-Aset-Heru and the Amun-Mut-Khonsu sects. The deities associated with The Anchor Central Sun are both Djehuti and Geb. Djehuti can be considered to be the visor of Asar, who represents Ptah/Enki. He was/is the being in charge of the handling of most things for this sect, which is probably why he is included at the base of the system. Geb is otherwise considered to be the father of snakes. This is a reference to the serpent brotherhood and sisterhood that support the Asar-Aset-Heru sect. To learn more about this sect, and about the serpent brotherhood and

sisterhood (including those that do the initiations in this sect), the reader can refer ahead to the section in Part II titled *Snake deities in Kemet and the Ethiopian Naga king Arwe/Wainaba*. The deity associated with God's Plenty Below is Asar himself, as well as his consort/mistress Aset. Asar, being a representative of Ptah/Enki (as a creator being) is at the head of the Asar-Aset-Heru sect. Aset is also mentioned in relation to this Central Sun. It is very apt for these two beings to be associated with this Central Sun, since they were twin flames. In fact, the two Adepts that practice this spiritual approach may choose to see themselves as Asar and Aset. The Magic Eye of the Belly Central Sun is associated with Mut, consort of Amun. Where Asar-Aset-Heru constitute one trinity, Amun-Mut-Khonsu constitute a second. The deity associated with The Eye of the Will is Khonsu, son of Mut and Amun. It does not get any better than this. Next, the deity associated with The Seed of the Soul is Ma'at, who belongs with the Asar-Aset-Heru side. The Seat of the Soul, the next Central Sun as we move upward, is associated with Hathor, also known as Hut-Heru (house of Heru/Horus). Here, Heru of Asar-Aset-Heru is included by association, since Hathor is another form taken by Aset. Heru is the son of Asar and Aset. The Voice of Divine Intelligence Central Sun is associated with Djehuti, the voice of reason, who can be thought of as the spokesperson for the Asar-Aset-Heru sect. The deity associated with the Central Sun known as The All Seeing Eye, is Neith, also known as Nebet-Hut. She is the female warrior deity that was the watchful eye over Kemet and that was also the twin of Aset. She belongs with the Asar-Aset-Heru sect. Finally, Central Sun known as The Great Cause of Light is associated with Aten-Min (i.e., Amun) and Nuit (i.e., Mut), both of whom are of the Amun-Mut-Khonsu sect.

Raising the Fire of Mut

"As the Great Goddess revivified her husband and brought forth her Son, so will the female Adept raise the Fire of Mut to bring forth the spiritual Fire within. As the Womb of the Goddess was the primal

waters from out of which all creation arose, so will the female Fire return the Soul to its Source in the Above. Having bathed and purified the body with salt and incense, the initiate must first anoint the Great Central Suns with Oil of Blue Lotus in a circular motion following the Great Sun God from east to west and through the Gates
of Night to greet the dawn and salute the rising God once more. Stand with feet apart facing the Great God. Keep the feet planted firmly on the Earth. Listen to the heart beat within, to the Soul fluttering softly within the body. With each beat rotate the hips first to the front, then to the right hand side, to the back and to the left hand side seven times. Reverse the direction and rotate for seven more circles. Wait. Breathe."

Commentary

This section of the ancient text starts to delve into actual practice. The content of this part of the text refers to practice done by by a female partner. I have not yet worked out whether same sex couples can do the practices in this ancient manual. They probably can, if both conduct the same practice following the steps for their respective sex. It might take some effort, but high level adepts will be able to work it out for themselves.

Back to the commentary. I shall begin with the line, "As the Womb of the Goddess was the primal waters from out of which all creation arose, so will the female Fire return the Soul to its Source in the Above." Here, we can think of the masculine and feminine principles commented on earlier. This internal alchemy practice between two Adepts will mimic the conditions at the start of the primal creation. In this regard, the female will serve as one party in the union. The two Adepts are about to become one, the Eternal One. Their Souls are already the Eternal One. If each Adept has done the respective work, at this point, of realizing that they are the Eternal One. Now, in this union, bodies and energies will come together. During this union, the female Fire will constitute one of the polarities of primal creation – the female polarity. Let us continue:

"Listen to the heart beat within, to the Soul fluttering softly within the body. With each beat rotate the hips first to the front, then to

the right hand side, to the back and to the left hand side seven times. Reverse the direction and rotate for seven more circles. Wait. Breathe."

Notice the reference to the number seven, this ubiquitous number associated with the serpent cult. It has appeared here as well, in this initial preparation practice that brings to mind energy work and sexual yoga. Rotating the hips in this way starts to activate the Central Suns, especially Gods Plenty Below. It also opens up the body, as the listening practice links body and energy to the Soul.

"The initiate then lies down in a cool, dark place. The most powerful time being in the evening after the fall of twilight as Ra fights his enemies in the Underworld, or with the dawn as Ra rises triumphant again. To raise the sacred Fire, stimulate the kat, the God's Plenty Below, in whatever way is most effective. A Ben Ben may be utilised or prestidigitation. The instant the Fire begins to burn, hold as still as a gazelle when beheld by the jackal. As it fades, begin stimulation again. Repeat two more times. Rest the left hand against the pudenda, the mound of Mut, with the middle digit extending over the clitoris into the God's Plenty Below. Place the right hand above it. With the tip of the third finger stimulate the kat until the waves of sacred Fire begin to burn. As the flames rise, engage the middle finger to stimulate the length and then base of the clitoris. Breathe in deeply, pull back the belly, and allow the sacred Fire to flow into the Great Central Sun at the base of the spine and to rise like a serpent up the spinal column opening the Secret Eye of the Belly, twining upwards and lighting up each of the Great Central Suns. When it reaches the heart it stimulates the Seat of the Soul which entwines with the Fire of Min to stimulate the Secret Chambers of the Central Suns. With every breath the Fire rises ever higher until it reaches the Gate of Min and the Great Cause of Light above the head. Once the raising of the Fire has been mastered, as the Adept exhales long and slow, the Fire cascades down through the body, arms and hands and
meets the God's Plenty Below. The Fire becomes a great circle uniting the Khat, material body, the Ba Soulbird, and the Great God. Cascading through the whole of the Adept's being, it animates the Khu, bringing the Great Body of Light closer to infuse the ka and the whole of the physical and spiritual being. So below, as above. The Neters are brought to the Earth and the Adept closer to the Heavens.
Repeat until the Fire has been lit seven times. The Adept may truly say: "I am the embodiment of the Goddess. I am become Divine." Once this is achieved, the Adept may use the power of the heart to master and

direct the Fire to circle in and store it beneath the navel in the Cave of Min."

Commentary

The next part to comment on is on the timings. Here is another instance where knowledge from practices in the Daoist tradition align with the exposition here. The ancient text tells us that "The most powerful time being in the evening after the fall of twilight as Ra fights his enemies in the Underworld, or with the dawn as Ra rises triumphant again." We can think of the phrase "Ra fights his enemies in the Underworld" to be symbolic and to represent the transition from day to night. Ra, which represents light "fights his enemies", the emerging dark. In the Chung-Lu (i.e., Wong, 2000), there is a beautiful treatise on the cycles of energy changes that take the same form for energy changes during a day, during a month, during a year and so on. The two periods of the day, dawn (roughly 5am to 7am), and dusk (roughly 5pm to 7pm) are two times in the day when the masculine and feminine polarities are balanced. In other words, in relation to the cycle of an entire day, the feminine polarity is strongest between 11pm and 1am at night, with midnight being the peak, and the masculine polarity is strongest between 11am and 1pm during the day, with noon being the peak. The sun is therefore at its height at noon, and at its weakest (including countries closest to the poles of the planet) at midnight.

Raising the sacred fire is a crucial part of this practice for both Adepts. Here, the ancient manuscript advises that the sacred Fire can be raised either through Ben Ben or through prestidigitation. Ben Ben is a Kemetic/Sirian term for sex. We can think of Ben Ben here as referring to sex in relation to tantra. Prestidigitation is a reference to internal alchemy, where one can use imagination to arouse and to guide the sacred Fire. In the practice of internal alchemy, the mind can

engage the Central Suns and can assist in the stimulation and the movement of the sacred Fires. Energy follows thought.

The next instruction is key, because it ushers in the start of the movement of the sacred fire. The text says, "Rest the left hand against the pudenda, the mound of Mut, with the middle digit extending over the clitoris into the God's Plenty Below." So here, the mound of Mut would be the belly, around the area described for the xia tian (lowest Secret Chamber). The left hand is placed there, with the middle finger connecting the Gods Plenty Below (sacral chakra) and the clitoris.

Once the fires are stimulated, it is time to circulate them. Here are the instructions:

"Breathe in deeply, pull back the belly, and allow the sacred Fire to flow into the Great Central Sun at the base of the spine and to rise like a serpent up the spinal column opening the Secret Eye of the Belly, twining upwards and lighting up each of the Great Central Suns."

This part is extremely important to be aware of. The route the fire should take, is from the belly, down to the coccyx, and up the spine, engaging the Central Suns as it travels up. Pulling back when breathing in deeply pulls the fires from the Gods Plenty Below into the lowest Secret Chamber (xia tian), which is covered with both palms at this point, right over left. From there, when the female Adept breathes out, the fires should go to the root of the spine, the coccyx (known in the Daoist tradition as the 'Sheng Si Qiao'), and then rise from there. Let us get some more:

"With every breath the Fire rises ever higher until it reaches the Gate of Min and the Great Cause of Light above the head. Once the raising of the Fire has been mastered, as the Adept exhales long and slow, the Fire cascades down through the body, arms and hands and meets the God's Plenty Below. The Fire becomes a great circle uniting the Khat, material body, the Ba Soulbird, and the Great God."

The breath is used to guide the fires. You cannot raise the fires without engaging the breath. This is also how I learned it in the Daoist internal alchemy system. In this process, some prestidigitation may help, even during sexual intercourse. Here is where will/focus/concentration is required. Essentially, here is what you can do: pull the breath into the belly. Then, when breathing out, guide the fires to the coccyx. That is one breath. Now, to raise the fires from the coccyx up, all the way to the top of the head, the Adept can do it in one breath or in several breaths. In other words, it is possible, with one breath, to guide the fires up from the coccyx to the Central Sun at the top of the head known as the Great Cause of Light. The Adept may also resort to several breaths, while keeping track of the movement of the fires up the spine. Once the fires reach the top of the head, they will descend over and around the physical body and aura but also down the front channel which connects the top of the head to the base of the spine. The front channel is basically the opposite of the back channel. Here, the Adept as they exhale, can guide the fires down the front of the face, neck, chest, abdomen and back to the Gods Plenty Below. From there, breathe in again, pulling into the belly, and then circulate yet another time.

(Source: Liao & Liping, 2012, p. 85)

There are a couple of points here to be aware of. The path that is given in ancient text goes from Gods Plenty Below into the belly and then down to the base of the spine, and then up toward the top of the head. In this particular rendition, once the fires get to Gods Plenty Below, they do not go to The Anchor, then up the spine. If the practitioner follows the path given in the ancient text, they should be aware that they may eventually be unable to have children. This is true for both men and women. The fires will be taken from Gods Plenty Below, into the xia tian, and then through the Central Suns. There is another way to move the fires where this will not be the case, however, that is not the instruction given in the ancient manuscript. Therefore, practitioners of these instructions should not simply experiment with them for fun. It may be better to practice this manner of internal alchemy and tantra if you are sure you do not want to have children, or after you have already had them.

"Practice over the course of several weeks may be required before the sacred Fire can be lit seven times, the full body irradiated with the orgasmic force and the Secret Chambers of the Central Suns fully activated. Once this occurs, taking the attention up through the body as the orgasm progresses unites heart and mind, body and soul with the divine force and facilitates control by the higher will over the process. Once true mastery has been achieved, the orgasmic force can be raised purely by The Power of Sekhem itself. It is seen in the Eye of the Mind and the force rises of its own volition and Will. The Adept is then ready to unite with the forces of Min. Notwithstanding, a greater secret will the Adept discover once the generative power is under control. It is a matter of Will and yet something beyond the Will. The Great Magnetic Power of Love can be joined to Desire and Intent. These powers when combined can be accumulated and projected over a vast distance to attract a new Love. A Companion of the Heart. A
Twinflame throughout Eternity. Such a One may be found by gazing at the image in a magic mirror and attracted by projecting the power into a ring to be worn on the Hathor, Heart, Finger or an amulet..."

Commentary

For this section, I shall start commenting on the text from the following line:

"Once this occurs, taking the attention up through the body as the orgasm progresses unites heart and mind, body and soul with the divine force and facilitates control by the higher will over the process."

The Adept merely needs to reach the stage of orgasm, at which point the process will take a life of its own and be divinely controlled. Of course, saying 'merely' should not take away from the Adept's focus and intent to bring about this condition. The ancient text goes on to say that "Once true mastery has been achieved, the orgasmic force can be raised purely by The Power of Sekhem itself." This means that the Adept at this stage would observe the process occurring as the Sekhem (life force) generated by the circulation of the fires follows a natural course. At this stage, the Adept would be connected with Infinite Energy.

It is a curious thing to experience energy working of its own accord. In my Daoist practice, there was an expression to describe a state. The expression was 'the breath breathes by itself'. It describes a state, unbelievable perhaps for some, where, breathing with one's aura, it becomes possible to no longer need to breathe through the nose. Until one experiences it, one might not believe this is possible. This state (while maintaining a condition of stillness) can be sustained up to several minutes. Buddhists have a version of this as well. There are instances of Adepts who have been buried underground for a protracted amount of time while remaining alive. They breathe with their aura or energy bodies. I have experienced this myself, this condition of arriving at a state not requiring one to breathe through the nose for a few minutes. The state is first brought about by intending to breathe in a particular manner with one's aura or energy body. After the process begins, it can take a life of its own, wherein the Adept reaches a state of simple observation of it happening on its own. This is in the same

vein that the ancient text states that "It is a matter of Will and yet something beyond the Will." There is a working, a mechanism in the universe, that functions with a will of its own. If we manage to connect into it, we become a part of it. It has its own will. It is the will of the Eternal One.

The papyrus is once again missing sections around where the ancient text says "Finger or an amulet…"

Raising the Fire of Min

"As the Great God Min raised the Ben Ben on the primeval mound out of the waters of chaos by the act of his hand, so shall the Adept by sau raise the sacred Fire in an Act of Will that transforms the mundane world. Having bathed and purified the body with salt and incense, the Adept must first anoint the Great Central Suns with Oil of Blue Lotus in a circular motion following the Great Sun God from east to west and through the Gates of Night to greet the dawn and salute the rising God once more. Each Central Sun is then saluted in turn. The Adept stands with feet apart facing the Great God. Keeping the feet planted firmly on the Earth he listens to the heart beat within, to the Soul fluttering softly within the body. With each beat he rotates the hips first to the front, then to the right hand side, to the back and to the left hand side seven times. Without pause, he reverses the direction and rotates for seven more circles. Wait. Breathe."

Commentary

We shall begin commentary of the process of raising the Fires of Min with the following lines:

"The Adept stands with feet apart facing the Great God. Keeping the feet planted firmly on the Earth he listens to the heart beat within, to the Soul fluttering softly within the body. With each beat he rotates the hips first to the front, then to the right hand side, to the back and to the left hand side seven times. Without pause, he reverses the direction and rotates for seven more circles. Wait. Breathe."

Raising the Fires of Min is the initial exercise for the male Adept, in preparation for practice with the female Adept. The Great God here is the Sun, Amun-Ra. The male Adept faces the Sun in the direction of the East. Curiously, Muslims face the East when they pray. Also, some Daoist chi gong and tai chi (energy) practices face the East as they begin, as they then circle through each of the cardinal points. Similar to the process of raising the Fires of Mut, the male Adept listens to the heart beat, and to the Soul. Heart practices are among the most important in all of internal alchemy practices. The listening process aligns body with energy and Soul. The rotations stimulate the Central Suns and the sacred fires.

"The Adept seats himself during the morning hours, the time of maximum potency for the male. To raise the sacred Fire, he places the middle digit of the left hand on the perineum behind the scrotal sac and the first digit to the right of the testes with the third digit to the left side. He presses firmly to awaken the sleeping God and activate the Fire of Min. The shaft of the henn is grasped with the right hand close to its base and the Staff of Min drawn up to stand proud like the Ben Ben rising from the Mound of Creation. As the Great God brought the world into being so the hand of the Adept creates anew. The rocking motion of the hand begins to raise the sacred Fire towards the Head of Min. As the Fire rises, so does the
hand until it is engaged under the Head of the God. The Adept pulls back the belly and breathes deeply into the scrotal sac, allowing the sacred Fire to flow into the Great Central Sun of Osiris. Taking the Breath of Life deep into the Sun of Osiris, he holds it there for as a long as possible. Keeping the buttocks and perineum firmly clenched, he allows the Fire to rise like a serpent up the spinal column opening the Secret Eye of the Belly. With each breath the Fire rises higher, twining through and lighting up each of the Great Central Suns. At no time in this stage of initiation must Seti be spilt. His right hand must hold as still as the mouse scented by the falcon until the urge to void the Seti ceases. The Adept must begin again, pulling the generative force ever higher up the spine and through the Central Suns. So does the Will learn to overcome Desire. When the Fire reaches the heart it stimulates the seat of the Soul which entwines with the Fire of Min to stimulate the Secret Chambers of the Central Suns. With every breath and each movement of the hand, the Fire rises ever higher until it reaches the Gate of Min and the Great Cause of Light ignites above the head. At the crown, as the Adept exhales long and slow, the Fire cascades down through the body, arms and hands and meets the Staff of Min Below.

The Fire becomes a great circle uniting the Khat, material body, the Ba and the Great God. Cascading through the whole of the Adept's being, it animates the Khu, bringing the Great Body of Light closer to infuse the ka and the whole of the physical and spiritual being. So below, as above. The Neters are brought to the Earth and the Adept closer to the Heavens. The Adept may truly say: "I am become the God. I am become Divine." Repeat until the Fire has been lit seven times. Once this is achieved, the Adept may use the Power of the Heart to master and direct the Fire to circle in and store it beneath the navel in the Cave of Min."

Commentary

Now, in order to activate the fires, the male Adept uses the middle finger on his left hand to press on the perineum, which is a meridian point between the scrotum and the anus:

"To raise the sacred Fire, he places the middle digit of the left hand on the perineum behind the scrotal sac and the first digit to the right of the testes with the third digit to the left side. He presses firmly to awaken the sleeping God and activate the Fire of Min."

Herein lies exquisite proof of the link between the Kemet practice and Daoism. The perineum is an important point in Daoist practice, be it sexual practice or internal alchemy practice where an Adept practices alone in sitting meditation. This meridian point is important to males because it is a junction at which energy from the male sex organ either follows one direction to re-enter the energy and meridian systems of the male or to exit through the male sex organ as an ejaculation. Due to this, some commentators (c.f. Chang, 1986) have termed this meridian point the "million dollar" point, because during sexual intercourse, just before the male ejaculates, if he is able to press on this point correctly, much or all of the semen that would ordinarily exit his body will instead re-enter his own energy system to produce a very intense (internal) orgasm. When the male locates this point on his physical body, he will notice that there is actually a little depression there, under the skin, when he pushes down on the point. During sex, the male would then feel like a

million dollars, to which a regular male orgasm is thought to pale in comparison. It is also possible to achieve this internal orgasm instead by exercising the muscles that control the region around the perineum. The outcome is the same – the ejaculation ends up being internal rather than external. This is a way in which a male practitioner can preserve his energy while still being engaged in the sex act.

(Source: Chang, 1986, p. 65)

The ancient text instructs the Adept to press on the perineum point shown above to stimulate the fires. This will redirect fires from the sex organ into energy/meridian systems of the Adept.

The next part entails the practices the male Adept must execute in order to raise the fires:

"The Adept pulls back the belly and breathes deeply into the scrotal sac, allowing the sacred Fire to flow into the Great Central Sun of Osiris. Taking the Breath of Life deep into the Sun of Osiris, he holds it there for as a long as possible. Keeping the buttocks and perineum firmly clenched, he allows the Fire to rise like a serpent up the spinal column opening the Secret Eye of the Belly. With each breath the Fire rises higher, twining through and lighting up each of the Great Central Suns."

This is tantra practice, people! By simultaneously pulling back the belly and belly and breathing deeply into the scrotal sac, the male Adept is drawing sacred fire from his sex organ into the "Great Central Sun of Osiris" which we know of as Gods Plenty Below (the sacral chakra). Taking the "Breath of Life" deep into this Central Sun, similar to the case of the

practice with the female Adept, will pull the sacred fires into the lowest Secret Chamber (xia tian) which is right in the region close to the Central Sun known as Gods Plenty Below. From there, the fires will start to circulate. In the case of the male Adept, it is important to clench the buttocks and the perineum during this practice for the very reason of closing that perineum meridian point. For men, the fires, when stimulated, either go up an into individual illumination, or out and into potential external creation.

Next, I shall comment on a direct reference to the Middle Secret Chamber and its location, which is another relevant connection with the Daoist tradition of internal alchemy:

"When the Fire reaches the heart it stimulates the seat of the Soul which entwines with the Fire of Min to stimulate the Secret Chambers of the Central Suns."

The Middle Secret Chamber is behind the Central Sun known in the Kemetic tradition as The Seed of the Heart. In the Daoist internal alchemy practices of the Complete Reality school, the tradition I practice in, the equivalent of the Middle Secret Chamber is known as the 'zhong tian' or the 'middle field'. It is in the same region as its Kemetic equivalent. This Middle Secret Chamber is one to remember for real practitioners because it is a gateway to the highest levels of attainment in internal alchemy practice.

"Practice over the course of several weeks may be required before the sacred Fire can be lit seven times without Seti. This practice, when under the control of the Will, irradiates with orgasmic force the Secret Chambers of the Central Suns. Once this occurs, Seti may take place – at the same time taking the attention up through the body as the orgasmic spasm progresses to unite heart and mind, body and soul with the divine force and facilitate control by the Higher Will over the process. Once true mastery has been achieved, the orgasmic force will be raised purely by the power of Sekhem itself. It is seen in the Eye of the Mind and the force rises of its own volition and Will. The Adept has become the God incarnate, the embodiment of the God and is ready to be united with the Flames of Mut."

Commentary

The most important point to comment on in this section is the last line, which underscores the necessity for the male practice up to this point to be done *independent of the female*. In other words, the male Adept would conduct all the exercises and reach the level of the God incarnate before conducting this practice with a female Adept. This is true also in the case of the female Adept, who would conduct the practice up to the point described in her section *independent of the male*. Once each party has attained the state of the God incarnate, they can then unite in joint practice. This would mean that it would necessarily take a while as each Adept conducts individual practice, informing their respective partners of their progress, and of their successes.

Raising Min and Mut in Unision

"Once the Fires of Min and Mut have been aroused in the individual Adepts, the moment comes when the two Spiritual Flames must be commingled in the Spiritual Bodies of the Beloved, the Priestess of the Heart and the Priest of the Soul who were promised to each other before birth. But the Adepts must be aware. This is not the Mystic Marriage they yearn for. This commingling is not one of physicality, it is of the Soul. A union of God and Goddess, of the Divine Ones. This is a preparatory stage and each must cleave to the other in Spirit only, not in body. There will be no nedjemit ndjemu ['love joys' or sexual pleasure] at this stage. A powerful test of Will, the mutual raising of the Flames without Seti is one of the last tests, perhaps the greatest of all the tests. The culmination of the training that has been undertaken for so long."

Commentary

The last line that states "the mutual rising of the Flames without Seti is one of the last tests, perhaps the greatest of all the test. The culmination of the training that has been undertaken for so long" is a reminder that the success of both

male and female Adepts in the joint practice depends on each having trained and having independently attained the level, so that once they bring their practice together, they can have a mutual practice, each at the level of a God incarnate. It is important for both to reach the God incarnate level and to maintain it during joint practice. If for instance the male Adept ejaculates (i.e., Seti) during the joint practice, before having his fires reach the highest state, there would be no joint experience of the Eternal One. The difficulties associated with sexual tantra when a male Adept ejaculates prematurely were described in the initiation of the Sirian-Reptilian entity Enki/Ptah, with an ancient Ama'argi, a female reptilian priestess. The reptilian priestesses are collectively known as the Amasutum. The Ama'argi, one kind of Amasutum, are apparently native to Earth. I tell part of that story later in this book in the section titled *Narayana the seven-headed intellect, and the supreme creator*.

"Having fasted all day, in the cool of an evening when the Light of Khonsu has risen to its full tide, the Adepts, having made their ablutions and offerings, stand together and disrobe. Each slowly anoints the Central Suns of the other with the Oil of Blue Lotus, feeling the sacred Fire rise within. Each in turn intones: We are become the Divine, the Great God and the Great Goddess incarnate.
They lie down on their right sides, male behind female, Great Central Sun touching Central Sun. The arms of the male enfold the female and rest on her Seat of the Soul. The female's hands cover his. Not a muscle is moved as, breathing rhythmically and deeply in slow unison, they activate The Power of Sekhem to open the inner eye and raise the Fires of Mut and Min. Each feels both currents rising up the spine, reaching out to the other, intertwining, activating the Secret Chambers and bringing the flames to the Heart. Burning in the ecstasy of the Divine, the flames rise to the Great Light Above, cascading down to begin the cycle again. Breathing, holding, breathing, holding, breathing, pulling up the Fires until God and Goddess are engulfed and the powers are commingled and sealed into place. No seed must be spilled so that the orgasmic force vivifies every part of the being uniting all the soul bodies and embodying the Sakhu here on the Earth. The Great Orgasm of Creation is complete. The Souls are forever joined."

No commentary is needed for the instructions given in the section immediately above.

"The Adepts must each make the sacred Inner Marriage with the Eternal One Within before moving on to the Mystic Marriage between man and woman that will commingle the two natures, physical and spiritual, and manifest the Divine on Earth."

Entering into Marriage with the Eternal One

"Seated in sacred space, the Adept takes ten slow, deep breaths withdrawing into the inner silence. The Adept breathes gently, establishing an even rhythm. The eyelids grow heavy and lie softly on the face. The Adept steps out of the Khat, the physical body, into the Soulbody, the Ka, which stands up. The external world falls away to reveal the inner planes. In the mind's eye the Adept stands in the entrance to a vast temple. Before the Adept there are tall walls with their high, ornate wooden gates covered in beaten gold. These are the gates to the inner courtyard. Slowly these gates open inwards. A temple guardian beckons the Adept in. The guardian conducts the Adept to a chamber in the inner courtyard. In this chamber a bathing place has been prepared. Temple eibatas bathe, dry and perfume the Adept with Oil of Blue Lotus and dress the Adept in new robes to prepare for the marriage. When the Adept is ready, the guardian takes the Adept to the offering chamber. The Adept makes an offering to ensure a successful inner marriage. Whatever is most appropriate is offered with reverence on the altar and the Adept turns to leave. The guardian conducts the Adept into the nuptive chamber to await the Divine Partner in this inner marriage. Food is prepared, drink awaits. Behind thin, gauzy curtains the marriage bed beckons. When the guardian withdraws, the divine partner comes to the Adept. The sacred prostration is made and the presence of the Above awaited. When the divine being appears, the Adept humbly offers their own being to Above. The Divine One raises up the Adept and leads them to the bridal bed. The Divine One whispers into the ear of the Adept the Secret Name that conveys dominion over the divine force. The Adept swears never to reveal this name: the Secret Name of God is sacrosanct. This name gives all power and dominion to the Adept, with this name the Adept may control the forces of Creation and command the Divinities themselves. This union is a total merging, a marriage on all levels, a pullulating ecstasy with the divine. Allowing the inner partner, the Divine Form Within, to come into the Great Central Sun of the Heart, to merge, to join with Soul, the Adept lets the Divine One do as they will to instill the divine essence within. But if the Adept is a male, Seti must not occur."

If you can reach this level, you do not need any guidance through commentary.

"When it is time to leave the bridal chamber, the temple guardian comes to conduct the Adept and the Inner Divine Partner back to the doors leading into the outside world. Walk with the guardian across the courtyard. Take off the sacred robe and put on that which is suitable for the outer world. The Adept steps out of the gates knowing wholeness within. The masculine and feminine energies have been integrated, God and Goddess, Above and Below, the Human and the Divine, the Soul with the Great Ones. Standing outside the temple, the Adept is surrounded and protected by the Light of the Great Sun-God. The Ka walks to the physical body, the two integrating once more. The Adept breathes more deeply and stamps the right foot on the ground three times to close the inner door. At this juncture the
female Adept is to be awarded the Menat amulet with its combined male and female organs of generation that signifies freedom from the erotic cravings of lesser beings and canalisation of desire into ability to rise above the limitations of the earthly being. The male Adept is awarded the Sem amulet with its risen phallus that signifies desire tamed into pure power. The holder of the Menat and the Sem rises Above into the pullulating raptures of male-female union and into the vitality of the Power of New Life."

3.7 Muata Ashby's work on Kemetic Tantric Yoga

In studying in the spiritual traditions of Asia such as the Daoist and Buddhist traditions, one finds a framework or paradigm within which the spiritual technology of internal alchemy is placed and practiced. This is done so that internal alchemy is not only practiced in a functional manner but rather as part of a tradition. One would find for instance that there is a religious Daoism, replete with deities, spiritual observances and what can be called a religious aspect. And then there are methods and practices that a human can do, including internal alchemy. This dichotomy can be seen to represent on one hand the mystical and on another hand the esoteric, which includes spiritual theories and practices. There are degrees of integration across different Daoist lineages. In some lineages, the mystical and the esoteric are integrated. In others, there is more of the mystical or more of

the esoteric. This is true also in Buddhism, and for example in Tibetan Buddhism the tradition, flavours, observances and extent of integration between mystical and esoteric would depend on the sect.

I give the examples from Asia to underscore the importance of the work Ashby did in writing about Kemetic tantra before Paschal Beverley Randolph's work became more widely accessible by working through Judy Hall as an amanuensis. Dr. Muata Ashby is a spiritual adept with great expertise in both the Kemetic system of spirituality and the Hindu/Vedic systems of Vedanta and Yoga. In his book Rau nu Prt M Hru (The Kemetic Book of Coming forth into the Light), Dr. Muata Ashby teamed up with his wife Dr. Karen Ashby to present the material. I draw on his work in the present book I am writing because he is one of the few persons of African descent I have come across who have done a deep dive into Kemetic traditions with the view of integrating and reviving the ancient spirituality of black people of the Nile Valley region for practice in modern day times. The other two groups I have come across are the Ausar Auset system integrated by Ra Un Nefer Amen, and the system of Kemetic spirituality taught by Dogon initiates at the Earth Center, founded by Gurmanche/Dogon priest Naba Lamoussa Morodenibig. In Muata Ashby's work, we are taught about, if you will, the mystical aspect of Kemetic religion. We learn the observances, the principles, the moral codes, the deities, and the culture. This is valuable for the practice of Kemetic tantra, because it provides a paradigm within which to understand, place and contextualize internal alchemy within Kemetic spirituality.

Ashby also gives a framework within which to practice yoga and meditation, in part 2 of his book titled *Introduction to Egyptian Yoga*. Here, I must applaud him for presenting a system of Kemetic yoga that is straightforward to follow and to practice. Here, I speak of the Smai Twai Egyptian Yoga postures, which are clearly based on yogic postures derived from Ancient Kemet. This covers the practice of "outer yoga".

For the practice of "internal yoga", this section of the book presents the glorious light meditation. What is this glorious light meditation? Well, let us first start with where it was found and practiced in Ancient Kemet. According to Muata Ashby, it was practiced at the Temple of Seti 1 in Waset (Thebes), at the Temple of Aset in Aswan. According to Chancellor Williams, in his book *The Destruction of Black Civilization*, "Thebes (Nowe) was the oldest and greatest center of black civilization" (p. 69). Thebes in the past was known among the black peoples of Kemet and Kush as Waset. The significance of this is that if the glorious light meditation should be found in temples in the lands of black people, governed by black rulers and their black priests and priestesses, then it should not at all be surprising that the black people of ancient times in this region practiced the glorious light meditation. Actually, it should follow that they did.

It is important to note here that Ashby was my predecessor in attempting to penetrate the Kemetic wisdom teachings with the lens of a related but different tradition. The tradition he chooses to use is that of the Hindu/Vedic Yoga system. He has a training in Yoga and therefore can draw from that paradigm to inform an understanding of the Kemetic tradition. In this book, I am attempting a similar approach. Where Ashby draws from the Hindu/Vedic tradition (together with his understanding of the history and culture of Kemet) as his lens for penetrating the mysteries of Kemet, I draw on my training in Chinese Daoism as well as in Tibetan and Mongolian Buddhism.

What I have however not yet seen, either in Ashby's books, or elsewhere, is a practical esoteric explanation of what the glorious light meditation entails. In section 6.5 of *The Guardians, Earth Humans, and Ascension* (an earlier book I wrote), titled *The Kemetic glorious light meditation*, I started going into such an explanation. Even there, I only briefly touched upon what this glorious light meditation entailed. At the time, I wrote:

"I am only describing the process. You need to know more than just the information being given here. What I am describing here is the fundamental process. So just be aware of that. But, the practice is the same. I was informed many years ago that this practice came from the "Sons of Light". Those from Sirius, among other places. The Enlightened Ones. They are said to have taken the practice from Lemuria and Atlantis, to Kemet and Mesopotamia, and to Asia and the Americas and elsewhere, a very long time ago. Among these "Sons of Light" were the Nungal, led by Djehuti" (p. 123)

Even at that time, when I wrote the earlier book, I made a link between this knowledge of meditation that embodies internal alchemy with traditions that has been found not only in Asia but elsewhere in the world. The time has come to elucidate on these esoteric practices some more, and this time in the context of a tradition found on the African continent. The paragraph quoted above pertaining to the knowledge starting in Lemuria, then Atlantis and several other places on this planet is more or less the material I am expounding upon and building into this book I am currently writing. In line with the extra information about nagas and where they went to and the esoteric practices of internal alchemy and tantra, it is fitting to explain more about the mechanics of the glorious light meditation, which I shall carry out in the next section.

3.8 Inner Knowledge on Kemetic Meditation and Enlightenment

In regard to Ashby's work concerning meditation and enlightenment, there are two aspects I shall comment on in this section. The first aspect concerns the glorious light meditation. This aspect falls in the realm of internal alchemy and tantra. It can be seen as a counterpart practice to the practices commented on above on the Alchemy of Night Enchiridion. The second aspect concerns a path of enlightenment as represented in Kemet. This aspect is given to us in the *Rau nu Prt m Hru*, or *The Book of Enlightenment*

(same as *The Book of the Dead/The Book of Coming Forth into the Light*). That which comes forth into the light is one's consciousness. Let us now start with the glorious light meditation.

I first learned the meditation techniques I am about to describe here from a teacher who has studied with various masters, including those legendary ones we sometimes hear about that live in seclusion in the mountains, and that occasionally come into civilization, whether in the East, in the West, or elsewhere. Part of this method involves bringing in the light.

It is the light of the spirit. This light exists in the universe, in different dimensions and densities, as well as within us. We are light beings, currently in a physical body. Our physical bodies are also made of a form of 'light'. The light of our physical bodies vibrates at a much lower rate, and therefore it appears physical to us. However, since we are more than our physical bodies, we can interact with other aspects of ourselves beyond our physical bodies. There is literally a way to build your light body. In Ancient Kemet, the light body I speak of here was known as *the Sahu*. The methods given in the glorious light meditation are one way to achieve the Sahu.

Why would anyone want to build a light body? Well, think about the fact that one day your physical body may die. I use the word 'may', because physical death, although being the norm for just about everyone of us, is not the only means of transition. In our original human prototype, we did not undergo physical death. Our physical bodies and our light bodies were perfectly united and harmonized. This meant that whenever we wanted to experience physical existence, we would simply manifest as a physical being. Once we were ready to leave physical existence, we would dematerialize, and leave. Now, that is no longer the case, because of ancient genetic manipulations that occurred here on this planet.

In the current situation, when a light being incarnates into the physical bodies we currently have on Earth, they lose their memory of their identity. Throughout life incarnated in a physical body, the light being learns to operate in and identify with its physical body. So much so that for many of us, the existence of the physical body becomes all that we think we are. And it also becomes a source of many of our fears, because there is that notion that when the physical body ends, life ends. But if at some point we do learn that we are light beings, and that our consciousness travels in light bodies, then we may also figure out that we have a chance to build our light bodies so that we can regain and keep our memory of who we are and not have to go through the process of dying and being born and dying and so on, over and over again each time having to figure it out all over again. We can build a new body, even while we are incarnated in these physical bodies. This new body is sort of physical, but not quite. It is an etheric body of sorts.

In Ancient Kemet, the multidimensional aspect of a human being was conceived of in several components, of which I shall at this point touch upon the Akhu or Khu, the Sahu, and the Khaibit. To learn more about the other components, the reader can refer to Ashby & Ashby (2000). Here, I shall give my understanding of these ancient concepts. First, the Ahku. This part of our human multidimensional selves can be described as being luminous. The nature of the Akhu is very subtle. It is what makes us 'light beings'. The luminous nature of the Akhu is consciousness expressing itself as light, and as love. This light is the same light as that of the Creator forces of the universe. It pervades the universe, and is not limited by space, or by time, or by physicality. When we become enlightened, we reclaim, or in fact it is better to say that we realize ourselves, our nature, as Akhu, as the light. The Sahu is also of the nature of light, however it can be thought of as the garment or the vehicle of the Akhu. In the Tibetan and Mongolian traditions of the Kalachakra tantra, there is an ancient work known as the *Vimalaprabha*, or the *Ornament of Stainless Light*. To put the Akhu and the Sahu

into context using this Tibetan/Mongolian text as an example, the stainless light is the Akhu. The ornament is the Sahu. It is the light body, or the body of the light. Through the Sahu, our consciousness as Akhu can interact consciously and fully within manifest existence. That would be in the physical and in the non-physical worlds. As and when needed, the Sahu can manifest body forms through which the Akhu expresses itself as consciousness at all levels of existence. In the original human prototype, the Sahu was an integral component. It came with the package. In fact, that being existed as a 'fully ascended' entity. It represented the start point and the end point of human spiritual aspiration. In the current Earth human prototype, the Sahu must be built. It can be built through spiritual methods such as the glorious light meditation. And now, to speak on the Khaibit. This is another 'ornament' of consciousness, however its reach is limited to the fourth density. It has been called by diverse names, such as the shadow, or the astral body. It is a vehicle or garment that becomes a mainstay of consciousness after death of a physical body, in cases of individual consciousness that have not awakened to their nature as the Akhu and who have not built and completed their transition into the Sahu.

A fourth term from Ashby and Ashby (2000) from Kemetic traditions that pertains to the work of internal alchemy, tantra meditation and processes that can lead to enlightenment, is Shekhem. Sekhem is the power, etheric energy, the life force, the Akasa. It is what flows through the meridians of the body and what makes up the etheric body. The etheric body is a counterpart to our physical bodies. Everyone has one. If you are alive, you have an etheric body. It is really just the sum total of all the energy fields that make up each cell of your body. So, we each start to grow an etheric body while we are in the wombs of our mothers. During womb time, our etheric bodies are sustained by the energy of our mothers, which comes to us through the umbilical cord. Once we are born, and the umbilical cord is cut, we start to breathe. The air we breathe contains oxygen, which is the

"fire" that combusts in our cells, giving them the fuel of life. The air also contains etheric energy, and that energy feeds the energy of the etheric body. It is the etheric body that becomes a ghost when the physical body dies, where it may even take a form such as a poltergeist. These are ghosts that have figured out how to interact with physical objects from the etheric realm. The etheric is a form of subtle matter, so when enough of it is concentrated, it can interact with the grosser physical matter. A ghost can be thought of as consciousness as Akhu embodied in Khaibit and surrounded by Shekhem. Once the Shekhem is depleted, once the power is gone (it can disintegrate after a certain period after death, in some cases where the individual did not consciously develop themselves through internal alchemy, tantra and other methods), the departure of Sekhem ushers consciousness into the 'astral worlds' (fourth density) or the spirit realms of the dead in the 'garment' of the Khaibit, there to await another opportunity to be born into a new physical body.

At any rate, a principle in internal alchemy, just as it is with external (regular) alchemy, is to transform base metals into gold, which is a stable metal that does not rust, tarnish or decay over the ages. You may find in spirituality, in this case internal alchemy, that some of the principles that apply in the physical instance also apply in the spiritual. Where in conventional alchemy, base substances are brought together in the alchemical process to create gold, in the spiritual version, light energy from the universe and your body's energies are brought together to create a light body, the Sahu. There are various approaches to doing this, but there are underlying principles that are the same across spiritual paradigms. The light body is not created at once. Like the process that leads to the birth of a child, there are different steps (depending on the paradigm), but the beginning stages can be explained by what is depicted in the glorious light meditation. *Once the light is successively brought into the microcosm from the macrocosm of the universe, it must be circulated through the chakras and through the meridians.*

These two processes go hand-in-hand. First, you realize your nature as a light being (Akhu). Next, you circulate your energy (Shekhem) through your microcosm. The interaction between the light of the universe, now in your microcosm, and the energies of your microcosm then give birth to the Sahu. Here is where the counterpart practice of the Alchemy of Night Enchiridion (or other comparable practices for circulating the energy/fire) come into play. If one only practiced the glorious light meditation without also including processes to develop one's Sekhem, then one would be unable to also undergo transformation that bring about the light body that can lead to liberation from the cycles of death and life. The two Kemetic systems from Randolph and Ashby exposed in this chapter can be practiced together.

I shall now go into material pertaining to the glorious light meditation. Here, I am basing the commentary I give on my own training and spiritual experiences.

In Ashby's book, *Sacred Sexuality*, for performing the glorious light meditation, he gives the first step as:

"(1) Posture and Focus of Attention
 iuf iri-f ahau maq b-phr nty hau iu
 body do make stand, within the sundisk (circle of Ra)
 This means that the aspirant should remain established as if in the center of a circle
 with a dot in the middle"

The explanation that Muata Ashby gave in that last line of the quotation struck me immediately. I find that in another of his books exclusively on the meditation, titled *Glorious Light Meditation*, Ashby gives this translation for this meditation:

"Whosoever shall recite the words, here written,
with conscious awareness of Djehuty
{mind with clear and keen intellect}
shall perform the rituals of sevenfold purification over 3 days
{the seven psychospiritual centers}
which are to be performed in the Divine presence,
when this book is being read

{studied, recited, remembered}
And they shall make their position in a circle which is beyond them,
And their two eyes shall be focused upon themselves,
All their members shall be composed
[relaxed, motionless]
And their steps shall not carry them away
[from the place of meditation]
Whoever among men shall recite [these] words
Shall visualize themselves as RA
On the day of his birth
And their awareness shall not become contracted
And his house shall never fall into decay
But shall endure in truth and righteousness
For eternity"

In this longer translation of the medu (hieroglyphs) for the meditation, we are told that "they shall make their position in a circle which is beyond them". Although this longer instruction for making the position in regard to the circle may appear perplexing (i.e., how does one make a position in a circle beyond them?), it makes more sense to me from the standpoint of actual internal alchemy meditation practice than the shorter instruction in the first quotation that states "[t]his means that the aspirant should remain established as if in the center of a circle with a dot in the middle". This is because when I learned a foundational meditation that in form is identical to this one, an initial step was to make a circle with a dot in the middle. However, this circle was not made to sit inside it. Rather, the circle was made on a surface, such as a piece of paper and then stuck onto a wall (or made on the wall, if you can get away with that), to which the aspirant would face during meditation. The catch, however, was that the circle with a dot on it was still within reach of the aspirant about to meditate. The aspirant had to sit away from the circle within reach of a stretched forearm. So, one could think of their stretched forearm (left, or right), as a radius, from their body as the point in the center of a circle, to the drawing on a wall being a circle with a point in the middle. The circle with a point in the middle is actually the sun, or sun disk, in Kemetic hieroglyphs. What I shall now give in the next paragraph, are instructions on the basic

process of internal alchemy meditation where one brings in the light from the universe into their microcosm. We can then compare what I write to the instructions given for the glorious light meditation.

Sit in a position that is comfortable to you. You may sit with your legs crossed (lotus position), kneeling, or even in a chair. The position is not important, however your back needs to be straight while relaxed. Have in front of you a small circle with a dot in the middle, at arm's length away from your physical body. Clear your mind of all thoughts and calm your breathing. Have your eyes in a position where they are neither fully closed nor fully open. Focus both eyes on the dot in the circle and imagine with your mind's eye that your vision goes far beyond the dot. Far, far, as far as you can imagine, to infinity. You imagine this while your eyes remain half open or half closed. At the far place at infinity, which may look like a horizon to your mind's eye, imagine that you see the sun or a star, at that imagined horizon. With your mind and intention, gently bring that light closer and closer to you, through the circle with the dot, toward your head, and to a point on your forehead slightly above and exactly between both eyes. Close your eyes as the light enters, and then continue imagining guiding the bright ball of light (which may appear as a sun) straight through your head to your central energy channel (the one that goes right from the crown chakra at the top of your head right the base chakra and then down into the Earth), and then down this channel into your lower abdomen area. Breathe naturally and sit calmly in meditation, while having your mind's attention on your lower abdomen. Imagine yourself as a creature simply abiding, as you guard a precious pearl within. While abiding, keep mind clear of thoughts, and breathe naturally. Just be yourself (just be cool), as though you are calmly sitting with nothing really going on, except attention mildly placed on the 'sun' in your lower abdomen area, and occasionally observing your surroundings energetically and through your physical senses. At the beginning stages, it is best to bring in the light no more than twice in one sitting session. Once one has sat

long enough (the time would vary from person to person), bring the session to a close by gently opening eyes, stretching limbs, getting up and then continuing with other business. One may choose to journal their experiences as they take meditation practices.

This is the basic step. In this basic step are several great universal secrets. One of them, is that energy follows thought. With our minds, we entertain certain thoughts, and through those thoughts, we attract to ourselves certain energies. Everything around us can be reduced to a thought form. The forms of things around us attract energies that sustain the underlying thoughts of those forms. So too, is our bodies a composite thought form. In our case, being multidimensional beings, we are a composite of thought forms of several grades of matter and vibration. As it is our consciousness that creates our thoughts which subsequently influence the energies that are attracted to us, we can, with our consciousness, reach out to different dimensions and densities, and attract to us energies from those dimensions. In the case of the exercise described in the preceding paragraph, it entails a process wherein our consciousness reaches out beyond the physical realm into subtler realms to bring into our microcosm higher vibrating light energy. This energy comes from fifth density, which is the level that Higher Selves are stationed at. This light energy, once it comes into our microcosm, begins to interact with and to influence the composite energies within the microcosm. Because the energy coming into our microcosm is of a higher vibration, being from fifth density and above, once entering our microcosm, it increases the composite vibration of the microcosm and thus of our entire multidimensional selves.

Now, let us compare the practice I gave to the one from the glorious light meditation. First of all, the practice I outlined can be carried out several times. You don't only have to do it once. In other words, for given sitting meditation period, the process of bringing in the light can be safely done for example between one to three times. Just remember that when you

bring in the light, it interacts with your body's energies. Therefore, there is no benefit to doing it a hundred times at a go. In fact, that would be detrimental. These practices entail gradual and committed accumulation. It is much more beneficial to do it a few times on a regular basis (e.g., once or twice each sitting, while sitting one to four times a day) than to do one-offs where you bring in the light many, many times. The reader has been warned of the danger, futility and the folly of this. If you choose to do the exercise intermittently, say once or twice a week, or once or twice every other day or few days, then on any of these given times it would be best to bring in the light only a few times, say one to three times. So, that is the first point. For how long should these exercises be done daily, or twice a day, or every other day or a few days a week, or just for one week, one month, or one year? That too will depend on the individual. I have personally done these exercises for decades on end. It can become like a habit, like a way of life, just as we eat often, or pray often, or brush teeth often or keep in touch often, and so on. For the best results, however, consistency seems to have been key in my practice as well as in the practices of other colleagues of mine who have taken such practices seriously. The practices I have described and commented on above are one view. For the reader who is studying under school, details of the actual method may differ.

The second point is that after the light is brought in and sent down to the lower abdomen region, it is beneficial to remain in quiet sitting for a while, simply being mindful of the energy in your abdomen region and breathing naturally. Avoid trying to move the energy or force it around or focus too intently on it. Remember that energy follows thought. It is best to remain calm but mindful during this time. Third, when you do reach an advanced level, you can even bring the light in with your eyes closed, simply using your pineal/inner sight to project out to infinity. It is what one does anyway, in the scenario of eyes half open, half closed. You may no longer need to use the circle on the wall after a few months. You can imagine the circle there, while you go through it, engage with

the light/sun at infinity, and then bring the light through the circle and then into your third eye (all in a straight line), before sending the light/energy into your lower abdomen region. The more you do this practice, the more you will accumulate energy that can keep your energy system fit, healthy and strong, and that can help keep sickness at bay. A final point is that if a practitioner chooses to combine the practice of the glorious light meditation with the methods in the Alchemy of Night Enchiridion, the practitioner can set days when they do one practice and days when they do the other.

Next, I shall do a commentary of the instructions in the glorious light meditation.

"Whosoever shall recite the words, here written,
with conscious awareness of Djehuty
{mind with clear and keen intellect}
shall perform the rituals of sevenfold purification over 3 days
{the seven psychospiritual centers}"

From these few lines, I deem the line "whosoever shall recite the words, here given" to refer to the use of special words called mantras (sometimes spelled as 'mantrams') that are included in some spiritual practices. Mantras can be powerful tools in one's spiritual practice. In order to clear and sharpen one's mind, it may help to use some mantras. They are sound signatures or vibrations that encode energy patterns. These energy patterns can have effects on other energy patterns and on matter. Different sects and traditions have the mantras they use to support their practices.

"which are to be performed in the Divine presence,
when this book is being read
{studied, recited, remembered}"

This part is very important. I deem the line "which are to be performed in the Divine presence" to refer to alignment with one's Divine Self (Higher Self) during this practice.

"And they shall make their position in a circle which is beyond them,
And their two eyes shall be focused upon themselves,
All their members shall be composed
[relaxed, motionless]"

This part, especially the line "And they shall make their position in a circle which is beyond them" has been the subject of detailed discussion in earlier paragraphs preceding this one.

"And their steps shall not carry them away
[from the place of meditation]
Whoever among men shall recite [these] words
Shall visualize themselves as RA
On the day of his birth
And their awareness shall not become contracted"

Here, the most important aspect as I deem it is the line "Shall visualize themselves as RA". On the surface, it may be confusing. Who was RA, and what did he look like? It is to visualize the sun/light, at infinity, in the world of spirit, in the world of light, in the subtler realms, the higher densities. We are the light. We are RA, which is why we visualize ourselves as RA, as the light, as the sun. This light becomes us. You will only begin to know yourself as RA, as the sun, as the light, when you have done the practice.

"And his house shall never fall into decay
But shall endure in truth and righteousness
For eternity"

This is true. The light does not die. As we become the light, more and more, the causes of decay and death can become less and less. As such, one desirable or beneficial outcome or side effect of doing such internal alchemy practices as this one correctly is a gradual strengthening of one's health. You will simply notice that you may get sick less and less, and eventually, not at all, or not for very long intervals. It is in fact possible, at very advanced stages of attainment of these

practices, to become immortal, physically, and/or spiritually, as a result of correct practice of the principles and methods of internal alchemy. That is the meaning of the lines "But shall endure in truth and righteousness, for eternity".

With these comments, I shall transition from the glorious light meditation to comment now on the enlightenment path, which translation is the main and incredibly valuable contribution to us from Ashby, in my opinion. This is because even in spite of correctly practicing methods of internal alchemy and tantra, without the deepest insight into our natures that leads to breakthrough and to realization, we will still not have attained the highest levels. The highest levels, entail realizing self as the Creator. In this regard, the Kemetic teachings of thousands of years ago are an unbelievable boon. They detail the method, the way, perhaps more intimately than I have found even in my studies of Buddhism and of Daoism.

What I am suggesting here then, is that if the reader takes interest in the paths of internal alchemy and/or tantra, they would do well to also pay attention to the methods of the enlightenment path, if they want to reach the highest attainment. This path is admittedly not for everyone. Not everyone is ready to leave the cycle. There is a timing in place for each being, as they progress along their own paths. Some practitioners would encounter the few words I have shared here, and it would be enough for them to find their way, all the way to the goal. Other practitioners may be interested only in improving their health, or in becoming powerful, or exploring a new paradigm, or for other reasons. You do not have to be like anyone else. Just be yourself, and meet your own needs. In all of this, nothing is ever wasted. All experiences are saved in one's Higher Self.

With that being said, let us now progress to commenting on enlightenment teachings in the *Rau nu Prt M Hru, The Kemetic Book of Coming Forth into the Light*. This book is in fact a meditation manual that guides one through their

subconscious mind, purifying it in order to arrive at the Light of the Eternal One within. The words below come directly from the translated medu (hieroglyphs) of the ancient texts. I made changes to the text, in places where it is found in blocks. The changes differ from from what is shown in the translation of the medu in Ashby and Ashby (2000).

Chapter 1 part 1

Here begin the words for going into the light
Praisings, glorifications coming out
Going into the lower astral plane
in [beautiful] Amentet

[The] words to say
[On the] day of burial
[When] going into the cocoon
[And when] coming out

Words by Asar _____
Asar's scribe the initiate _____
Life force Amentet
Hail Djehuti, king [eternally] in me
[I am a Great Neter in a boat]

Fought I for thee I am one of those
[Thriving] Neteru
[Divine] magistrates allow me to become
Spiritually victorious
Asar as to [his] enemies
His day that of weighing words

[I am your advocate, Asar!]
I am one in those [numerous] Neteru
[Children of Nut, that are slayers of the enemies of Asar!]
[And restrain those persons that are fiends]
I am an advocate [of] yours Heru

(Source: Ashby & Ashby, 2000, p. 157)

At this beginning of chapter 1, we learn that this system of enlightenment sits squarely in the camp of Enki (i.e. as Asar), his mother Nammu (i.e., as Nut), and his visor Djehuti (as himself). All three have strong connections with the Sirius star system, and with the Nommo/Abgal, those amphibian beings that brought knowledge to mankind. In fact, Enki's mother is part Abgal, just as Enki is himself. Together with Djehuti, we can surmise that this system of enlightenment is coming from the Sirian guardian group (i.e., the 7 Abgal companions, Nammu, Enki, and his female partner, all of whom have Abgal/Nommo family connections). Let us continue:

"29. Having been accepted in the House of God and becoming one with God, let the commands of
Asar_____ be performed in the House of Asar.

30. May the commands of this Soul be effective as those of God are effective. May this Spirit be glorified along with yours (God's), and may there be found no fault of any kind in the Soul of
Asar_____ so let the balance scales of justice be cleared and may the trial of
Asar_____ be ended." (Ashby & Ashby, 2000, p. 162)

Here, I would like to draw the attention of the reader first to the phrase "Having been accepted in the House of God and becoming one with God". In the Christian faith, there is a saying by Jesus that "I and my father are one". This phrase often generates confusion. How can Jesus be one with God if

he is the son of God. The Christian ecclesiastics explain this away by saying that Jesus is God. In fact, this is true. However, there is a catch. It is not only Jesus that is God. You are God. I am God. We all are. That is why in chapter 1, part 1 above, there is a phrase saying "I am one of those [thriving] Neteru". Neteru is the plural in the medu for God.

As we achieve enlightenment, we become God. Or the Neteru. Or the Creator. Some people may feel embarrassed by this thought. If you are religious, you may have been brought up being conditioned and programmed to fear God, or to revere and to find God outside of yourself. That God is out there in the sky, watching over you. Meanwhile, you have always been the Creator, without having realized it yet. The Kemetic text is telling us that the initiate coming forth into the light becomes God. We are told that "May the commands of this Soul be effective as those of God are effective. May this Soul be glorified along with yours (God's), and may there be found no fault of any kind in the Soul". Through our purification of mind, body, energy, and emotions, we increasingly achieve the state of pure light, pure love, which is the faultless state of the Creator, the state of *stainless light*, our original state as the Akhu.

However, it is our physical bodies that almost everyone invariably identifies with the most, from the beginning. Because of this, we may develop complexes about our bodies, based on what is deemed 'beautiful' or 'not beautiful' in current society. Our physical bodies are the side of our incarnated selves that we physically show everyone else that sees us or that interacts with us. Learning to love, could therefore begin with learning to love, to care for, and to accept the bodies we chose to incarnate in. Within moderation, this would mean accepting every aspect of our bodies that we may have been unloving about, taking them as a given for the current moment. Learning to love self would however go beyond simply accepting our physical bodies, in all its beauty, as well as any perceived flaws. Learning to love self would also include, at any given time,

accepting *all* the ways we express our thoughts, our emotions, and our energies, in all their beauty as well as any perceived flaws. This is not to say that we would become complacent. Rather, it is to say that we are where we are at, at any time, and that our current station in life serves a purpose in our overall development. We can have this point of view if we think of ourselves not only as a physical body or as a personality, but also as an infinite spirit that is in a continuous process of learning and evolution.

And thus, if we learn to love by developing the capacity to love ourselves, in expressions, beautiful and not-so-beautiful, we can also have the capacity to extend this attitude beyond ourselves, to love others as well. We can understand, through this, the nature of positive and negative, that being whole and complete, both expressions exist within each one of us, and so what we experience inside of us can be related to what we experience outside of us. If we can accept and then love ourselves, in all our beauty and ugliness of body, mind, and emotion, then we can also learn to do the same for other perceived selves. At the very greatest extent, each of us is expressions of infinite spirit, therefore loving ourselves from the standpoint of infinite spirit expressing itself in one fashion can be extended to loving self from the standpoint of infinite spirit expressing itself in another fashion. And so, learning to love means accepting, embracing and honouring all the different aspects of the self we carry around, as well as all the different aspects of other selves. This love also includes scenarios where we do not necessarily allow ourselves to be trampled all over by other expressions of infinite spirit, but rather that we allow those other expressions to be and to express as they are.

PART II

4

THE SEVEN-HEADED SERPENT CULT

4.1 How it is I began the investigation

It is said that often a single strand, a puzzle that seems not to fit in, can be the catalyst for unravelling an incredible truth previously unknown. For me, this has been the case with the story of the seven-headed serpent or snake (I use these two words interchangeably in this paper) that was spoken of in legends associated with the Ghana empire. In this chapter, I shall discuss the legend of this seven-headed snake, starting with an unusual story that emerged from among the people of the Ghana empire. I shall discuss the legend of the seven-headed snake of the Ghana empire in relation to the appearance of seven-headed (and sometimes a different number of multiheaded) snakes in the legends of people in other parts of the world. This discussion will be framed primarily in connection with a lost continent that has been called Lemuria or Mu, and also in connection with the group of people known as nagas, who were early proponents of the spiritual practice of tantra, and who were the subject of detailed discussions in chapter 2. I shall share with the reader thoughts that started off as hypotheses which eventually emerged to be true.

In effect, it appears to be little known that the nagas, a people originally associated with the now mostly sunken continent known as Lemuria, and whose presence can be traced as one

travels progressively west, from Lemuria to Cambodia, Thailand and neighbouring areas, to India, and to Nubia, had members of their group who eventually ended up all the way in West Africa! There was a Naga settlement in what is today eastern Mali, and we can tell this through the legend of the seven-headed serpent that is so well-known and so well integrated into the history of the peoples of the region in the same area that used to be the Ghana empire. By suspecting that the appearance of a snake legend in the heart of West Africa with qualities that were also identical to one I had learned of in Asia could likely not be an isolated fact, I hypothesized that there must be a trail of evidence linking the seemingly isolated incidence of a naga tradition in West Africa with naga traditions elsewhere in Africa and beyond, to Asia and even to Lemuria. This hypothesis eventually turned out to be true, if we take into account that the spirituality of the various peoples the nagas influenced was in fact one faction of a larger effort by an ancient serpent cult which has acted as a benefactor of humanity since the very ancient time, and which has influenced the cultures and the peoples of Lemuria and different parts of Asia, of the Yucatan, of Kemet and Europe, and also of Mesopotamia.

Wherever the naga people went, they had with them their symbol, the seven-headed snake. The seven heads were actually representative of cosmic and esoteric principles, not seven literal heads. Seven-headed creatures do not commonly appear in the natural world. The nagas have great spiritual knowledge and are among the early proponents of yoga and tantra, spiritual paradigms that can lead individual practitioners to enlightenment. Once the nagas lost Lemuria as their base after most of this continent sank, they continued under different names such as Naacals and Naquals. Because of their knowledge of esoteric principles, such as the occult power and significance of the number 7, the nagas influenced the histories and the spiritual philosophies of cultures in Asia in particular, and perhaps also of Africa as well.

What follows now is a presentation of evidence supporting the hypothesis I presented.

4.2 The Ghana empire

To begin our story of the seven-headed snake and its significance, let us start with what is today known as the "Ghana empire". What has come to be known as the "Ghana empire" was in fact known then and now amongst the people of the area as the empire of "Wagado". At the very least, it was and still is known as "Wagado" by the Soninke people of the region. The Soninke are an ancient people that are today found in Senegal, Southern Mauritania and the Gambia. If you are quick to catch things, you may notice that "Wagado" and "Wakanda" are quite similar, aren't they? Hmm, is there a connection there? Especially as I read online accounts that the director of the movie Black Panther, Ryan Coogler, as well as Michael B. Jordan, a main character in the movie who plays the role of the main antagonist, were both thinking about making a new movie about Mansa Musa and the Mali empire? Just a thought. Ryan Coogler probably knew about the empire of Wagado, and probably based Wakanda on Wagado. This is speculation on my part.

In any case, "waga" or "wago" was the name the indigenous people gave to the founders of what became known as "Wagado". The "waga" themselves were people who chose to follow Maghan Diabé, who was said to be their first ruler. By the way, people, the Jewish 'star of David' is known as 'Magen David', making Maghan Diabé translate as 'star of Diabé'. Something to keep in mind for later, as we link the Soninke leaders to the 'Judeo Sirians' (according to Delafosse), and also directly to the Ancient Hebrews via king Solomon.

Moving on. According to Delafosse (1913), in an account replete with magic and the mystical, the python that later

became known as the seven-headed snake Bida of Wagado met Maghan Diabé at a tree and at this place, a magical drum was found which, when beaten, caused people on horses to come from four different directions. After a magical ordeal, where leaders from the four groups (who each wanted to be overall leader) put a hand in the inner portion of the magical drum. With the exception of Maghan Diabé, the drum did not stick to the arm of any of the other contenders. Through this ordeal, the four groups of people recognized Maghan Diabé as their leader. This episode is reminiscent of the creation of the Asante Confederation (in what is now known as the country Ghana) through the devices of the extremely powerful Okomfo Anokye. After Maghan Diabé won the magical ordeal, thus becoming leader, he had to make a deal with the snake that had presumably assisted him. The story goes that at first the (seven-headed) snake wanted Maghan Diabé to supply many women each year as a gift, but after negotiations, the snake settled for getting a gift of the most beautiful pure woman from one of the four groups that supported Maghan Diabé. The conventional wisdom that people have is that the woman ended up being a sacrifice to the snake (i.e., that she lost her life), but I personally suspect that the snake (and by extension the nagas of the region at the time) were using these beautiful women for breeding purposes.

This is a brief version of how the Waga Soninke people got their first leader. This leader was called the Ghana/Kha-na. Ghana was his title, not the name of the empire, and the title has means "serpent king". We will see a connection with this later, with the early kings of the Yucatan Mayan people. It was the seven-headed snake that gave "the Ghana/Kha-na", his mandate to rule. Later on, Islamic writers who wrote about the Waga people and their empire called them the Ghana empire, and so that became part of the academic literature in modern times.

In order to get a better picture of the legend of the seven-headed snake as it relates to the Soninke people, I shall

examine four versions of the legend that I currently have access to. The first is the version provided in Delafosse (1913) that has just been alluded to in summary form in a paragraph above. The second is a version from Professor Levtzion, the third is a version that appeared on diawara.org and the fourth is a version that appeared on mfsumareh.weebly.com.

I am examining different versions of this legend because I think the legend is an important part of what I am arguing in this book, which is that the seven-headed snake story is actually an indication of a naga presence in the West African region. So, it is important to delve into different versions of the African account of this story in sufficient detail before examining other accounts and versions of the seven-headed snake story from other parts of the world. The four versions I shall discuss in this paper also have similarities and some differences, so from these we can learn different things about the legend.

Of the four versions just mentioned, I shall reproduce three of the accounts in this paper. I shall not fully reproduce the account found in Delafosse (1913) because it is fairly long. Rather, I shall quote from it on occasion. I should also point out that there are other published versions of the seven-headed snake of Wagado story I wish I had access to. In his book (see next part), Professor Levtzion points out among others the French author Charles Monteil who published in 1953 the title *La légende du Ouagadou et l'origine des Soninke*. In his publication, Monteil cited 5 different versions of the legend, according to Prof. Levitzion, including Monteil's own account, the sixth, which Monteil received from a griot. I am particularly interested in the Monteil account because Monteil apparently worked with (or rather under) Delafosse at one stage while they were both in the country now known as Cote d'Ivoire. Both were anthropologists and ethnologists for French
colonial territories in West Africa. At the time of writing this article, I have been unable to get hold of Monteil's

publication. I shall now start with Professor Levtzion's version, and then proceed to the other two French versions.

The legend of Bida the snake, according to Levtzion

Let us now learn more about the "Wago" people, and the legend of Wagado and Bida the snake (spelt differently from 'Biida', which is a spelling found among some French sources), as written by the late Israeli professor Nehemia Levtzion in his book *Ancient Ghana and Mali*. I must thank the late professor for a detailed account and detailed sources in his book. Professor Levtzion lived and worked in Ghana (the current nation or political entity) during a period of his academic career. I quote from his book because it gives us one formally published source of the legend of Wagado.

Having said that, I think Professor Levtzion's version is in my view a "watered down" version, safe for consumption by academics, because it does not mention that the snake had seven heads, only that it was a snake. To his credit, some other authors before him (c.f. Meillassoux, 1963) also do that in their published accounts, however after conducting some painstaking research, I have discovered that Levtzion's version appears to be a summary of the account given by Delafosse (1913), itself based on an unpublished Arabic manuscript by Mamadi Aïssa. In his book, Levtzion appears not to have explicitly attributed his version of the legend to Delafosse, although reading Delafosse's account, it is clear that it is a much more detailed version of Levtzion's. Perhaps both accounts have the same source, however I suspect that Levtzion simply paraphrased and summarized Delafosse's version from Mamadi Aïssa, which he included in his book.

For those who know Rattray and his work on the Ashanti/Asante and other people in what is today Ghana, we can think of Delafosse as a "French Rattray", that is, an ethnologist for French territories in West Africa at the time. While Levtzion takes out almost all of the magic and the

supernatural components of this story in the account he published in his book, Delafosse (1913) leaves them in, and Delafosse (1913) also includes the part of the legend that talks about the serpent having seven heads.

Understandably, if you are a certain kind of academic, like Levtzion appeared to be, you may frown upon mention of a snake with seven heads, because snakes with seven heads are not readily found in nature. It is only when researching more widely, for instance by reading sources by authors such as James Churchward, that one learns that in Lemuria, the snake that was referred to as the seven-headed snake was really just a regular snake like a cobra. According to Churchward (1933), the Lemurian people called the cobra "naga". The seven heads are symbolic, and representative of the number 7, which is a highly significant number in many ways in the occult sciences (e.g., seven cosmic planes of existence, seven "chakras" of the human energy body etc.).

In spite of this, I think Professor Levtzion's version of the legend is a helpful one because it outlines some elements of importance for the discussion that I intend to dwell on by comparing different versions of the legend. If you want a fuller, more extensive and perhaps more authentic account, I can vouch for Delafosse (1913), since I have personally read that one. I would also like to read Monteil (1953) at some future point. So, without further ado, here is Professor Levtzion's account of the story in his book:

"The story runs thus. Dinga came from the Orient and stayed in Jenne for some time. He then moved to Dyara-ba (Dia) in Massina, where he married. One of his wife's sons was the ancestor of the Soninke in Diafunu (in the Sahel near the Kolimbine river), another son, Fade al-Hajj Suware, was the founder of Diakha-sur-Bafing, which developed as the centre of the Diakhanke.

From Dia, Dinga moved to Kingui, and reached a place south-west of Nioro, which had been dominated by goblins. There followed a magicians' duel from which Dinga emerged victorious and married the three daughters of the goblin. Dinga's sons from these wives

were the ancestors of many Soninke clans; among them was the Sisse clan, the royal clan of Wagadu.

Before his death Dinga wanted to bequeath his power to his elder son Khine. But (as in the story of Jacob and Esau) a younger son, Dyabe, outwitted Khine and obtained his father's blessing and power. Following Dinga's death, Dyabe had to flee from his brother's rage. He found refuge in the bush, when one day a mysterious drum (tabala) fell down from a tree before his feet. At the sound of the drum four troops of cavalry came out from the four corners of the bush. The four commanders recognized Dyabe as their superior, they became his lieutenants, and later - after the foundation of the kingdom - they became chiefs (fado) of the four provinces.

Dyabe, at the head of his new army, set out to establish a kingdom. He was directed to Kumbi, between Goumbou and Nema. The place was guarded by Bida, a black snake, who gave Dyabe permission to settle there on condition that he would be given the most beautiful young virgin every year. In return, Bida promised abundant rain and gold.

The new kingdom of Wagadu, with its capital at Kumbi, prospered under the rule of Dyabe Sisse and his descendants, who were given the title manga (or magha). The kingdom was divided into four provinces, each headed by one of the four commanders (fado). The descendants of Dinga and the four fado arerecognized as the aristocratic clans of the Soninke, or the wago. The wago, who gave their name to Wagadu, are clearly associated with the history of that ancient kingdom of the Soninke.

Once a year, representatives of the four provinces of Wagadu assembled at Kumbi to celebrate the sacrifice of the virgin to Bida. This ceremony ensured the continuation of rain and gold, and may also have promoted cohesion of the kingdom. Some versions of the tale say that each year another province in its turn had to offer the virgin for Bida.

During the reign of the seventh king of Wagadu, when the virgin was brought forth to Bida's cave her brave suitor killed the snake. The dying snake pronounced a dreadful curse, which caused the desiccation of the land and the cessation of the gold. The head of the slaughtered snake fell down in Bure - in the country of the

Malinke - which then became the land of gold. Deprived of rain and gold, Wagadu was ruined, its Soninke people dispersed and their country turned to desert." (Levitzion, 1973, pp. 16 – 18).

The legend of Biida the seven-headed serpent, according to diawara.org

This version of the legend that I am sharing is translated from the article *La Légende du Serpent*, which can be found in a link the reference section below. It is an account that does not begin with the events of Dinga but begins with offerings to the serpent Biida and also with the demise of this serpent. In the online version, there are sections that have the number "¾" denoting parts of the text. In the translation below, I have taken out those parts that have this number, and replaced the number with quotation marks:

"The beginning of the end began with Maadou [aka Maadi, my emphasis] son of Djaméré Soukhouna. Indeed Wagadou had 99 villages and one of these had the well in which resided the Totem Serpent of Wagadou: the Biida.

According to legend, the Biida brought abundance to the empire and rained gold nuggets there. And as a reward, a young girl was given to it.

Each year after the harvest, the notables of Wagadou tell the griots to scour the empire in search of the most beautiful, the most graceful and the cleanest girl in order to offer her to Biida. When we speak of cleanliness, we do not speak of the [cleanliness] of the body. In Soninkara a proper person is a person who is the son [or daughter] of his [or her] father [i.e., of "good birth", or not born out of wedlock; my emphasis].

This is how one year fate chose Siya Yatabéré and this is also the year she was to get married. She was the most beautiful girl in the empire and she was clean. But she was also Maadi's fiancée. Maadi, an orphan was an only child and had a really strong character and he never said a word twice. This is the main character of a Wagué. [In other accounts, Maadi is described as a person who always kept

his word, in that he never had to repeat something twice because he always did it the first time he said it].

Siya lived a few villages from Maadi. Her father had a servant who called out to Siya when the news broke:

"Isn't this the year you have to get married?"

"Yes", replied Siya

"You are promised to Maadi and we want to give you to Biida", asked the Servant.

"This is my fate and Maadi will recover from it," Siya replied.

"I don't know what will happen but I will update Maadi on the situation", said the Servant.

The next day very early, the Servant took the road to the village of Maadi. When the sun reached the zenith, the Servant reached his goal. After the customary courtesies he said:

"Maadi?"

"Yes", replied the latter.

What is the nature of the friendship between man and ape, asked the Servant?

"If the man throws his staff at the baobab tree and it stays nestled in the branches, the monkey returns it to him," Maadi replied.

"What if the monkey doesn't return it", asked the Servant?

"Then the friendship will be broken," Maadi replied.

"I come to warn you that the notables of Wagadou have decided to give your fiancée as an offering to Biida," the Servant revealed to him.

"When will the ceremony take place?", asked Maadi

"As usual, it will be on the seventh day of the seventh month after the last rain", said the Servant.

"Thank you, go back and tell Siya that fate is sealed but she won't end up in Wagadou's well."

A few days later, Maadi [secured] his horse and got ready to go out. His mother Djaméré Sokhouna asked him where he was going. He told her he was going for a walk. He rode towards the village of Siya Yatabéré. When he reached his destination, he stopped in front of the wall and asked his fiancée to be called. When she arrived he asked her:

"I have heard that the notables of Wagadou have appointed you as an offering to Biida."

"Yes", replied Siya.

"I don't know what will happen to the empire, but my fiancée won't end up in the Wagadou well", Maadi said.

"Please don't do this because people will think I'm not pure. Each person has their detractors. And if you kill the Serpent, Wagadou won't get any more rain", begged Siya.

"Farewell, I am going back to my village", said Maadi.

The death of the Serpent of Wagadou

[After he arrived] at his village, he went to his blacksmith friend [Bomou] and asked him [what] was the nature of the friendship between man and monkey. The blacksmith replied that if the man throws his staff at the baobab tree and it gets lost in the foliage, then the monkey returns it to him. And if the monkey doesn't return it, then the friendship will be broken.

The reason for my visit, Maadi said, is that I have a sword and I want you to devote yourself to sharpening it. I hire your services for a week. Your food and that of your family are my responsibility.

All week long, the blacksmith [devoted] himself to sharpening Maadi's sword. At the end of the week, Maadi [came] to see his

blacksmith's results. He was satisfied with his work and thanked him.

The night before the fateful night, Maadi [told] his mother that he doesn't know what will happen, but the Serpent will not eat his bride. If that should happen, he will eat us both or I will kill the Biida of Wagadou.

"Before I leave, I want to know if I am my father's son."

"Maadi", his mother replied, "if I have known a man other than your father, then go and never come back."

"Amiin", said Maadi.

He [secured] his mount, and set off in the direction of Wagadou's well. That day, [the people of Wagadou] braided Siya and adorned [her] with a gold hairstyle. [She] was nursed and the griots [sang her] praise and that of the Yatébéré. When the night had come, the procession took the direction of the sacred wood where the [well] is. When [they] got to the well, Siya was made to sit on the golden stool. Before returning home, the griots said:

"Siya we will go home and we will know tomorrow if you are clean or not. As you know, if you are, we won't find you sitting here. But if you're not clean, the Serpent won't want you."

"Griots of Wagadou", said Siya, "I don't know what the night will hold for me and Biida but know that I am clean."

"Yatabéré", said the griots, "we are going back."

Siya sat for hours that seemed like an eternity, then suddenly she felt a presence and turned around. When she [saw] Maadi standing next to her, their tears flowed. She [told] him:

"You really intend to destroy the empire. Because if you kill the Serpent, Wagadou will no longer receive rain."

"Siya", replied Maadi, "our fate is [already] sealed."

He walked away and took refuge on the other side of the well and waited for the fateful moment. Then came the moment when no

drop stirs in the canaries. This is the time when the spirits come out, this is the time of the reverse order, this is also the time when the Serpent takes possession of his offering due to the pact he made with Dingha and his children. Each year, Wagadou gives him a pure young girl and in return, he will rain nuggets of gold.

The Serpent of Wagadou had seven heads. The first was silver, the second was gold, the third was fire, the fourth was black, the fifth was white, the sixth was red, and the seventh was normal.

The Serpent always takes out the seventh head first to determine whether its prey is pure or not. When this is pure, he brings out the seven heads successively in the reverse order. But if the daughter offered to him is not pure, he just pulls out the seventh head and will not touch the offering.

Knowing all this, Maadi stood ready. When the Serpent took out the seventh head, Maadi cut it off. The Serpent comes out with a red head and Maadi beheaded it. Maadi reserved the same fate for the other heads up to the golden head. When the Serpent took out the last head, that is to say the silver head, the night was lit as in broad daylight. Maadi raised his arm and before hitting the Serpent, the Serpent let out a cry that was heard throughout the empire. He said: "I swear by the Lord of the Seven-Headed Being, for seven years and seven bad years, for seven months and seven bad months, and for seven days and seven bad days, Wagadou will not receive a drop of rain, and all the more so with gold nuggets." Maadi the stubborn chopped off that last head. The serpent's body fell into the well and Maadi said to Siya:

"Here is my left shoe, the scabbard of my sword, my ring and "dannan koufoune" (cap). If the next day you are asked for an explanation, show them this evidence and they scour the Empire in search of the culprit."

The end of the Soninké empire

Maadi returned to his village and he related to his mother what had happened and she said to him:
"You are my only child and it is because of your fiancée that you [are planning to kill] the Biida. But the notables of Wagadou will not let this act go unpunished. I swear on the mind of your late father that I will come between you and Wagadou."

As soon as the sun rose and nature was bathed in a reddish color, the notables asked the griots to go and inquire about the news of the well. As soon as they saw Siya sitting on her golden stool, they headed back to the village. The notables asked them why they did not take the stool. They said the stool is still busy. Those who did not carry Siya in their hearts showed their joy by saying that the Serpent proved them right: Siya is not pure. The notables went with the griots to question Siya. And with awe, they saw the seven severed heads of Biida, they asked Siya what happened during the night. In response, she showed them the shoe, sword scabbard, cap, and ring.

The sacred drum was sounded, and the notables of the ninety-nine villages gathered hastily. We must find the perpetrator of this act and give him the fate he deserves. We toured the empire and we systematically asked everyone to come and try the evidence. When they sent a messenger to look for Maadi, his mother said to him: "I am accompanying you, my son."

Maadi put his sword in the scabbard, and the latter married it like a glove. He put his foot on the shoe andit was about his size. He put the cap on his head and the ring on his finger. All the objects fit him wonderfully and he declared that it was he who killed the Serpent of Wagadou.

People rushed to capture him, but his mother Djaméré Soukhouna intervened and asked [to say a] word. She said:

"I thought there were men in Wagadou but I hardly see any. You are afraid of the Serpent's prediction before you die. But one thing is certain, my son will not be killed because of a snake. I hardly see any men. You will know for sure that my loincloth is better than all your pants put together. During these seven bad years, and these seven bad months and these seven bad days, Wagadou's needs are my responsibility. In return, my son will have his life saved and will be able to marry Siya."

Dead silence swept through the assembly and the notables kept their heads down and declared that the deal stood. This is how Djaméré Soukhouna carried Wagadou at arm's length for seven years. At the end of the Serpent's curse, Djaméré Soukhouna died and the notables of Wagadou met for the last time. They *said,

"Djaméré Soukhouna kept [her] word and the agreement has come to an end. Therefore, fate will come true. Once fertile Wagadou has become arid and it hardly rains any more. The trees have stunted and the earth barren. Dingha's children are forced to leave this now inhospitable place. May each family go towards its destiny."

The legend of Bida the seven-headed serpent, according to mfsumareh.weebly.com

The account I am about to share below is shorter than the other two. Here it is:

"For the Soninke people, the decline of their empire was due to the legend of Wagadu, and the rupture of the pact between the empire and the black snake. This happened after the nobles chose Siya Yatabare as the annual sacrifice.

She was the most beautiful and "cleanest" virgin girl in that year, but she was also engaged to be married. Her fiancé, Maadi, was the son of Djamere Soukhounou whose unique quality was that he always did what he promised. When Maadi was told him what would happen, that his fiancée would be given to "Bida" – the black snake of Wagadu, he promised Siya that she would not die in the well of Wagadu.

Siya tried to convince him that it is her destiny, that he should let her to be the gift to the snake in order to save the Empire, but Maadi refused. Within days, he asked his friend, the blacksmith of his village named Bomou, to sharpen his saber.

When the day came, Maadi set on his way in the direction of the well of Wagadu. Siya Yatabare was well dressed and her hairstyle was in plaited with gold. The praise-singer [i.e., griot; my emphasis] encouraged her, as did her family. When they left, she saw Maadi and they both fell in tears. Siya told him that if he killed the snake, Wagadu would not have any more rain and the empire would be destroyed forever. Maadi refused, saying their destinies are ratified. He left her and hid himself nearby to wait for the snake.

The snake of Wagadu had seven heads. When the snake took out his first head, Maadi cut it. He did the same to all the others. When the snake took out his last head, the one in silver, the night became clear like the day. The snake said, "I swear by the lord of seven head,

during seven years and seven bad years, and during seven months and seven bad months, during seven days and seven bad days, Wagadu will not receive any rain and any piece of gold".

Maadi did not mind, and cut the last head. The snake died. Maadi gave to Siya his shoes, the sheath of his saber, his ring, his "danan koufoune" cap. He told her that, if tomorrow they ask you some clarifications, give them those things. Maadi went to his village and told all the details to his mother. She said "you are my only son and it is because of your fiancée that you killed the "Bida", however, the nobles of Wagadu will try to punish you. I swear in the memory of your father that I will do everything to protect you from Wagadu."

When the sun came up, the nobles asked the praise-singer [i.e., griot; my emphasis] to go check the well of Wagadu. When they saw Siya, and the heads of the snake in the well, they asked her what happened. As an answer, she gave them the shoes and all the things that Maadi gave her. The nobles of the 99 villages called everybody to come and try to wear the articles of clothing. When Maadi wore the shoes, the bonnet and the ring, everything fit. People knew that he killed the snake.

They were going to take him when his mother intervened and said: "I thought there were men in Wagadu, but I do not see any. You are afraid of the prediction of the snake even before you die. But there is something sure, nobody will kill my son because of a snake. I do not see any men here. You will know that my loincloth is better than all your trousers accumulated here. During those seven bad years and seven bad months and seven bad days, the needs of wagadu would be in my charge as an exchange of my son's life and his marriage with Siya Yatabare."

With shame, the notables of Wagadu concluded the agreement. After Djamere Shoukhouna died, the nobles of Wagadu met and decided that she did what she promised and the agreement was at end and the destiny of the nation would be accomplished. Wagadu went from fertile to dry, and there was no more rain. The children of Dingha, the Soninke, were forced to leave that place which became inhospitable. Thus every family went to his destiny that is the decline of the Ghana Empire - the end of the Soninke Empire."

4.3 Comparing accounts of the legend of biida the snake

There are similarities as well as some differences in the versions we have already examined in the previous section. Let us first begin with the similarities, which will help consolidate the story. One similarity that cuts across all 4 versions of the story is mention of a snake and an offering made to the snake. The offering is a woman. In all 4 versions, the snake is killed, and as it dies, it pronounces a dreadful curse. In terms of similarities, it would also appear that Levitzion's version seems to be a summarized or much shorter version of the one that appears in Delafosse (1913). Similarly, the version of the story that appears in 2.3 above from mfsumareh.weebly.com appears to be a summarized version of the one that we read in 2.2 from diawara.org.

Now, let us examine some differences. In the case of the online versions and in Delafosse (1913), the woman's name is given as Siya Yatabaré, and the man, her lover's name as Mamadi. In fact, Delafosse (1913) even goes as far as giving the man's full name, as Màmadi Séfé-Dokhoté. Apart from Levitzion (1953), the other 3 versions also mention that the snake had 7 heads. For the benefit of the reader who does not read or understand French or who might not manage to find a copy of Delafosse (1913), I shall provide an English translation of the section in this publication pertaining to the seven-headed snake:

"Màmadi then made arrangements to kill the python treacherously, and he sharpened his sword without anyone knowing. Everyone had gone to Koumbi; when they arrived there, they prepared to deliver Siya to the python for the feast day and they brought her to the opening of the well in which the serpent was standing. Now it was the python's habit, when a young girl was brought to it, to stick its head out three times as a game and then to seize the young girl quickly and to descend with her to the bottom of the well. As the python, having thus stuck out its head twice, pulled it out a third time and prepared to seize Siya, Màmadi drew his sword and cut off the python's head; but the python kept coming out one head

after another and Màmadi was cutting them off (1), until we had reached the number of seven heads." (Delafosse, 1913, p. 17).

Another difference is that with the exception of Levitzion (1953), the other 3 versions describe the curse as consisting of 7 bad days, 7 bad months, and 7 bad years. There are versions of this 7-7-7 curse in these 3 versions. Clearly, 7 is an important number, as not only does the serpent have 7 heads, it also pronounces a curse that has 7's all over it. We shall delve into the significance of 7 shortly.

One important difference between the formally published versions (Delafosse, 1913; Levitzion, 1953) and the informally published online versions (diawara.org; mfsumareh.weebly.com) is the point at which the story of the legend starts. With the former, there is a backstory that includes Dinga, the legendary forefather of the Soninke people, and events that led to the formation of Wagadu and the pact with Bida. In the two formally published versions, it is only later that the part about Mamadi and Siya comes in. With the latter, that is, the informally published versions that appear on the two online websites, the story begins with Mamadi and Siya. This difference is important because it is in the details of Dinga and "the people of the snake" that we can glean important clues to the origin of Soninke people and their connection with the nagas.

Specifically, Levitzion (1953) hints at the notion that Dyabe Cisse (i.e., Maghan Dyabe Cisse), the founder of Wagadu, interacted with people of foreign origin associated with the seven-headed snake who were instrumental in forming Wagadu. These people of foreign origin are those in the story who came from the four corners once the magic drum was played and who became the chiefs of the four provinces. Levitzion also states that Bida, the snake, had been in the area that became the Ghana empire before Dinga's son Dyabe Cisse formed his kingdom. Below is an excerpt from Levitzion's account in the section above:

"Dyabe, at the head of his new army, set out to establish a kingdom. He was directed to Kumbi, between Goumbou and Nema. The place was guarded by Bida, a black snake, who gave Dyabe permission to settle there on condition that he would be given the most beautiful young virgin every year. In return, Bida promised abundant rain and gold."

Where the legend says "the place was guarded by Bida, a black snake, who gave Dyabe permission to settle there", we can think instead that "the place was guarded by the Nagas, a black people, who gave Dyabe permission to settle there".

Earlier, we also learn that Dinga, Dyabe's father, came from the Orient. It seems to be the case that Dinga and his people arrived from the Orient (i.e., the East), via Djenne, to Dia, this place that is so important to many West African people (Meyerowitz, 1972). Dinga is described as descendant of Solomon, and in fact, Delafosse (1913) gives his genealogy, which I shall quote:

"It is said that a man named Dinga, son of Khiridion Tamaganké, son of Yougou Doumbessé, son of Job, son of Solomon, son of David (salvation be upon him), arrived from the East with his companions; he had with him three hundred magicians, and the chief of these magicians was Karabara Diadiané, the ancestor of the Soudoro clan. They continued their journey until they reached a village named Djenné and were there stopped by the inhabitants of this village." (Delafosse, 1913, p. 6).

I think there are some important and interesting points that should be noted from this quote just given. First, Dinga's genealogy leads him back to the Hebrew king David, but more interestingly (in my opinion) to Solomon. Why is that? It is because first of all, we learn from esoteric sources that Solomon was a great magician. Manly P. Hall (1928) writes that "Fully convinced that their Scriptures sanctioned it, numerous mediæval Qabbalists devoted their lives to the practice of ceremonial magic. The transcendentalism of the Qabbalists is founded upon the ancient and magical formula of King Solomon, who has long been considered by the Jews

as the prince of ceremonial magicians." (n.p.). This is important because Dinga, his supposed descendant, seems to be steeped in magic, having 300 magicians, and was himself a magician. One would imagine that Dinga and his group were practitioners of Solomonic magic. Secondly, we are told that Solomon had hundreds of concubines (Hall, 1928). From Dinga's genealogy, it could well be that one of Solomon's wives or concubines was the mother of Dinga's ancestor. If that is the case, then out of the hundreds of wives and concubines, it could be that Job's mother or Job's wife was a Cushite/Kushite woman.

At any rate, the Kushites inhabited the region around today's Sudan, Egypt and Ethiopia. This region, then known as Kush (later as Nubia), has been inhabited for at least 10,000 years, according to archeological evidence (Ross, 2013). It is also asserted that those known as the Nagas migrated from India to Nubia, about 15,000 years ago (Churchward, 1931). Churchward's source consists of ancient Naga records held by sages in India whom he met while in the country (The reader will find close to the end of Part II of this book, in the section titled *The ancient city of Naga'a in Nubia-Meroë and the temple of Amun,* that there was in fact a Naga city in Nubia-Meroë).

Long story short, the Nagas, having lived among the Nubians, one faction eventually migrated to West Africa, in the region known as Dia, and neighbouring areas. Much later on, again from Nubia or neighbouring areas, Dinga, the leader of the Soninke people, also migrated to Dia, and neighbouring areas. One of Dinga's sons, Diabe Cisse, got in league with, and support from, the nagas who had arrived in West Africa earlier than the Soninke did. They struck a pact and formed an alliance. At some future point, the alliance fell apart because the pact was broken.

Delafosse forwarded a theory that Dinga and his people were "Judeo-Sirians", whose culture had Aramaic, Egyptian, and Berber elements, and who he thinks were the 44 rulers of the

area, 22 of which had supposedly lived before the Hegira, according to the Islamic scholar Es-Sadi (Delafosse, 1912; Shaw, 1905). Delafosse even attempts to estimate the start of the reign of monarchs based on these 44 rulers, coming up with a number around 180 – 300AD, which would make the region that eventually became the Ghana empire the contemporaries of the latter days of Kush/Nubia prior to it being conquered by foreigners. Dinga's Aramaic origins may be traced to the region around present-day Israel and Palestine. In ancient times, the place was called Canaan.

According to Meyerowitz (1972), these Kushites were a matrilineal people, much like the Ancient Egyptians and the Imazighen (Berber) within the region. We do know that the Kushites/Nubians practiced matrilineal succession, as has been argued by some researchers (c.f. Saito, 2015). I think that Kumiko Saito has done some excellent work in demonstrating the Iroquois/Crow system of matrilineal succession in Kush/Nubia. This is a system where the current king is the son of the previous king's sister. We know that there was a system of matrilineal inheritance practiced in Wagadu, or the Ghana Empire (Shaw, 1905), as reported by Lady Lugard, quoting Islamic scholars who lived during those times. Lady Lugard (i.e., Florence Shaw) writes that:

"In the years 1067 Ghana was still the principal black kingdom of the Western Soudan. The name of its reigning sovereign was Tenkamenin, who ascended the throne in the year 1062, in succession to his maternal uncle, Beci. It was the custom amongst these blacks for the succession to go always to the son of the king's sister." (Shaw, 1905, n.p.)

Now, obviously, we might think that it might be a coincidence that the Kushites/Nubians on one hand practiced this matrilineal system in the north-eastern part of Africa, and the people of the Ghana empire across on the other side, in West Africa, also practiced the same system. In truth, the matrilineal system of succession has been a mainstay among many African groups across North and West Africa. Meyerowitz (1972) shows for instance how the rise of Islam

in these three regions dismantled the matrilineal system in many places, again and again replacing it with the patrilineal system. Victorious invaders married royal females and through them, birthed new dynasties, only that the succession was now done through the male line of the king, not the female line through the king's sister. Murdoch (1959) gives even more examples, and in greater detail, of the spread of both matrilineal and patrilineal cultures across all of Africa.

Between Kemet/Kush in the northwest, and present-day Akan in the southern bosom of West Africa, the one culture in all of West Africa that is most similar to the Kemet/Kush culture of matrilineal succession as to be identical with it is that of the Dogon people of Mali. The Dogon in Dogon country inhabit the Bandiagara escarpment. Identical to the Kemetic/Kush and the Akan, the Dogon people unlike their neighbours also have a society based on the Iroquois/Crow matrilineal system of inheritance. This should come as no surprise, given the now widely known fact of descent of the Dogon people from Kemet, and of their very intimate knowledge of the Sirius star system. Here is what Murdoch (1959) tells us about the Dogon and their neighbours:

"The tribes of the Grusi and Mole clusters reveal a distinctive pattern of social organization, characterized by patrilocal residence, patrilineal descent, exogamous totemic patrisibs, segmentary lineages, patrilineal inheritance and succession, local exogamy, kinship terminology of the Hawaiian type, and the prohibition of marriage between first cousins of any kind. A settlement is occupied by a localized major lineage, thus constituting a patrilocal clan-community, within which the component minor lineages are commonly localized in distinct quarters as clan-barrios and the minimal lineages, of course, as patrilocal extended families. The tribes of the Bargu, Gurma, Habe, and Tem cluster appear, on the basis of incomplete evidence, to possess social systems of essentially similar character. The Dogon, however, have cousin terminology of the Iroquois rather than the Hawaiian pattern, and only the quarters of a village have the structure of patriclans." (pp. 83 – 84)

Akan and Dogon culture are essentially identical, so I was not surprised to learn that in their migrations from northeastern Africa to what is now known as the country Ghana, one group of Akan people actually lived in the region that the Dogon are currently at, that is, Dogon country or the Bandiagara escarpment, but had to continue their journey southward. During this trek of an entire group, the Bono people, this group of Akan, received assistance from a Voltaic group known as the Gurmanche, to settle in the region. This goes to show that groups of Akan also interacted with various Gur and Mossi peoples before reaching their present homes in the southern regions of West Africa. During their trek and as they stayed with different people, these Bono people kept their matriarch/matrilineal culture intact, a culture that for all intents and purposes points back to Kemet/Kush and even further afield, all the way back to Lemuria. Meyerowitz tells us in *The Early History of the Akan States of Ghana* that:

"The Bono who, about three hundred years later, became the founders of the Bono kingdom in Ghana first settled 'south of Timbuktu' in a mountainous region between 'Mali and Mossi' which can be identified as the Bandiagara, because they were attacked there after at time by the Kibisi whose home was the Sangha region to the north. The Bono then moved to the plains of the adjacent Yatinga country in Mossi. Once more harassed by an enemy and in search of a new home they were given land by the Gurmanche situated in the triangle created by the Red and White Volta rivers in Mossi where they built Wasi as the capital of a city state. About A.D. 1000 the Mossi Kingdom, according to Nana Kwame Frimpong (of Tuobodom and a royal son of the Bono-Tekyiman stool) was a confederation of seven states: Yatinga, Yako, Bausouma, Obritinga, Zadoma, Gurmanche and Marro." (Meyerowitz, 1975, pp 9 – 10).

Among the Akan migrants from Dogon lands were the Koromante, a group who are now part of the Fante sub-group of the Akan. From Bandiagara, the Koromante and other Akan went to Gurma territory, within the general Mossi area. The first Bono kingdom was destroyed, however the second one persisted in the Savanna within what is today Ghana for over 700 years. The Koromante, who had traveled with the

groups of Akan people from Bandiagara, eventually ended up at the coast of today's Ghana. The Koromante were once referred to by the Greeks as the Garamantians. They are the group that Robert Temple, the writer of *The Sirius Mystery*, thought were Greek. They were/are in fact "DiaMo" (see Appendix 3). Garamante, Koromante, Bandiagara, and Gurmanche, all have Gara/Koro/Gur (i.e., the Gur people) as a root word. They are the descendants of the Ancient Egyptians. In fact, you could say that they are ancient Sirians, the "Annu", people strongly connected to the Sirius star system. If you decompose the name "Bandiagara", you get Ba-Dia-Gara. These are the children/descendants (i.e., the Akan word "Ba" which means child, or descendant) of the Dia kingdom, that are Gara, or Gur. In other words, the Gur or Voltaic group, of West Africa. Asona and Agona members of the Akan Koroma/Koromante, as well as the Mossi Gurma/Gurmanche are two such "DiaMo" people. They are the same as the Akan Asona people, the Soninke, those that Delafosse (1912) referred to as the "Judeo-Sirians". They are in a sense, those people who we can band together or call today's Mossi, the largest group among the lot within the Gur region. I give a much more detailed rendering of these lines of thought in Appendix 3 of this book.

The observant reader may also have noticed that this information about the Bono and their migration that occurred around AD 1000 (after the Islamic Berber Azawagh people destroyed the black nation of Dia, and its matrilineal Dyala/Diana dynasty) is contemporaneous with the matrilineal dynasty existing in the Ghana empire (AD 1067), as reported from the Islamic sources given by Lady Lugard above. Certainly, Dia existed long before that, since we are told by Delafosse (1913) that the founders of the Soninke empire passed through Dia. A very deep dive into Dia and African peoples connected with it can be found in Appendix 3. What we can discern from Dia and the Ghana Empire both having matrilineal royalties occurring concurrently is that the Akan system of rule was more widespread across much of West Africa than may be realized. A system of rule that also

existed in the Kemet/Kush region, and that was practiced on Earth millennia ago, on the now mostly sunken Lemuria. When I spent some time with Zulu high shaman Credo Mutwa at his home back in 2012, one of the many stories he told me had to do with the Garamantians and the Sword of Shelumi, a legendary sword that was in Mutwa's possession and that was once wielded by King Solomon. The sword is said to have been crafted by the Lemba people, a Jewish people found in Africa. Mutwa was not known as The Lion Shaman without good reason. This sword is now used for spiritual purposes and not for war. At the time, I had not yet worked out that King Solomon, the Garamantians (i.e., the Akan and others of these people), and the Zulu all had in common a connection with the "DiaMo" people who can otherwise be called the Ammonites, Solomonic peoples, or Ancient Egyptians. As it turns out, I have now come to realize that Akan people in West Africa and Zulu people in South Africa have more in common than I had ever imagined possible at the time we met.

Back to our main story. In relation to Lemuria/Mu, which we will soon talk about at greater length, the point is that Mu promoted feminine energy and the matriarch/matrilineal culture. At one point on the planet, when Lemuria was still the pre-eminent culture on Earth leading in spirituality, most of its satellite cultures had the feminine energy/matriarchy. And then patriarchy rose in Atlantis. From then on, the two systems struggled. Today, it seems that patriarchy is the stronger of the two systems, in general, around the world.

So, those contemporary cultures (many are also ancient) that still hold the Lemurian current identify with this Iroquios/Crow matrilineal system of inheritance, and other forms of matrilineal succession. There are others, such as the Native American Hopi people, who also have this Iroquois/Crow system of inheritance. The Hopi are interesting for a number of reasons, one of which is that there is a tradition that has been preserved by the Hopi people, of their escape of the destruction of Lemuria and its aftermath,

in the Americas. Blumrich (1979) has a translation in German, of a book based on this Hopi tradition, however the reader may also find a copy of an English translation of the same book online (see reference section). Similar to the Hopi, the Akan people of West Africa also practice Iroquois/Crow style matrilineal succession (Thomas, 1980).

So, anyway, the matriarch/matrilineal system of succession is in my view one major strand of connection to Lemuria and its resultant cultures. We will see shortly as we delve further into Lemuria that some of those that departed after the continent sank took the matrilineal system with them as they moved from place to place. We find some evidence of it from people practicing matrilineal succession or matriarchal systems in Asia (c.f. the original Cambodian royalty, the Dravidian people, etc.), in Kush/Nubia, in Canaan (which is probably why Jewish people are matrilineal), in Kemet/Egypt and also in North Africa among the Amazigh/Berber, and the Tuareg people (Imazighen), who are literally descendants of Atlanteans.

To sum up, this section covers quite a few items. The main points of note are that the examination of historical sources appears to point to a faction of the people known as the nagas having found their way to the western coast of Africa, what later became known as the Ghana empire. These nagas probably migrated from the Kemetic/Kush area before these cultures were overtaken by foreign invasions.

At a later stage, the nagas encountered a second wave of people, who Delafosse (1912) calls the "Judeo-Sirians". These Judeo-Sirians are a Kemetic/Kushite people with possible Amazigh/Berber and Aramaic admixtures. They are the group that I refer to as the "DiaMo" (see Appendix 3). This second wave of people that have been led by the "Judeo-Sirians" formed a pact to co-exist with their Naga precursors. The Judeo-Sirians then created the Kingdom of Wagadu, which Islamic scholars called the Ghana empire. At some future point, the pact between the Nagas and the people with

Kushite/Ethiopian and "Judeo-Sirian" ancestry fell apart, bringing to an end the hegemony and pre-eminence of what is today known as the ancient Ghana empire.

4.4 The seven-headed serpent in Lemuria

The name 'Lemuria' has been around in academic and esoteric writing for at least several decades now, although I should point out that within mainstream academia, the idea that there once existed a vast continent in ancient times known as Lemuria/Mu that is now mostly sunken appears to be discredited. I just happen to not only consider mainstream academic sources, but also non-mainstream academic sources, such as esoteric doctrines and the oral histories of indigenous people (both of which also tend to be discredited by mainstream academia) as interesting and useful sources of information to be studied. I consider these non-mainstream sources because I have come to realize that the boundaries of what is now known is mainstream knowledge tend to be expanded first at the fringes. It is at the fringe that some of the most interesting advances in knowledge that later becomes 'mainstream' occurs. I have come to realize that this trend tends to be true in philosophy, science and even in spirituality.

I first learned about Lemuria from the work of Helena Petrova Blavatsky known as *The Secret Doctrine* (1888). This was about two decades ago. Blavatsky was a Russian mystic who is said to have studied with spiritual masters of the East. Her written work is a synthesis of the learning she had received. For me, Blavatsky's work was an entry point to many ideas about esoteric history and philosophy. I would however caution readers of her work to be circumspect and to practice discernment, if they choose to study her work, because it may be difficult to find accessible references for her sources.

I later learned about Lemuria from many other sources, however the one source that has provided much information in my research on Lemuria has been the works of James Churchward. Churchward was an Irish man who was in India as part of the then British Empire. While in India, he crossed paths with a rishi or sage. Through this meeting, he struck up a friendship, that eventually led to a sort of apprenticeship. It is from his relationship with this rishi that Churchward learned much about the sunken continent of Lemuria, which he referred to as the land of Mu in his works. Here is an account of his tutelage under this sage:

"For seven years I had the great privilege of being the only pupil of the greatest Rishi who has lived during the past two thousand years, and yet generally unknown. It may well be said, "the world has never known her greatest men." He would willingly and gladly explain to me various phenomena, what to us today are the Mystic Sciences. I could never, however, induce him to teach me how to perform any of the phenomena along certain of the lines. Whenever I appealed to him to do so, his invariable answer was: "My son, I am teaching you how to learn the ancient history of man. I cannot go beyond that science with you because you have not been prepared to advance into others." (Churchward, 1931, p.263)

In classic naga style, the tutelage lasted seven years, so the esoteric number seven comes up again. It is clear from the quote above that Churchward held his teacher in high regard. It also appears from Churchward's account that the teaching was mostly informational, and not an occult discipleship where a neophyte learns to practice and demonstrate spiritual phenomena through the training of their own consciousness, energetic and psychic abilities. Through his association with this teacher, Churchward built a foundation in esoteric history upon which he continued years of investigation into connections between what he learned from this rishi and connections with other Earth civilizations and cultures to Lemuria or Mu, that he uncovered.

According to Churchward, in ancient times, Lemuria became overpopulated. At that time, its people began to migrate to

other locales on Earth. These seafaring emigrants were known collectively as "mayas", wherever they settled. The nagas were themselves one branch of the people of Mu who developed their own culture. Churchward (1931) states, "When Mu, the Motherland, became overcrowded, or, among her great navigators, some ambitious and enterprising company found new and available lands, a colonial development was started. These emigrant children of Mu were called Mayas. All who left the Motherland in any direction were called Mayas." (p. 20). We shall return to this notion of mayas later in the book as we trace different cultures that were influenced by the people from Mu, especially those that ended up in the Yucatan.

So, moving on, central to this story of Lemuria, or Mu, is the notion of the seven-headed snake. According to Churchward, the idea of a snake with seven heads originated in Mu. In Churchward's own words:

"Two of these serpents are especially prominent. One was the cobra, called in the Motherland, Naga. This one had seven heads. This number was given to correspond with the seven stages of creation, the seven mental planes, et cetera. The seven-headed serpent originated in Mu and was there called Naga. In various Mu colonies it received added names. Judging from the geographical position of the colonies where we find it, I think that the lower western half of Mu was where it was used. The people using this symbol were called after it—the Nagas." (Churchward, 1933, p. 61).

Naacal

(Churchward, 1933, p. 64)

The image above shows one depiction of the seven-headed serpent from sacred naga symbols. One way to think about the image above is to imagine what happens when a ray of light hits a glass triangular prism. What happens is that due to the properties of the prism, the light ray gets refracted, which means it gets dispersed into bands of light of different wavelengths. There are seven bands of light, that constitute the seven colours of the rainbow. This idea of seven colours that make up the rainbow, and the seven serpents may in fact also be linked with the idea of the "rainbow serpent".

Churchward tells us that to the people of Mu, the number seven was symbolic of much that is esoteric. That is, the seven stages of creation, the seven mental planes and such. Indeed, in occult teachings, seven is a very important number. In the Law of One material transmitted by the entity RA, we learn that there are seven densities of physical manifestation, and that the eighth density starts a new octave. I discuss these planes of existence and some of my consciousness explorations of them in my book *Out of Body*

into Life. The number seven is also important in the occult teachings of Djwal Khul (DK), a Tibetan adept who transmitted his teachings to Alice Bailey. DK discusses the seven rays (Bailey, 1999), which are spiritual emanations from Source, from which spiritual beings originate. Interestingly enough, DK's lineage of spiritual teachings has at its head a group of seven spiritual masters called Kumaras. I have long suspected that these Kumaras may be among the original teachers of the nagas, or at any rate, the two are related.

There are many other esoteric traditions from which we can learn of the importance of the number seven. I will refer to only one more, because I think that this tradition, along with that of DK, all have their source in Mu or Lemuria. This tradition is the Toltec tradition of Don Juan, the "nagual" (aka "naacal", "naga"), and spiritual benefactor of Carlos Castaneda. Castaneda frequently encounters the number seven during rituals and experiences as part of the earlier stages of his apprenticeship (Castaneda, 1998b). Later in his apprenticeship, Castaneda is also taught that there are seven bands or emanations from Source that give conscious life to manifest existence (Castaneda, 1998a).

There are other ways that the number seven is significant in an esoteric way. For example, there is also the connection between the number seven and the seven energy centers that interpenetrate the human physical body. Those seven energy centers have been known as chakras, a Sanskrit word meaning "wheel" and which has been commonly used to denote the vortical motion of these energy centers.

I shall now cite seven examples (out of several more) from Churchward (1933) of what he gives as "the sacred seven", and also indicate the culture that each is from:

"Persian: The seven rays of Agni" (p. 162)
"Hindu: The seven steps of Buddha at his birth" (p. 162)
"Hindu: The seven rishi cities of India" (p. 162)
"Egyptian: Their seven days of creation" (p. 162)

"Egyptian: Their seven days of the week" (p. 162)
"Egyptian: The seven classes of Egyptians" (p. 162)
"Norse: The seven families that accompanied the mythical Wotan, founder of the city of
Nachan" (p. 162)

Thus, the number seven has appeared prominently in different cultures across the world. As we progress through the rest of this book, there shall be more instances where we shall meet instances of seven-headed snakes and instances of the number seven in different cultures across the planet.

4.5 The seven-headed serpent in Cambodia

What we know of today as the country Cambodia would have in ancient times been north of the Lemurian continent. Among the people of Cambodia known as the Khmers, there is a strong link to the nagas, whom they consider to be their ancient ancestors. This is because there is a Cambodian legend that connects the formation of their nation with the marriage between a Brahmin man, called Preah Thaong, and a Naga princess, called Nagi Soma. Readers will remember that the people of Mu were led by a matriarch. For this, it is through a female royal that the nation is 'birthed'.

Miriam T. Stark gives a published account of what is known as the Khok Thlok story, or the origins of Cambodia. From this story, we learn more about the Nagas:

"It is the year AD 68. Preah Thaong, a brahmin from the east, reaches the Mekong delta by water. Standing at the prow of his ship, he sees the island of Khok Thlok; at its shore is a beautiful woman serpent princess named Nagi Som ā. She sees the intruder, assembles her army, and defends the island against Preah Thaong through pitched battle. Preah Thaong conquers her, they fall in love, and their marriage ceremony is held in her father's subterranean nāga kingdom. After they are wed, Somā's father (the nāga king) "drinks the waters" that cover this land, and creates a land he calls Kambuja. The descendants of this kingdom's residents

are the modern-day Khmers who live in the kingdom of Cambodia. Cambodians teach this amalgamated version of the origin story to their children today. This Khok Thlok, Preah Thaong, or Kaundinya story appears in Cambodian schoolbooks, and King Preah Thaong and his queen, Somā, are also described in post-fourteenth-century Cambodian royal annals (Gaudes 1993, 335–38). Cambodian brides and grooms reenact this story in each traditional Khmer wedding because wedding rituals symbolize the marriage of Preah Thaong and his beloved Nagi Som ā (Gaudes 1977; Lewitz 1973). Deeply entrenched in Cambodian ideology, the Preah Thaong story is integral to understanding the origins of the Khmer people." (Stark, 2006, p. 307 – 308).

Okay so this to me is a great account, because it shows how 'legend' that is lived, can actually reflect an attempt to preserve a historical account. This manner of 'living an origin story' is also common among African people. A historical event is re-enacted over and over again during ritual. The power of the re-enactment is to strengthen the memory of the historical event by living it. Such re-enactment is arguably more powerful than writing the historical event in hieroglyphs on papyrus or walls, on clay tablets, on scrolls or even in books. In Africa, historical events when re-enacted at festivals and other occasions, can include music, drumming and dancing. The drum has its own language that the people understand. As the people re-enact the event, the memory of their past is instilled in their physical and energetic memories. Essentially, entire groups of people become like human 'hard disks' or data banks for the historical event, and what ties it together for everyone, is the associated ritual of re-enactment. This is one way to pass down histories from generation to generation.

The Khmer people are understandably strongly connected with the nagas. In fact, they see themselves as descendants of the nagas. It should therefore come as little to no surprise that the seven-headed serpent features as a national symbol of the Khmer people. This serpent is found in many of their temples, not least the most famous one, Angkor Wat.

As I conducted research for this paper, I came across an article on "The Cambodia Site", titled "Nagas" (see references), which reiterates the story about Preah Thaong and the naga princess. In this version of the story, the princess has a different name. She is called Neang Neak. There is a curious part of this article that references Nagas as a reptilian race from Mu:

"In a Cambodian legend, the Naga were a reptilian race of beings who possessed a large empire or kingdom in the Pacific Ocean region. The Naga King's daughter married the king of Ancient Cambodia, and thus gave rise to the Cambodian people. This is why, still, today, Cambodians say that they are "Born from the Naga.""

It is said that "truth is often stranger than fiction". If the Cambodian people believe that they are descendants of a race of reptilians from a large empire in the Pacific Ocean, then it does not sound too strange if Colonel James Churchward claims that this race actually existed and was from a continent in the Pacific Ocean. Again, Churchward based his claims on his encounters with a rishi/sage in India, who belongs to a sect that has preserved the memory of the nagas.

4.6 Narayana the seven-headed intellect, and the supreme creator

As mentioned in the previous section, the people of Mu held the seven-headed creator in the highest regard. This was a being that gave them seven laws of creation. A being that embodied the occult significance of the number seven.

As turns out to be the case, in Southern India, there is evidence of spiritual practice that considers the 'godhead' in the context of a seven-headed being. Specifically, the Hindu deity Narayana, who is thought of as being an aspect of Vishnu. Vishnu is one of the principal deities in Hindu religion, and in the Hindu trinity, Brahma is the Creator,

Vishnu is the preserver, and Shiva is the Destroyer. Or, as one Hindu man used to tell me, "Brahma, Vishnu, and Shiva, are GOD, and that means Generate, Operate, and Destroy".

As a principal deity, Vishnu has different avatars that this being has incarnated into, and one of these avatars is Narayana. The connection between Vishnu and the nagas can also be seen in the easily found image of Vishnu lying on Shesha, sometimes called Ananta Shesha, or Adi Shesha. Shesha is the king of the nagas, and Adi Shesha means "the first naga". So, we find already that the Nagas are connected with Vishnu, one of the principal deities in Hinduism, and a being that is actually seen as the supreme being in Vaishnavism, one denomination of Hinduism. As a curious aside, the root "adi" also appears in the Akan language when speaking about "first" and "foremost". Akan speakers say "Adi Kan" to emphasize that which comes first.

There is a curious section in Churchward's book *The Lost Continent of Mu*, where he discusses an episode of translation with his rishi teacher, of the creator, this seven-headed serpent, the self-created, which gave forth seven commands of creation. These seven commands of creation are like an esoteric version of Genesis chapter 1 of the Christian Bible (for those who are Christians, who were Christians before or who know about Christian doctrine).

This esoteric version is remarkably similar to Genesis chapter 1, a bit more esoteric. Both accounts take seven stages, and arguably, the seven-day week that exists in most parts of the world is based on this notion from Genesis chapter 1 that 'God' created humans on the sixth day and rested on the seventh day (Sunday), and so Sunday became a day that Christians rest and go to church. The secular seven-day week and the weekend (Saturday and Sunday) are based on Christian ideas, so even Christianity has been influenced by the number seven.

There are differences between the Christian and Lemurian versions, however. For example, in Genesis, 'God' creates things in one day. 'God' creates light and darkness in one day. In the Lemurian/Mu version of the nagas/naacals, translated from their sacred tablets, the primordial being issues commands. These commands are not limited to being fulfilled in a single day. In fact, Churchward (1959) states that "The seven commands are, without doubt, also indicative of seven periods of time. A period of time is not measured by any particular number of years. It may mean a day, a year, or millions of years." (p. 19).

So, what I am gathering from all of this, is that it is entirely likely that those who composed the Christian Bible (i.e., the First Council of Nicaea), may well have been aware of this Lemurian doctrine. No surprise there, if that is the case, because Lemurian lore is said to have survived into Atlantean and even Egyptian times. Churchward (1931) reveals that the secret/esoteric school of the sage/rishi who he studied with in India was aware of the being who went by the name of Osiris, who was a human being that attained mastery and became something like a Christ figure in Atlantis. According to Churchward, Osiris went to the East (just as Jesus is said to have done), at a time when Mu was still intact, and there he studied and became a Master. Upon completion of his studies, he returned to Atlantis. There, he founded the Osirian current, which was very strong. The Osirian current was also in Kemet (Egypt), where there was a trinity (Osiris/Asar, Isis/Aset, and Horus/Heru). Research has shown that the Egyptian/Kemetic religion was one of the world religions that influenced Christianity (Acharya, 1999).

Two points. The first is that if we take it to be true that the Lemurian version of creation by their supreme deity, this seven-headed being, is true, then since Lemuria predates the time when the Christians say the world was created (i.e., around 4,000BC, which seems to coincide with the most recent deluge, and subsequent Sumerian/Mesopotamian culture), we can also easily imagine that the Lemurian

version of creation predates the Christian one. The second point is that since the Lemurian and Christian versions are so similar, it is possible that the Christian one is a derivation or an adaptation of the Lemurian one. Which would then mean, if true, that those who compiled the Christian Bible must have known or had access to earlier accounts of creation, such as the Lemurian one or others that may have been derived from it.

Now, here is where it gets interesting. We are still discussing Narayana. The seventh command is where humans are created. The seventh command is interesting because it mentions Narayana. I shall quote it:

"And when all this was done, the seventh intellect said: "Let us make man after our own fashion, and let us endow him with powers to rule this earth". Then Narayana, the Seven-headed Intellect, the Creator of all things throughout the universe, created man, and placed within his body a living, imperishable spirit, and man became like Narayana in intellectual power. Then was creation complete." (Churchward, 1959, p. 18)

Let me explain why I claim that this in interesting. In the Christian Bible, we are not told who 'God' is. 'God' is this abstract entity, infinite, self-creating, and all-encompassing. That is not new. Many cultures also had an idea of 'Source' that fits these descriptions. The closest thing to an actual being, that the Christian God is described as, is 'Elohim'. The interesting difference is that the Lemurian version of 'God', according to Churchward, includes a seven-headed serpent!

In the Lemurian version, 'God' is associated with a serpent, albeit a seven-headed one. What is more? This 'God' made humans in its own likeness and image! Where have we heard that before? In the Christian Bible. So, let us remember that. In Lemuria, among the Nagas, the Godhead had a reptilian quality.

That is interesting! Where else do we find serpents in religion? In the Christian Bible, the serpent is... the devil! Oh!

How come? In the Christian Bible, it is the serpent that is blamed for misleading Adam and Eve by giving them knowledge of good and evil. The Christian Bible claims that Eve is deceived to eat the fruit of knowledge, after which she also entices Adam to do the same. Once this occurs, both Adam and Eve realize that they are 'naked' (i.e., they have lost their innocence), and from then on, both Adam and Eve can no longer stay in the 'garden of Eden'.

Folks, I would like to indicate here that I have long thought that the 'serpent' in the Christian Bible was a reference to the nagas/naacals... and to their benefactors, the serpent cult. This is a brotherhood (or, in fact, it would be very correct to say, it is also a sisterhood), that has had a history of being on this planet since ancient times. I am talking about Reptilians that have been here for tens, even hundreds of thousands of years.

I think that the people of Lemuria/Mu must have been in league with a faction of reptilian people, snake brotherhood/sisterhood people, that taught them esoteric lore. This, to me, is not so farfetched, because we have learned that there have been snake brotherhoods and sisterhoods on this planet for tens or even hundreds of thousands of years. From the works of Anton Parks, we can learn about the 'Amasutum' priestesses (Parks, 2007; Parks, 2010). They are a sisterhood of female reptilian adepts, who are both scientists and spiritual adherents. Apparently, there is a faction of this sisterhood that were 'seeded' on Earth a very long time ago that are known as the Ama'argi. That is, they were born here, so they consider Earth to be their home. They are said to live in the Inner Earth region. Again, there are regions inside the Earth, within the crust, and in "different reality" zones that can be accessed via dimensional portals. In these zones, there are entire civilizations, some of which have been around for a very long time (i.e., millions of years) and are unknown to most surface dwellers. Indigenous people, through their secret societies have been going to and coming from these places for thousands of

years. Also, indications are that Earth's secret societies and powerful military and industrial interests also know of these 'underground people' and certain factions on Earth are in contact with certain groups 'below'.

But I digress. Let us return to this sisterhood, the Amasutum, the female reptilian adepts, who, indications are that they are actually 'on the side' of the genetically engineered humans on the surface (see Appendix 2), that is, us.

For those who know about the reptilians in general, the first thought that many have is that reptilians are bad or evil. Well, a case can be made for there being some truth to that notion. In this galaxy, it seems that reptilian types, in general, but not in every case, tend to orient toward the 'negative polarity'. Basically, that means that these negative polarity reptilians tend to promote empire building through invasion, control, domination, deception, treachery, outright aggression, sometimes of the extreme kind. Imagine entire civilizations and worlds (not talking a single solar system or a small collection, but hundreds, maybe even thousands) of beings whose primary purpose is to conquer and subjugate others. Then we're talking of some reptilian collectives found in the Draco and Orion constellations in particular. But, in all of this, there appears to be a minority of reptilians that in general seem to orient toward the positive polarity. It would appear that some members of the Amasutum, at least those on Earth, Ursa Major, Altair and other places and their amphibian allies from Sirius and other places fall in this second category.

Similarly, although the majority tend to be, not all human ET groups tend to orient toward the positive polarity. There are examples of human ET groups that are said to be in league with the negative polarity reptilians and their allies. One group is said to be a civilization in the Pleiades star cluster, around the star Alcyone. Now, there are other human civilizations in the Pleiades, and it would appear that a great majority of these orient toward the positive polarity. Again,

there are exceptions, such as the Alcyone group. Another human group that is also said to be in league with the negative polarity groups are some around the Altair system, that are said to be allies of negative polarity reptilians in the Altair system and in other places.

Anyway, the purpose of this section is to discuss Narayana and seven-headed serpents, and their relations to Earth humans, especially the group known as the nagas. Not to get too side tracked with ETs and galactic history. To learn more about the story of the Earth human, how we got to be created to be here, and such, I would refer the interested reader to Appendices 1 & 2 of this book, to chapter 7 of my book *The Akan, Other Africans and the Sirius Star System*, as well as chapters 4 and 5 of my book *The Guardians, Earth Humans, and Ascension*.

In a nutshell, a highly advanced version of humanity was seeded on Ancient Earth by a group of beings that are collectively known as "the guardians" or "the watchers". These latter beings look over "Creation" on behalf of "Source" or "The Creator". The amphibian beings, the Nommo, that the Dogon people of Mali famously met, are members of this group and others have been calling "the guardians". According to Temple (1998), "The Nommo is 'the monitor for the universe, the "father" of mankind, guardian of its spiritual principles, dispenser of rain and master of the water generally.'" (p. 449). More on guardians in this and in my other books. These advanced Ancient Earth humans, the versions seeded on Earth, had incredible light bodies/mer-ka-ba bodies that allowed them to seamlessly transition between their physical body selves and their light body selves in order for them to function in physical worlds or in high spiritual worlds. They were androgynous and had a DNA template that had 12 active strands, rather than the 2 strands that contemporary Earth humans have active. About a million years ago (the Ancient Earth humans had been here for some millions of years before that), reptilian extraterrestrials from Orion came to this solar system and

genetically tampered with the DNA template of the Ancient Earth human. After this initial manipulation, some Sirian-Reptilians (often referred to as 'the Annunaki') and their allies also came into this solar system (around 300,000 years ago) due to warring factions. They later started more genetic manipulations of primates in this solar system (around 250,000 years ago). This began a long series of genetic tinkering of primates that also brought in human groups from different star systems (there ended up being a total of 22 different groups, according to Corey Goode and his sources, the Sphere Being Alliance and Earth's Secret Space Program). The result of all these genetic manipulations is the contemporary Earth human, with 2 active DNA strands. Contemporary Earth humans have the potential to develop spiritually in order to activate their light bodies. Spiritual technologies such as internal alchemy methodologies as well as the "highest yoga" tantras (the subject of chapter 3 of this book) can help reactivate the human light body/mer-ka-ba body that we inherited from the advanced Ancient Earth human. This can enable the contemporary Earth human to also escape the cycle of birth and death in order to achieve ascension – a process where the human being becomes 'complete' and no longer 'dies' to incarnate again in another Earth human physical body. The human can choose to live in the physical or in the spirit worlds, or both, without worrying about getting old and dying in the ways that have become 'normal' for contemporary human life on Earth. So, this is the summary.

This is the main reason why, as a black or non-black person, you may choose to study one of the "highest yoga" tantras within Buddhist Vajrayana systems. Of these, I can recommend the Kalachakra tantra (especially the Jonang tradition, which can be accessed through the Rimé School), one tradition that I have personally studied and practiced. Among Daoist traditions, I can also recommend the Quanzhen or "Complete Reality" school, which I have also personally studied and practiced. There are of course other Buddhist and Daoist systems, as well as other spiritual

systems outside of Buddhism and Daoism that can lead to completion.

In any case, let us return to the Amasutum, because I think it is very important to understand their link to this story about the nagas, to the snake brotherhoods and sisterhoods, and also to a discussion of the spiritual practice of tantra. From Anton Parks' works, we learn that these female reptilian priestesses have advanced spiritual knowledge. It is the female priestesses that initiate Enki/Ptah, the well-known Sirian-Reptilian character that is said to have worked on the genetic engineering of the human races, among other things. From Anton Parks' book *Adam Genesis*, we learn of a spiritual initiation that Enki went through, which, for all intents and purposes was a tantric sex rite. From *Adam Genesis*, we can learn about the nature of this tantric sex rite from this small, translated excerpt on Enki, in Africa, about to get initiated into sexual tantra by a reptilian priestess:

"Your initiation is very special because it is complete. Mamitu is a Kadistu [a Guardian], but not a proven sexual technician. She does not have the practice that you will integrate today, the one of the Dark ones of Nalulkara...Nevertheless this act, thanks to the intensity of the pleasure it provides, deploys the Sagra (Chakras) and elevates practitioners beyond the conditions of individual existence." (Parks, 2007, p.264)

In this practice, Enki/Ptah was about to engage in the highest order of tantra, which, were he to be successful (he was), would transform both himself and his female partner (and teacher) to the highest spiritual heights, becoming one with the infinite. It is arguably in the same spirit of the same tantric sex rite that was taught in Ancient Kemet as recorded in *The Alchemy of Night Enchiridion,* that has been a major subject of Part I (chapter 3) of this book. That system was also taught to Paschal Beverly Randolph in Luxor, Kemet, by the daughter of the man who gave him the ancient manuscript he has now made available to the world. There are secret societies and schools in Africa where a male initiate engages in a sex rite with his female teacher as part of the

initiation process. The late Zulu high shaman Credo Mutwa underwent such an experience with a female partner, a shaman and his teacher, during one of his initiations in what used to be Rhodesia, now Zimbabwe.

So, it should not come as a surprise that female reptilians teach male reptilians tantra, and then the female and male adepts of this snake brotherhood and sisterhood form a secret society that then goes on to teach human-reptilian hybrids as well as some humans who then teach other humans how to reach spiritual ecstasy through tantra. I think this is what happened in ancient times in Lemuria. I will go one step further to say that it is my strong opinion that this is in fact what happened. At the very least, the creation of the human version of tantra must have been influenced by knowledge from the adepts of the snake brotherhoods and sisterhoods. In the Christian Bible, the serpent or the snake that taught Adam and Eve the difference between 'evil' and 'good', these are the snake brotherhood and sisterhood people. These are the faction of female-aligned Sirian-Reptilian and amphibian people that were led by Enki/Ptah, and that supposedly were and are more on the side of humanity, against another faction of Sirian-Reptilian extraterrestrials known as 'The Annunaki'. The Annunaki are a male-oriented group that had colonies in many star systems including this one, and the Sirius star system. On Earth, they were led by Enlil and Anu, two deities in Sumerian and Mesopotamian lore. There is a lot of information out there on the Annunaki, some of which can be found in my first book. Some of it can be found as well as in Robert Morning Sky's work.

So, the Christian Bible calls the snake brotherhood or sisterhood people evil, because their intervention caused Adam and Eve to be thrown out of the garden of Eden. According to my older brother Robert Morning Sky, it is a matter of perspective. Since Enki/Ptah had played a key role in creating Earth humans of today, he supposedly wanted to help equip us with knowledge needed to break out of the

garden of Eden. Imagine the garden of Eden as some kind of slave plantation. The genetically engineered Earth humans were slaving away for the Annunaki and their allies in their 'garden' in Mesopotamia (i.e., on their plantation) with all the controls, rules and regimented behaviour one will expect on a plantation. So, in order to help the genetically engineered Earth humans 'break out of the planatation', Enki and his faction taught them some 'survival skills' – how to farm, how to make their own clothing, their own shelter, how to hunt game, how to cure themselves of illnesses using herbs, and how to make love to build families and a tribe. Basically, they were taught how to survive and rule themselves while living off the "Annunaki grid".

We find then that not only did the snake or serpent brotherhood and sisterhood teach people in Africa, but as Temple asserts, they were also the benefactors of people in China. In *The Sirius Mystery*, we are painted a picture of two Chinese deities, Fuxi and Niwa, who, in many respects double up as Asar and Aset in Kemet:

"If we examine the Chinese myths, we find that there were a number of amphibious beings, in addition to Fuxi, his wife, and the being from the Yellow River who revealed the hexagrams. There was the other mythical hero in China called Gong-Gong, just mentioned, (old spelling: Kung Kung) who was 'a horned monster with the body of a serpent', and who corresponds to the Ogo of the Dogon or the Set of the Egyptians. Gong-Gong was a rebel engaged in a cosmic struggle, who crashed against a mountain and was responsible for the Earth tilting on its axis: 'Heaven and Earth have since that time sloped toward one another in the northwest but have tilted away from one another in the opposite direction.'3° Two other amphibians at the beginning of Chinese history were the mythical Emperor Yü, first emperor of the first dynasty called Hsia (supposed to date to 2205 BC) and his father Gun (old spelling: Kun). The Chinese character for Gun contains the element (on the left side) meaning 'fish', and that of Yü contains an element commonly used with reptiles, so that both mythical heroes were 'of non-human origins'." (Temple, 1998, p. 438)

From the quote above, we can infer that amphibians and serpent beings were responsible for interacting with and teaching people in the early stages of human cultures, not only in Africa, among the Dogon, but also in China. In China, Fuxi (also spelled as Fu-Hsi) can be likened with the Kemetic Asar, whereas his wife, Niwa, would be the Chinese equivalent of the Kemetic Aset. Thus, the Han people also received teachings from the Sirian-Reptilians (the faction that rebelled against Enlil and Anu) and their Sirian guardian companions. Those initiates who received the teachings would have ultimately received them from members of the snake brotherhood and sisterhood. *This is also the reason why the Kemetic system of internal alchemy as detailed in chapter 3 is so similar to be almost identical to the Chinese Daoist system of internal alchemy. It was the <u>same team</u> that encouraged teachings of Earth humans in both locations.*

And, as you can imagine, this knowledge made the initiates become 'rejects', just like in the movie *The Matrix*. In that movie, once people took 'the red pill', their bodies let off some vibration that caused "the matrix" to reject them. So, this banishment is a part of the story that Genesis, the first book of the Christian Bible, failed to elaborate on. Genesis just said that the serpent (i.e., Enki, and his faction), who were referred to as "the devil", taught humans the difference between good and evil, and that caused these humans to be removed from the garden of Eden. Basically, that means they were taught to fend for themselves. At that point, these humans started to exercise their free will, which was to live autonomously and independently. And, the enslavers (Enlil and his faction of Annunaki legions, and their reptilian hierarchy) were bound by universal law to release the newly initiated 'rejects', especially those that were incarnated Higher Selves. This led to the creation of many 'indigenous cultures' that live off the land, go figure!

Of course, there is much of the story that is being left out. Robert Morning Sky tell the story better than most accounts

I have come across, in his book *La Transcript*. There, he goes as far as to call the 'rejects' renegades. He wrote that Enki's trained initiates, the humans that learned the difference between "good and evil", became known as "EA-SU". EA was one of Enki's titles. They were among the people of Enki who set up the Kingdom of Dia (i.e., TA. EA – EA's land; see Appendix 3). Robert writes, "Those teachers who learned, directly from Prince EA, the secret knowledge, the forbidden knowledge, the 'diabolical' knowledge...they were known as 'EA-SU'. And these 'secret teachers' went around to the multitudes, and they began to 'spread the word' on the mountain sides and in the caves. And the 'EA-SU', that title, is the root for the name 'IESU'!" (Morning Sky, 1996, pp.72–73).

For those who never knew, Morning Sky did admit that he is a renegade. In his own words, he said, "And do you know what being an EA-SU means? You have to love people...even when they sh* on you...and do what's right. That's what the eight of us were trying to do. That's why I began this tour, and I'm saddened that it will probably end, at least for a while." (Morning Sky, 1996, p. 85). The eight refers to eight individuals who were adopted by six grandfathers, Native American men, who had rescued a "star elder" (an ET) whose vessel crashed in the four corners region of the US. In exchange for the help these six men gave to the ET, he gave them information about the Earth, its history, about the ET struggles for dominion on Earth, and about being a star warrior.

Speaking of EA-SU, one article that I have read again and again on occasion over the last many years is titled *The Solar Brotherhood and the Seven rays* (see references). The seven rays are the subject of the teaching also of the Alice Bailey paradigm of the Tibetan esoteric knowledge shared by Djwhal Khul (DK), and deriving from the seven Kumaras, which, this article being connected to Lemuria, points to the notion that the Kumaras were active on the Lemurian continent. I bring this article up because in it, there is a

reference to the EA-SU. They are not called "EA-SU" in this article. Rather, the description of the initiates in this article in my view fits that of the EA-SU.

Why do I say that? The Solar Brotherhood article mentions explicitly that the initiates of the brotherhood are children of both Earth humans and of the Annunaki. This would mean that the solar brotherhood are beneficiaries of the 'snake brotherhood and sisterhood', *meaning that the seven Kumaras are the 'seven serpents' of the seven-headed snake cult associated with Lemuria. These are the 'serpents of wisdom'.* The article traces one movement of initiates of this brotherhood from Lemuria to South America. It also references the nagas as "serpentine kings". Together with the assertion that the initiates of the brotherhood were hybrids between the Annunaki and the "Elder race" (that is, the humans of ancient times, who could live to almost 1000 years), and whom we find descendants of, all over the world (e.g., Uighur, India, Yucatan, Peru, Nubia & Egypt, and Mesopotamia), we can surmise that the nagas of Lemuria are those hybrids of the Annunaki and the Elder race. There could be other nagas, perhaps those in Africa, that are hybrids of Africans and also of Enki and his band of reptilians who initiated humanity in 'forbidden knowledge'. So, there could be more than one 'naga' race, based on time period of creation, and heritage.

In fact, in addition to Morning Sky's account of Enki's group teaching the EA-SU (i.e., the snake brotherhood and sisterhood disciples), we also have at least one other account, this time from Parks in his book *Le Reveil de Phenix* (from chapter 9, titled Semhaza), of an interaction between members of Enki's group/faction (i.e., Aset/Isis, Djehuti/Thoth, and a contingent of Ama'argi (female reptilian priestesses and scientists) and male Nungal or watcher soldiers, and his seven Abgal Sirian amphibian companions, who were not reported as taking part in this specific engagement). The scene appears to be taking place during an evacuation of indigenous people out of Lemuria as

the continent sinks. The memory of this event was recorded in a crystal, which Heru (Horus) accesses holographically, and which he shares in the retelling below:

The scene takes place in an unknown environment. The humans are of the Sinumun type (Native American), I suppose it is the ancient continent of Kaskara (Mu), that which will be confirmed later. It is a major evacuation. Nungal ships land on a huge square of an imposing city. A pyramidal-shaped Ama'argi mothership is found in the very center of the city. White and red stone buildings appear through a threatening smoke rising towards the sky.

Well first of all, this brings to mind those pyramidal-shaped craft shown in the Stargate movie and the Stargate-SG1 scifi series that followed. When I first saw this show, I wondered whether there were pyramidal-shaped craft out there, and then years later, I saw news coverage of a mile-wide pyramidal-shaped UFO over Moscow in Russia, that was observed by many eyewitnesses on site. This was back in December 2009. A ship that big would likely be a mothership. The event was covered widely, even in centrist and conservative mainstream newspapers such as the British Telegraph (not to mention CNN). Let us continue:

Thousands of people board the vessels in a noise of sirens. The confusion is total. The person filming is visibly located on the terrace of a high house. She zooms in towards the central plaza. Humans jostle each other, some fall and are trampled. In the crowd, an elderly man ceaselessly gesticulates in an attempt to reason with those around him. Setting in focus centers on the stage and on the face of the individual, one can read on his lips in Emenita language: "Do not go there, they are the spirits of evil, the sons of the Serpent. Don't follow them, they drag you to an even more frightening death than that which awaits us here."

This part is interesting. Clearly, there is commotion that is resulting from the upheaval. What caught my attention when I first read this, however, is the language the elderly man was speaking in. Emenita refers to the Sumerian language. It is a term used in Parks' books to refer to Sumerian. That came across as surprising because Sumerian is often associated

with Mesopotamia. It is however not surprising if we take into account that the Solar Brotherhood article mentions that the Annunaki were in Lemuria. The Annunaki speak a language that is akin to Sumerian. It would also explain why Robert Morning Sky wrote about connections between Hopi and Sumerian culture. Several Native American groups that are now found in North and South America have ancestors who were once in the Pacific, in Lemuria/Mu. In an article titled *Atlantis against Mu* (see references) we learn of an incredible history, preserved by the Hopi people, of their migration from Lemuria or Mu to South America, and the trek that their ancestors made from South America to their present home in the north. The ancestors of the Hopi were among those that were in Lemuria, before it went down. Morning Sky adds further details about the involvement of Enki and his faction. In *La Transcript*, he points out during a Q & A session that EA's (i.e., Enki's) colony in the Pacific, Lemuria/Mu, was actually the first of four colonies he set up on Earth. Here is the account:

"Q: We're talking about the beginning of Atlantis, what about Mu?
A: What about Mu? What about it?
Q: Lemuria, Mu is supposedly a civilization before Atlantis.
A: Right. And what's the question?
Q: Where is it, what happened to it and what's the history of it and how it evolved?
A: Well, it is another seminar altogether, but let us explain it in this way. When Prince EA came down and he established his colony... all of our records point to Mesopotamia as the initial colony. That's not correct. It was the fourth colony in Sumeria, in Eridu. There...there were three that preceded it...excuse me...two, that preceded it and one that followed it. Sumeria was actually the third one.
[Pauses]
The other two colonies, the first one, was way over on the other side in a place we now call the Pacific, that was his first colony. The second colony was in a place that we call the Gulf of Mexico near the tip of what is known as the Yucatan. The third colony was Sumeria, and the fourth one was the Atlantis that Plato wrote about and that one was somewhere else." (Morning Sky, 1996, p. 152)

This information provided by Morning Sky supports the ideas in this section, that first of all, Enki and his snake brotherhood and sisterhood were firmly established in Lemuria/Mu, where they must have taught the people there a lot of esoteric information, including alchemy and tantra. They were the benefactors of the real nagas, those human-reptilian hybrids, as well as the humans who took up the name naga, because of their connections as descendants of, or beneficiaries of those 50-50 human/reptilian naga people. His information also supports the idea that some of the people migrated from Mu, under the names of nagas or mayas, and that the ocean exploring people led by snake kings and queens settled in several places that include the Yucatan (this has been recently confirmed by archaeology, see Yucatan section of chapter 4) and Kemet as well as the land and ocean exploring people that ended up in various parts of Asia such as Cambodia, Thailand, India and further afield, even to Mesopotamia and to Kemet/Nubia, Abyssinia (as we shall see later in this chapter) and also in Wagadu/ancient Ghana of West Africa. It also underscores the point that there must have been different human races in Lemuria/Mu, as evidenced by Mu's various daughter colonies in Yu (Asia), Yucatan, India and Africa. The case of "serpentine kings and queens" has been recently confirmed archaeologically in Guatemala where an incredible discovery was made in 2012 of an ancient Mayan snake queen. More on that later. For now, let us continue by returning to the recording of the calamity of the demise of Mu, from Parks' book *Le Reveil de Phenix*:

I hear the voice of Meri as if she were at my side, it is this that confirms to me that she was the person who recorded this event
- What horror! Can't we do anything?
- Nothing, unfortunately, answers a second voice muffled by noise. The focal length widens, showing humans fight each other despite the Nungal column dispatched to bring the situation under control. A richly dressed man painfully emerges from the crowd
and stares at the lens. The one who films is now pointing her apparatus to the entrance to the terrace by rotating it by 45°.

Djehuti (Thoth) appears in the image, surrounded by guards. A voice rises in the distance. Djehuti fixes the apparatus which records the scene, which happens to be [with] my mother, and then makes a swipe at her:
-Don't worry, Venerable Aset, we'll get it under control...
-I'm not worried, Meri answers.

So here, we find an interaction between two important personalities of Enki's group. Aset is Isis, the 'mother goddess' and cosort of Asar, himself representing Ptah or Enki. Aset is basically Enki's partner. Djehuti, who has been known by many as Thoth, can be thought of as Enki's prime minister. Or perhaps, if Enki is thought of as the chairman of the board, then Djehuti is the CEO. He was the leader of the 'watchers', the Igigi/Nungal, those Sirian-Reptilians that were sort of on the side of humanity and who followed the lead of Enki. The third individual, the richly dressed one, is a human, the ruler of Lemuria, who is about to be the subject of the next section:

- Your soldiers would have done better to kill me than to put me in your presence.
-We never take a life without a reason. You're wrong throughout your clan. What is your name?
- Osaya, I am the 469th ruler of this Empire.
- 469th? How time passes quickly on this world ...
Djehuti ironically smiles. Osaya laughs.
- The planet is about to burst into flames. We are all about to
pass away. What use will your immortality be to you, Son of the Serpent?
-Son of the Serpent? So you know our name? resumed Djehuti.
-Who doesn't recognize your faces and your actions? You have no right to be here; you are not welcome and you are not the Kasin'a (messengers) [i.e., the Katsina of the Native American people] that we are waiting for.
- Yes, we are not the ones you are used to meeting.
However, the individuals you are referring to will not come. War has claimed the sky up to the borders of Udu'idimsa (Mars). Their safety is no longer guaranteed, that is why we have come to help you in their place.

This fascinating exchange between Djehuti/Thoth, and Osaya, 469th ruler of Lemuria, is enlightening for a number of reasons. First of all, it shows that the rulers of Lemuria knew about different non-terrestrial entities. They know who the Sons of the Serpent (i.e., Reptilians) are. They also know who the Kasin'a are. Of the latter, we can think of the Katsina that the Hopi and other Pueblo Indian peoples believe in and make dolls of. In my view, the Katsina represent the Guardian races – those Avian but also Amphibian, Feline, Angelic Human and other species who work for the benefit of all races on behalf of Source. The Katsina are said to be located in the Pleiades (those will be the guardian races around the Alcyone star system) but I have learned that there are others especially around the Procyon star system that have played an important role with Native Americans, especially those in South and Central America, as well as some in the North. From their knowledge of the Katsina, it is clear that the people of Lemuria/Mu learned not only from the Sirian-Reptilians of Enki's faction but also from the Guardians. In his book *Indaba, My Children*, at the very beginning, in the story regarding Lemuria, Credo Mutwa calls these Katsina, the bird-race Guardian people, the 'Kaa-U-Laa birds'. Amazingly, a very ancient book (I am convinced that the contents of this book originally date back to Lemurian times), perhaps one of the oldest puranas, the *Markandeya Purana*, which was mentioned in Part I (section 2.2) of this book in regard to nagas, also has accounts of conversations with the "wise birds" (i.e., Avian race of guardians who literally spoke to mankind in those ancient times). The other significant point revealed in that exchange is the ongoing war which was the cause of the evacuation. This was a war between Atlantis and Mu, and by the account of the exchange, the war had extended beyond Earth to reach as far out as the planet Mars.

We shall wrap up this section on the snake brotherhood and sisterhood benefactors of mankind with a recap. To be complete, as well as more specific, esoteric spiritual technologies did not reach contemporary Earth humans only

through the benevolent reptilians and their amphibian and other allies. In addition to ourselves, there are many human ET groups that have also influenced spirituality on Earth. Above all, those that I refer to as "the guardians" gave Earth humans some of the most advanced spiritual ascension teachings. So, it is good just to be clear on that. It is not only about a group of reptilians. To sum up the various points encountered in this long and fairly complicated section, let us put together a summary:

SECTION SUMMARY

(1) The creation story of Mu matches the version in Genesis, the first chapter of Christian Bible in a number of respects. One of those respects is that creation took seven stages in each account. Also, mankind was created close to the end of the creation period. A key difference is that in the Lemurian version, the supreme being is associated with a reptilian form, while in the Christian version, the ultimate evil, "the devil", is associated with a reptilian form.

(2) I have argued in this section that the reptilian form that is seen both as "the creator" in the Lemurian version of the creation story, and "the devil" in the Christian version refer to one and the same entity or group.

(3) This group is what I have called in this book the "serpent cult" or the "snake brotherhood and sisterhood". The serpent cult consists of Enki/Ptah, his partner, his son, his visor Djehuti, his soldiers the Nungal watchers, and the Ama'argi, Earth's female reptilian priestesses and scientists, and the seven Abgal/amphibian companions of Enki. This serpent cult has taught people on Earth since ancient times, including nagas and Earth humans (i.e., those EA-Su, the 'renegades' of Enki/Ptah, or those that were rejected from the garden of Eden'. This group that seems to have had the best interests of Earth humans at heart, I argue, are ultimately led by a faction of reptilian beings whose leader was known as EA/Enki, a being who had the support of a group of positive polarity reptilians and amphibians. These beings, collectively, were ultimately of extraterrestrial origins. Enki's

faction were/are in opposition with the group of Annunaki of the Mesopotamian region that sought to enslave humans (led by Enlil, ultimately representing Anu) by keeping humans on the 'Annunaki plantation'.

(4) Internal alchemy and tantra as practices that have an origin as far back as with the serpent cult, which on the one hand comprises Enki and his faction, and on the other hand also appears to include a group of ancient 'serpents of wisdom' (they were here before the Sirian-Reptilian Annunaki arrived) known as the Kumaras.

(5) Asar-Aset in Kemet and Fuxi-Niwa in China as the same beings whose team taught the same things to humans in the two locations. This is why Kemetic and Daoist internal alchemy practices are similar to the point of being called the same.

(6) The seven Kumaras are the seven 'serpents of wisdom' who were active among the nagas in Lemuria, and who are represented as the 'seven serpent heads' of the seven-headed serpent cult.

(7) The nagas (also known as naacals, or naguals), were/are originally a hybrid race, a crossbreed between humans and the reptilians, although certain human groups also carry that name to represent themselves and their group. They are students and followers of this snake brotherhood and sisterhood. It is an ancient brotherhood that existed in Lemuria and which has now spread across the world to various locales where these nagas (and their various name variations) went to. In Lemuria, both the seven-headed serpent cult (the ancient Kumaras) and the serpent faction led by Enki and his group were active. It should therefore come as no surprise if both orders of the serpent cult have also been active on the African continent. The nagas have been an important subgroup within the hierarchy of the serpent cult, as they have served as intermediaries between the serpents and humans.

4.6 The seven-headed serpent in India

As is well-known, the nagas have had an influence in India. Much of that influence has already been touched upon in chapter 2 in regard to aspects of Yoga and Buddhism. Quoting the ancient Hindu historian Valmiki, Churchward (1931) states that "The Mayas came from the Motherland, one moon's journey towards the rising sun. They first came to Burma where they became known as Nagas." (p. 172). Having discussed Cambodia in section 4.5, we can imagine that in order to get to India, the nagas were in Thailand, which borders Cambodia, and also in Burma, which borders both Thailand and India. We find this to in fact be the case.

In Thailand today, there is a strong association with nagas as well, just as one might expect. One good example of naga representation in Thailand is at the royal crematorium at Sanam Luang, in Bangkok. At Sanam Luang, there are representations of several-headed nagas amidst Buddhist statues. The association between the nagas and royalty appears strong in this part of Asia as is the connection between nagas and Buddhism, which was intimated earlier in this book. The reader can find more on nagas in Cambodia and Thailand in the article titled *Thai and Khmer Nagas: A journey through the semiotics of the snake divinity* (see references).

Back to speaking about India, again from Churchward, we learn that Lemurians came to India in at least two directions, and readers may find this interesting, because a similar thing happened in Nubia and Egypt. In India, one faction of the people of Mu came as nagas through Burma into what is Central and Northern India. Another band of naga people had also come by sea. An ancient monastery in Tibet has records that show that the nagas that came to India were black.

Melchizedek (1999) asserts that humans spent 65,000 to 70,000 years in Lemuria, and that tantra was founded by black Lemurians. More on that later. As an aside, back in 2013, I interacted with Dogon initiates, who intimated to me that their secret school goes back at least 70,000 years. So, I suppose that connects back as far as Lemurian times. In

regard to the Dogon, and of the African continent, Churchward also claims that the people of Mu arrived in Africa in two different directions. One was during the excursions and expeditions of the mayas, who went out from Mu to colonize different lands on Earth. Those settled in the Nile Delta region, in a place now known as Sais. The second wave were nagas that came to Nubia. This is some of what Churchward says about Nagas migrating from India to Africa, to the region where the people known as Cushites/Kushites formed their civilization:

"After the Babylonian Colony was formed, how long afterwards is not known, the Nagas from India took another step to the West. From India they went to northeast Africa. They made settlements in the Gulf of Aden and at different points on the West Coast of the Red Sea. Both Indian and Egyptian records speak of their settlement at Maioo in Nubia, Upper Egypt. Maioo was on the Red Sea near where the modern town of Suakin is situated. This colonization took place somewhere in the neighborhood of 15,000 years ago. At that time the country was flat, for up to this time the African mountains had not been raised." (Churchward, 1931, pp 150 – 151).

As to whether Churchward was correct or not about nagas making their way to Africa from India, it would be found at the end of this chapter that there was a naga city in Nubia and that nagas were in fact in the region, in Abyssinia, in Kemet and in Kush/Nubia.

4.7 The seven-headed serpent in the Yucatan

While some of the emigrants of Mu headed generally in the Western direction from Mu, there were others who headed east, according to Churchward (1931). Among those that did were mayas who ended up in the Yucatan area. It would appear that these mayas of the Yucatan also had a seven-headed serpent deity. This deity was known as Ah Ac Chapat. Churchward (1933) mentions this deity, and so does Augustus Le Plongeon. This latter author was a British

archeologist who was a major proponent of studying Mayan ruins in the Yucatan. A precursor to Churchward, Le Plongeon's studies on the mayas in the Americas later provided much context later on for Churchward's own work on mayas and nagas. From some of his written work, we learn about seven-headed serpent beings. From his work *Sacred Mysteries among the Mayas and the Quiches*, he has this to say, in conducting comparisons between seven-headed beings in different cultures similar to what I am attempting to do in this book:

"Do we not see a simile of the Ah Ac Chapat or seven headed serpent of the Mayas, totem of their seven primitive Rulers, that is of the seven members of king Can's family, in the seven-headed heavenly Serpent on which rests Vishnu, the Indian creator, that corresponds to the Egyptian Kneph or the Mehen (Canhel) of the Mayas; or in the seven serpents that form the crown of Siva; or again in the Seven rayed god Heptaktis [Hephaestus], of which the emperor Julian was so reluctant to speak?" (Le Plongeon, 1888, p. 145)

Thus, from Le Plongeon, we find that the seven-headed being also featured among the mayas who migrated to the Yucatan from Mu. Churchward in his own works shows just how close Mayan culture, especially its alphabets, its writings, are to those of Mu.

The idea of snake kings of the Yucatan was proven by a recent discovery in 2012 of an excavated Guatemalan site at El Perú (known in ancient times as *Waka'*). The excavation unearthed the tomb of Mayan snake queen k'abel, described as a "Maya Holy Snake Lord". In an article by ancientpages.com (see references), we learn of the 'kaanul' rulers, known also as the 'Maya Snake Kings'. Now, one may realize that the words 'kaanul' and 'kha-na' are one and the same title for serpent kings. In other words, the maya snake king title of the Yucatan people was the same as the naga snake king title of the Waga people of ancient Ghana, who were discussed in section 4.2. This could be so only because

the maya and the naga people have the same source, which is Lemuria.

Let us now continue to examine the seven-headed snake in one more ancient place: Canaan.

4.8 The seven-headed snake in Canaan and Mesopotamia

The place that was known as Canaan is what is today the Levant. That is, Israel, Palestine, Syria, Lebanon, Jordan and parts of Turkey. Mesopotamia in ancient times included the cultures of the Sumerians and the Akkadians.

In ancient times, there were legends of a seven-headed snake in these three regions of the world as well. In Canaan/Kanaan, the seven-headed being was known as Lotan (Van der Toorn et. al., 1999), and are also told that "Lotan = Leviathan" (p. 168). We also find that Leviathan features many times in the Christian Bible (for instance in the Book of Job chapter 41, in the Book of Isaiah chapter 27, and Psalm 74, which indicates that Leviathan has several heads). It would appear that the Biblical Leviathan is based on the more ancient Canaanite Lotan, and it is from studying Canaanite and other ancient lore from the Mesopotamian region that we can get some deep insights associations between the seven-headed serpent, that is, the nagas, and the "gods of old". This is because Canaan and Mesopotamia, that region, was inhabited by these "gods", whom, I have argued in my published works were in fact extraterrestrial entities who overtly lived with and interacted with surface Earth humans for millennia before becoming more covert. These are the non-terrestrial people, some of whom have been called Annunaki, who were particularly active in the Mesopotamian region. Let us first examine the quote below, and then comment on it:

"...the Canaanite storm god → Baal, son and agent of the highest god → EI, facing opposition in the council of the gods, is forced to battle Yam (the Sea). He defeats Yam (and also Lotan [→ Leviathan], the dragon in the sea), and obtains a palace from which he thunders forth against his enemies in the council and on Earth. " (Van der Toorn et. al., 1999, p. 245)

In my first book *The Akan, Other Africans and the Sirius Star System*, I show that Yam or Yamm, refers to the same entity known elsewhere as EA, and Enki, who is spoken of extensively in section 4.6 above. This EA or Enki, was an extraterrestrial being with connections to the Sirius Star system. It is very interesting (to me, at least) that Yam/EA/Enki will be associated with Lotan/Leviathan, the seven-headed sea dragon/serpent. First of all, EA/Enki is the "god" of the rivers and seas, and has been even compared with Poseidon, the Atlantean/Greek "god" of the sea. *The Tano deities that have guided the Akan and other black people in Kemet and Kush in the temples of Amun (as well as in the Greek oracles of Delphi, Dodona, Didyma and elsewhere that Ammonite/Tano priestesses went to) since ancient times have been associated with rivers. This will be argued conclusively in section 5.1 of this book.*

I also mentioned in *The Guardians, Earth Humans, and Ascension*, that EA/Enki has since ancient times been accompanied by...would you guess... seven sages! These are seven amphibian beings, referred to in Mesopotamian times as the "abgal" or the "apkallu". The wise ones of the ages, who taught mankind civilization since the most ancient times. These seven amphibian beings, their entire race, in fact, are known as "guardians", or "monitors", or "watchers". The role of guardian beings is to 'watch over creation' on behalf of "Source" (i.e., Creator forces), by supporting the development and advancement of all life and all beings. All indications are that these same beings are still teaching mankind, as is evidenced by them meeting the Dogon people of West Africa, who call them 'Nommos', a word that connects with water.

It is interesting then that Enki too should be associated with the seven-headed serpent, a symbol that appears to be of central importance in the serpent cult. Enki himself is said to be part amphibian and part reptilian. I suspect that the "abgal" and the amasutum and others like the Igigi/Nungal taught Earth humans in Lemuria how to do tantra. I have this opinion because the amphibian beings are said to have done this before, in the far remote past. There is a fascinating story in *Le Livre de Nuréa*, or *The Book of Nuréa* (Parks, 2018), Anton Parks explains how and why the amphibian beings (Abgal) taught a group of reptilian beings he calls Usumgal ("great dragons", a branch of the reptilian family including An/Anu and his predecessors that constitute the hierarchy of reptilians leading the Annunaki legions) how to access universal energy and use it, in some of the ways it is done in tantra. Of course, there is also the example I already gave from Adam Genesis (Parks, 2010) where Enki gets initiated into tantra (this one was of the physical, sexual intercourse kind) by...would you guess... an Amasutum... a female reptilian priestess. The Amasutum have had the ability to use universal energy for millions of years, and as I mentioned earlier, they also have advanced scientific and spiritual knowledge.

Anyway, from the quote above, Yam/Yamm refers to Enki, Baal refers to Enki's nemesis Enlil, and El refers to Anu the leader of the Sirian-Reptilian group in this solar system that have been called the Annunaki. There is much on this group, who in conventional sources are called the Annuna. The interested reader can spend hours reading about these beings from conventional sources such as the *Electronic Text Corpus of Sumerian Literature* (ETCSL), whose link can be found in the references section. Just bear in mind that in place of 'gods', think flesh and blood beings from other star systems that came to this solar system.

In another quote, we learn that Lotan/Leviathan actually had seven heads:

"As in Job 40-41 where the ox-like Behemoth is paired with the sea-dragon Leviathan, so at Ugarit El's calf Atik/Arshu is paired with seven-headed sea-dragon, both of whom → Anat claims to have defeated: "Surely I lifted up the dragon, I... (and) smote the crooked serpent, the tyrant with the seven heads... " (Van der Toorn et. al., 1999, p. 168).

For the quote above, we do get a reference to seven heads. Also interesting is mention of the personality called Anat. Now, Anat is a 'goddess' who goes under different names in different cultures. She has been known for instance as Inanna by the Sumerians, Ishtar by the Akkadians, Babylonians and Assyrians, Ashtarte by the Phoenicians and Aphrodite by the Greeks. This goddess was a warrior supreme, a granddaughter of Enlil. As Inanna, she was always doing controversial things – flirting with gods (Annuna/Annunaki) and men, causing wars because of her flirtations. She was said to be both incredibly beautiful and a deadly warrior. In any case, this warrior woman was one of the reputable Sirian-Reptilian personalities of old.

As a final point in this section, there are four groups of African peoples I would like to speak of in this section, that have strong connections with the Annunaki of ancient Mesopotamian times. The first group are the Tutsi (also known as the WaTutsi). These have been called 'children of the reptile' by the late Zulu high shaman Credo Mutwa and by others. They are 'nagas', direct descendants of the Mesopotamian Annunaki. The second group are the Yoruba people of Nigeria. They are among the 'children of Inanna' (among whom are the Ashkenazi Jews). To a much lesser extent, the Yoruba and related groups are also descendants of the original Mesopotamian Annunaki, and also of the indigenous black people of Africa. The third group I would like to mention are the Maasai. Similar to the Tutsi, but to a much lesser extent, they are also 'nagas'. It is noteworthy that the creator god of the Maasai, in their own language, is known as En-kai/Engai. The reader can connect the dots. The fourth and final group, I am not allowed to talk about

beyond a certain point. Suffice it to say, however, they are a secret black group that have been associated with the African continent for a very long time, and they 'come and go'. Their language is Sumerian.

Now, let us transition to Europe, to speak of appearances of the many-headed serpent in legend and lore.

4.9 The six-headed serpent in Greece and Rome

Europe in ancient times included the Romans, the Greeks, the Celts, the Germanic and Slavic groups, and others. In Greek lore, Heracles (known among the Romans and in modern times as Hercules) is said to have battled the Lernaean Hydra, a serpentine creature which, in the most ancient rendition of the lore as told by Hesiod, circa 700BC, the Hydra is said to have six heads (Ogden, 2013). Also in Greek lore, there is Scylla, a sea dragon or a serpentine being with six heads spoken of in the Odyssey. Among other actions, Scylla captures and devours sailors as they pass through a strait. Ogden (2013) states:

"Scylla is closer to a drakön than to a kêtos. Let us note first that, although overlooking and fishing in the sea, Homer's Scylla is emphatically land-based, dwelling in a cave on a high crag: in this regard she strongly resembles the great drakontes Ladon, Python, Typhon, the Serpent of Ares, and Lamia-Sybaris (Ch. 4). His physical description of her focuses upon the inordinately long necks behind each of her six heads." (p. 132)

So, in the case of Europe, it was not exactly a "seven-headed" snake. It would appear that Hydra and Scylla have six rather than seven heads, differing from what we have generally encountered with nagas thus far. It is worthy of note, however that in the ancient world, even numbers were used to represent female manifestations while odd numbers were used for male manifestations. It is possible that both Hydra and Scylla were given six rather than seven heads because they dealt with female beings. In Asia, nagas were

sometimes represented with different number of heads, as can be found in Sanam Luang in Bangkok, a site we discussed earlier in section 4.7. It is also noteworthy that both Hydra and Scylla are associated with water bodies, Hydra with the Lernaean lake and swamp, and Scylla with a narrow strait. Thus, we have a connection back to Yam/EA/Enki/Poseidon, "god" of water bodies. A final point about Hydra. It is likely that the word 'hydro', that is associated with water, comes from association with this being.

Thus far in this book, we have traced the appearance of the seven-headed (or sometimes just multi-headed) serpent in different cultures across the world, starting from what has been known as the Motherland, or Mu. The seven-headed serpent was the hallmark of the naga people, who found their way to different cultures, including some in West Africa. We shall now transition yet again, finally to cases of nagas and of the serpent cult elsewhere in Africa other than in West Africa.

4.10 Snake deities in Kemet and the Ethiopian Naga king Arwe/Wainaba

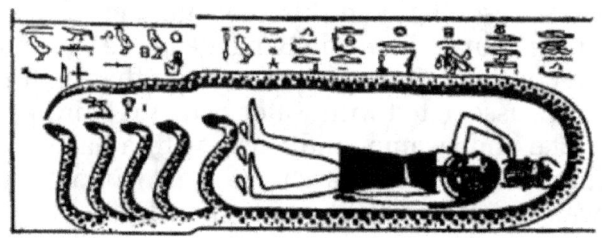

Above: The Serpent Power is the force which engenders Creation - The god Khepri causes the primordial serpent god *Asha Hrau* (many faced one-i.e. manifold heads) to churn the primeval ocean and thereby cause *Dech* or vibrations and these cause matter to take shape. (From Theban Tomb-Ancient Egypt)
(Source: Ashby, 2005)

In the image above, said to be from a Theban tomb, we are shown the classic multi-headed snake that is often associated with the Nagas. One would imagine that Kemet being a main center of culture, civilization and spirituality on the African continent, that if there were instances of nagas as multi-headed serpents (as seen in other parts of the world) that they would feature in Kemet as well. This happens to be the case. Not only were there indications of nagas in Kemet, but also that they were in association with Waset/Thebes, that ancient city of black civilization, culture, and spirituality that has come up earlier in this book in regard to discussing the ancient internal alchemy and tantra text of prince Yar Kheper'set, whom I posited was a prince of the Theban dynasties of the eleventh to thirteenth dynasties in Ancient Kemet. If true, it would mean then that the nagas, with their spiritual disciplines and knowledge, also interacted with the Ammonite priesthood of Kemet. It would follow naturally and quite easily then, that both nagas and Ammonite people (Soninke) would later co-exist in the territory of Wagadu that

would be known also as the Ghana empire. The next image details members of the serpent sect.
(Source: Budge, 1911)

When it comes to a depiction of Enki's group that I have been

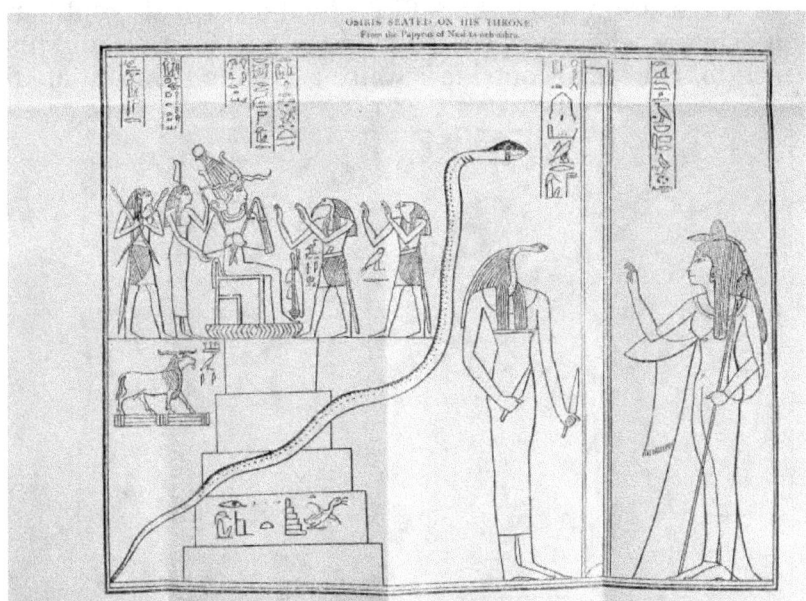

calling the 'snake brotherhood and sisterhood', there is scarcely a better depiction of it than what is shown immediately above. For the saying, "a picture is worth a thousand words", we can say for this depiction that "a picture is worth a million words". Here, we can think of the content of the image as we think of items on a Tarot card. Each item has a meaning, is symbolic and important. There is nothing on this image that is there for no reason. This is the assembly of the serpent sect. It has Asar/Osiris representing Enki/Ptah. In front of him are Djehuti/Thoth, and Heru/Horus. Behind him, are Ma'at, and Pehti. Djehuti and Pehti represent the Nungal and the Shemsu-Hor, followers of Heru/Horus. Curiously, Pehti holds two serpents in his hand, which represent the two forces of Mut and Min (Amun). The ram beheath them is a representation of the sect

of Amun, which shows unity of Asarian and Ammonite sects. Curiously, and most importantly, an actual serpent is clearly and visibly shown in the image. In front of the actual serpent, is a female serpent in front of a door, with two knives in her hands. The female serpent by the door is representative of the 'Amasutum' (Ama-SSS-TTT), or those female reptilian priestesses who have been a major support for Enki and his faction. The female outside is waiting to enter to be initiated.

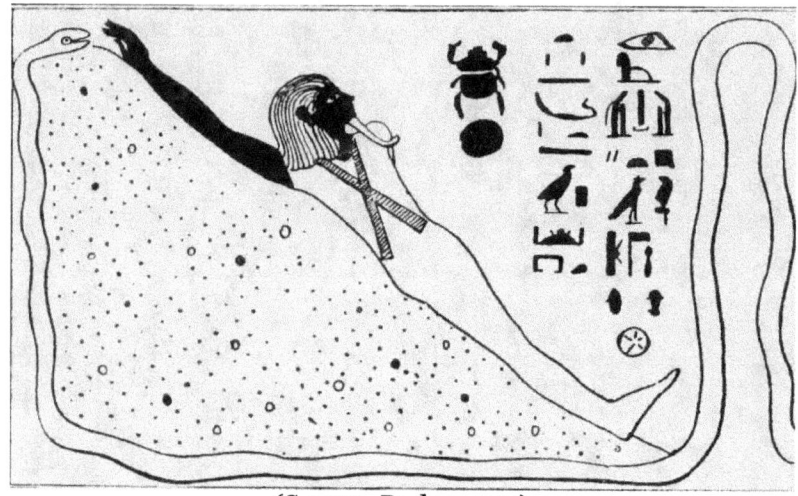

(Source: Budge, 1911)

In this image above, we once again see Asar/Osiris as Enki/Ptah leaning on an incline with a serpent serving as support. It is an image that reminds us of the support that he receives from the serpent brotherhood and sisterhood. The serpent is known as Aat, which, I suppose is also Arat, the serpent deity that taught humans in Kemet internal alchemy and tantra.

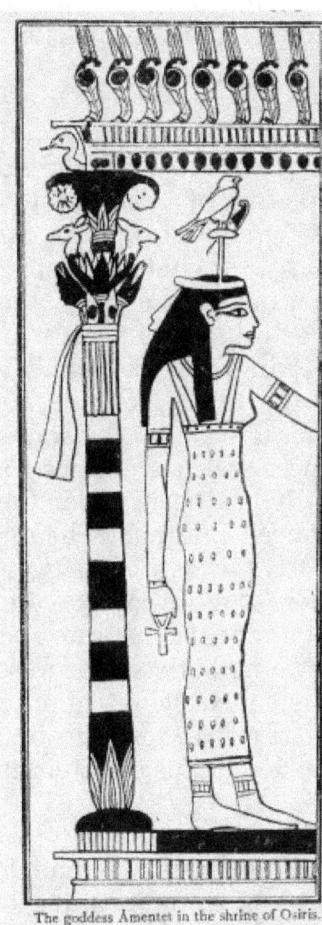

arms and shoulders of the god are covered with some dark material, and streamers of parti-coloured cloth hang down, one on each side of him. In another papyrus of the same period (XXIInd dynasty) Osiris is seen lying on the slope of a mound of earth, with his right arm extended to the top of it. His hand nearly touches the head of a huge serpent, the body of which passes down the back of the heap, and emerging from under the front of it continues in deep undulations. The legend reads: "Osiris-"Res, Khenti-Amenti, "great god, dweller in "the Tuat, that is to "say, Ta-tchesert, the "Aat of Kheper-Rā."¹ In the papyrus the god is ithyphallic. In the Papyrus of Anhai² (Plate 5), the god wears a different crown, viz., , and a wig with a fillet with two uraei; by his side on the throne stands a hawk wearing a disk; before him is

The goddess Amentet in the shrine of Osiris. From the leather roll of Nekht.

² British Museum, No. 10,472.

(Source: Budge, 1911)

One other serpent priestess to pay attention to is Amentet, shown in the image above, who was mentioned in chapter 1 part 1 of the *Rau nu Prt m Hru*. She is a female (reptilian) priestess (i.e., Amasutum) that presents esoteric knowledge to initiates. In Ashby and Ashby (2000), we learn that Amentet means 'hidden'. That is, esoteric. Occult. Further to

this, we see in the image of Amentet that she is associated with eight cobras. That is an indication of a connection with the serpent sect.

At this juncture, I would like to make an observation that is of great importance to any who choose to study the *Rau nu Prt m Hru* for the purposes of spirituality and enlightenment. The comments I am about to make connect with content in chapter 3 (section 3.8). What has been known by some as the Egyptian Book of the Dead and by others as the Kemetic book of Coming Forth into the Light is in fact both of these. It a book about dying, and simultaneously a book about being reborn into the Light. For, the book is neither about death of the physical or about the soul going into the netherworld where some discarnate entities go after death of the physical body, as it has been understood by some. Rather, it is a very advanced internal alchemy text. This is a text pertaining to *alchemy of the soul*. Transformation. We can think here of those complex Jungian archetypes of the subconscious mind that constitute a certain lens for studying psychology. The netherworld represented in the *Rau nu Prt m Hru* is the subconscious mind of the initiate, who must 'die' to his old self in order to be 'born again', in the light of his Original Self that is the Eternal One, that of the Akhu.

We can now leave the study of serpents associated with Ancient Kemet in order to move on to the country known today as Ethiopia. As it turns out, the Ghana empire are not the only ones whose history is intimately connected with nagas. The country known today as Ethiopia, too, has a very real connection (in terms of their history) to a time when the people of their region were ruled by a snake king. This snake king was defeated by an ancestor of what became the ruling (Solomonic) dynasty of Ethiopia. Interestingly, where the defeat of the seven-headed snake biida of Wagadu (the Ghana empire) led to the demise of those blacks in the region, after seven years, seven months and seven days, the defeat of Arwe, also known as Wainaba, led to the birth of a

new era in Abyssinian/Ethiopian history, which was that of that of ushering in the era and dynasty of human kings. Without further ado, let us examine the story of Ethiopian naga king:

"Waynaba is a name given to a mythical serpent that ruled the Ethiopian people until he was killed by a stranger, Angabo. In Geez legends, the stranger marries a princess (negeita Azeb 'the Queen of the South') who was to have been sacrificed to the creature and founds the dynasty from which Ebna Hakim (Menilek I), ancestor of the Ethiopian kings, derives. It is often assumed that this legend harks back to a time when a serpent cult existed in Ethiopia." (Arwe, see references)

In my view, both stories refer to nagas (and perhaps the same group of them), even though the Ethiopian accounts of the nagas that I have so far laid hands upon is absent of details involving seven heads or other aspects of the number seven. A comparison with the legend of biida the snake from the Ghana empire shows that the two accounts are highly similar. The main similarity is that both accounts involve serpent beings. A close second is that in both accounts, the serpent being requests that a woman be sacrificed. Obviously, the third point of similarity is that a human man eventually kills the serpent. The main difference is that in the demise of the serpent biida in the legend of Wagadu, disaster was wrought on the people because they broke their pact with the nagas. The demise of the serpent Wainaba on the other hand brings prosperity to the new dynasty of human rulers in the region now known as Ethiopia.

I would like to draw to the word 'Wainaba', and would like to suggest that in the meaning of this word is encoded the term 'serpent king', or 'snake king', just as we saw for the title 'Kha-na' in section 4.2 means 'serpent king', for the leader of the Waga people, and also the word 'kaanul' we saw in section 4.8 in regard to mayas of the Yucatan region, a title which also means 'serpent king' . 'Wainaba/Waynaba' also means serpent king. This is because in the languages of the DiaMo people, consider for instance the Mampruli language of the

Mamprusi people of Ghana (see Appendix 3, under Dagomba) who are strong members of this DiaMo group, we find that the word for snake is 'wa`a', and the word for king is 'naba'. Put the two together, and you have 'wa`a naba', or 'snake king'. The Abyssinian kings were and are led by DiaMo people. In the Akan language, which has some similarities with the Mampruli language (in terms of word meanings), the word for snake is 'owo', and the word for king is 'nana'. Thus 'wainaba' would be 'owo nana'. Not exactly as close as in the case of the Mampruli language (one of the 'Dogon' languages in present-day Ghana) but close enough to assist in the understanding and the decomposition of the word.

And now, let us transition to the discovery that surprised me the most of all in regard to the ancient naga presence in Africa, as I conducted research to unearth evidence on this subject of the "naga mystery of West Africa".

4.11 The ancient city of Naga'a in Nubia-Meroë and the temple of Amun

You cannot make this stuff up. I suspected strongly that there had to be a naga presence on the African continent that would connect with the Naga presence in West Africa as reported in the legends of the Ghana Empire. We should also remember that Churchward (1931) asserted that there was a naga settlement in Kush, as far back as 15,000 years ago. We also have the amazing story of the presence of the naga king Arwe (also known as Wainaba, which was shown in the preceding section to mean 'serpent king') who predated the Abyssinian kings of Ethiopia, and the first dynasty there, to add to the story of biida, the naga of the legend of Wagadu of the Ghana empire.

As fate would have it, as I meandered through research materials, tracing the appearance of serpents in Kemet and Kush/Nubia, as well as present-day Ethiopia, I finally discovered that there was in fact a naga settlement in Kush

for thousands of years, right in the heart of the region (it is about 170km north-east of Khartoum, capital of Sudan) and that there are also ancient ruins still present at this city. One can search for Naga'a/Naqa to find this settlement, which was made a UNESCO World Heritage Site in 2011.

If we now follow this line of thinking, then we come to realize that Naga'a/Naqa is the root of the word Naqada in Upper Kemet, and of Napata in Kush/Nubia. For the suffix 'da' or 'ta' refers to 'land' in the Ancient black peoples of Kemet and Kush. That would mean that both Naqada and Napata refer to naga lands or to naga kingdoms of the region in ancient times. These lands in Upper Kemet certainly include Thebes/Waset as the center of black culture and civilization in the ancient time, and land of the gods of old. That is why the temple at Luxor, also a UNESCO world heritage site, has such oversized figures, and even the blocks used to build the temple are oversized. They were built for and by the gods, that is, the serpent cult of Enki/Ptah and his group. It is also why we find the image of the multiheaded snake embedded in the image from the Theban tomb.

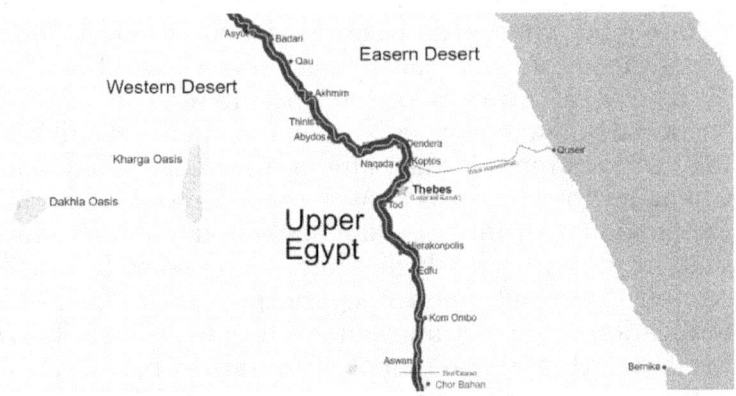

This image from Wikipedia demonstrates the extent of the Naqada culture that flourished between 4000 BC and 3000 BC, before the unification of the two lands. Williams (1974),

writing on the history of lower and upper Kemet before unification, states the following:

"Kurt Sethe, in attempting to reconstruct the prehistory of Egypt concluded that the division of the country between Africans in the south and Asiatics in the north was due mostly to a split over religion. According to this view, the Africans refused to accept the cult of Horus that dominated the Nile delta. They, therefore formed a "second nation" in Upper Egypt and established their national religious shrines at Omnos, Thebes, Thines and Napata" (p. 64)

Williams again speaking of the time before unification of the two lands, confirms the importance of Naqada/Napata (in addition to Thebes) as an important center for black culture in the ancient world:

"The blacks had established their Egyptian capital just across the river at Nekheb. Thebes and Napata continued to be the cultural centers of the black world" (p. 66)

Williams is obviously using Napata to refer to Naqada, since if one looks on the map above, all the other sites (Omnos = Kom Ombo, Thebes, and Thines) are all in the region. The significance of this quote is to draw attention to the preference of Africans of the ancient time to using their "national religious shrines", which was then and still is today the sect of Amun. Today, among the Akan of the country Ghana for instance, it is known as the Tano shrine, which is the "national shrine" of Akan states today. Much more on that in section 5.1 which follows immediately after this section. A second point of significance is that prior to the unification of the two lands, the sects of Asar-Aset-Heru (i.e., the cult of Horus) and that of Amun-Mut-Khonsu (the older of the two cults of significance to black people) were separate in black culture. Today, they are no longer separate but are the two important sects for black people since the time of unification of lower and upper Kemet by Menes.

A final point in regard to Naqada/Napata and to nagas is the idea that the naga lands or the naga cultures of Naqada were the 'Land of the Gods', a reference to the serpent cult that has interacted with the black people of this region for millennia. For this reason, as non-black culture repeatedly encroached into Kemet (for much more on that, see Williams, 1974), the Naqada/Napata culture repeatedly retreated back deeper into the heart of Nubia. This so much so that the last black period to rule the united lands of lower and upper Kemet (there were two periods of black dynasties ruling both lands before this third one), the 25th dynasty consisting of Nubian/Kushite rulers moved their capital deep into Nubian territory...to...the city of Napata! This is a reason for the move, given in Williams (1974):

"Piankhi and his successors in the Twenty-Fifth dynasty apparently preferred the capital city of Napata in the deep south over both Thebes and Memphis. Was this because the Holy City of Napata was like Meroë, the one great all-Black city that had never been defiled by the conquerors' hands? We may so speculate." (p. 100)

Napata was holy because it was the "Land of the Gods", that is, the land of the nagas and of their serpent cult superiors. It had long been that the land of the gods was in the south of the region (upper Kemet and Nubia/Kush), before it became associated with the north (lower Kemet, including the delta area). There were two Napatas. One in Kemet and the other in Nubia. Speaking of the Napata in Nubia (this time, not the Napata/Naqada up north by Thebes/Waset, the one shown in the map above) being a Holy Land, Williams (1974) is quite descriptive in his exposition:

"Napata was a beautiful city that was favored by surroundings that helped to make it so. Located below the Fourth Cataract above the great curve where the Nile has turned southward and, as though changing its mind, turned north again. An imposing hill, the "Throne of the Sun God," was the site of temples. The city itself was regarded as the "Holy of Holies," the capital of what the Egyptians called "The Land of the Gods". But "Napata" referred not only to this central city but included what today we would call a

metropolitan area that covered towns and villages for miles in all directions from the present day town of Karima" (p. 131)

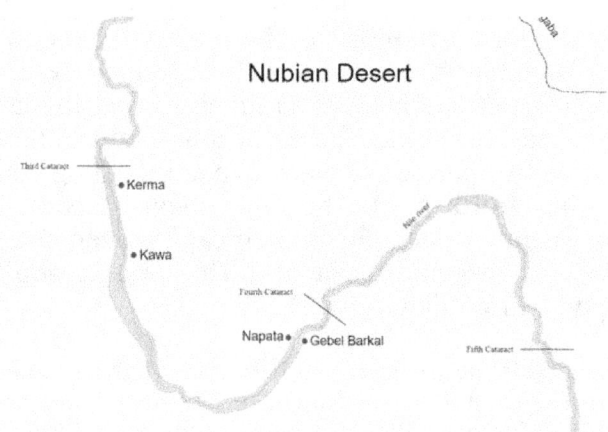

So here, Williams (1974) confirms my theory that Napata or Naqada was really Naga'a-ta, or land of the nagas. It was holy and it was also associated with the gods, because of the nagas and of the serpent cult. The temples that were in this metropolitan area were the same temples that were in the region of Naqada/Napata in upper Kemet around Thebes. Those were the temples of Amun. Most importantly, we find in the quote above that there is reference to the "Temple of the Sun". That, my friends, is the Solar Brotherhood of Lemuria mentioned at length in section 4.6. This brings full circle the story of the nagas and the serpent cult, first beginning in Lemuria, and then moving around to different parts of the world, including Africa.

How amazing is that?! My personal discovery of the ancient city Naga'a in Nubia revealed what appears to be a really significant bit of hidden history of the black peoples of the continent of Africa. It is no longer such a stretch of the imagination to imagine that naga people migrated from this ancient settlement further into Africa as I originally posited,

eventually settling at least in one location in what became the ancient Ghana empire. As is shown later in this section, there was a strong presence of the sect of Amun in Naga'a, the city at the heart of Nubia-Meroë. Akan descendants of the Ghana empire and further afield from Kemet continue the traditions of the temple of Amun to this very day, as will be shown in the next chapter.

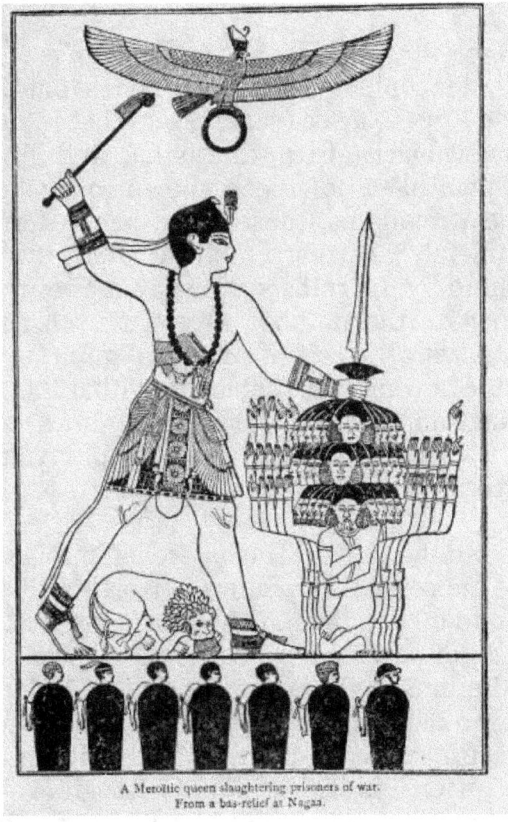

A Meroïtic queen slaughtering prisoners of war.
From a bas-relief at Nagaa.

(Source: Budge, 1911)

So, James Churchward has been vindicated. With the presence of nagas in Africa now being shown to be true, that begs the question of where else could these naga people have settled in Africa? Apart from East and North Africa, did they

only settle in West Africa, or could they also have gone elsewhere in Africa, influencing the peoples, the cultures and the histories of those places? I suppose that is now an open question for research. This is a new discovery, the extent to which these naga people were present in the region, and to which they may have extended out of Kemet and of Napata-Meroë in Nubia and further into the African continent, interacting with and influencing African groups that they met.

One may think that it could be mere coincidence that there is a city by the name Naga\Naga'a (same thing) that is found in the heart of ancient black Africa, that is has nothing to do with the Nagas who have now been shown to be strongly connected to the Dravidians, those black peoples of Asia. This view is completely incorrect, and fortunately, it is to the evidence left behind by the ruins at Naga'a that point to the naga connection with the number seven, as well as their strong connection with the cult of Ammon/Amun, that can lead us to conclude beyond reasonable doubt that the people who settled in Naga'a in fact had the characteristics we have so far in this book associated with naga people from Asia (and originally from Lemuria).

Let us revisit the number seven. The bas-relief in this section also satisfies the expression "a picture is worth a thousand words". The item to take immediate note of in this bas-relief is the appearance of seven men at the base. Seven is the number that is of immense importance in the Naga culture, as has already been detailed in earlier sections of this book. Additionally, we find several uraei or naga cobras at the forehead of the queen. As if that is not enough. To make matters more interesting, the city of Naga'a itself, which is said to have been a royal city (see book titled *Naga: royal city of Ancient Sudan*, which was published in the German language) is another clue, as we often find that nagas have been associated with royalty (e.g., in Cambodia and in Thailand, as was shown earlier). The fourth point is that the city of Naga'a has become well-known for its temples of

Ammon/Amun. We would recall that in the Alchemy of Night Enchiridion (discussed in Part I), Mut and Min are the two energies brought together during sexual tantra. Min is a form of Amin/Amun/Ammon. Khonsu is the child of Mut and Min. The city of Naga'a must be intimately connected with the story of the ancient alchemical text, especially as Mut, Min, and Khonsu were strongly supported deities all over ancient Kush, and certainly at Waset/Thebes, perhaps the most central site of the temple of Amun/Ammon among all black cities in Africa, just as was discussed earlier in the section concerning the period of ancient Kemetic history prior to the first unification of the two lands. What all of these features point to is to the conclusion that nagas, who among others influenced black people – the Dravidians from Asia, originally from Lemuria, in turn interacted with and most likely influenced black people in the heart of ancient Africa (Kush), and particularly in their practice of spirituality. This is a conclusion that cannot be summarily dismissed.

Based on what has already been explored in this book on the question of Nagas, we can surmise four aspects. First, that there were nagas on the continent of Africa. The evidence presented is overwhelming. Second, that the Nagas interacted with the black people of the Ammon sect, and that this occurred in Nubia-Meroë, in the city of Naga'a, as well as around the Nubian metropolitan area of Napata/Naqada, and certainly in Kemet, within the region and the culture that was known as the Naqada period during pre-unification of the two lands (4000BC – 3000BC). The nagas also interacted with black people in Abyssinia before the era of their current human kings, and finally also in Wagadu, known commonly as the Ghana empire. All four instances involve black people whom I have called the "DiaMo" in this book. The third fact is that with the exception of the people of Wagadu (and to a lesser extent, also those Abyssinian people under the Naga king Arwe/Wainaba), we are not sure of the full extent of the nature of the interactions between the nagas and the black peoples of Nubia and Kemet. While we have connected the nagas with royalty and with spirituality

(both in their ability to display their spiritual power and also to be part of the serpent cult who have been teachers of mankind), it is not yet exactly clear (at least to me) what forms the intimate details of interactions were for these two regions (Kemet and Kush) which, from the derivations I have made, would have interacted with nagas and with the serpent cult for millennia. and For example, what forms did interactions take beween the nagas at Naga'a and the sect of Ammon there? Did the nagas also interact directly with human royalty, or only with the priesthood? Given that the nagas and the serpent cult people most likely interacted with the priesthood (it was after all, the Holy of Holies city of the Gods, with its numerous temples, and compare that with the numerous temples in the Kashmir valley dedicated to the Karkota Naga, in the little town of Bhadarvah and surrounding villages as was mentioned in section 2.2), what were the nature of interactions between nagas and priests of the temples of Amun as far as the practices of internal alchemy and tantra are concerned? Did the nagas teach the Ammonites? Each group teach one another? (we find nagas learning from humans in the histories of several Asian cultures). Or did they have exchanges as fraternities, all of whom were under the larger tutelage and patronage of the serpent brotherhood and sisterhood? Fourth and finally, did the black peoples of Africa interact with Nagas that were human-reptilian hybrids, Nagas that were actually human people (like Dravidians) but that have taken on the Naga name, or both?

Suffice to say, although some questions have been answered by the investigations detailed in this book, others still remain. I would like to speculate on the fourth aspect, however. Of that one, we at least have some data from the Arwe/Wainaba story from Abyssinia/Ethiopia. There is a version of the Wainaba story from an article titled *Wainaba, the Serpent Ruler* (from oxfordreference.com – see references), we learn that Wainaba ruled for four hundred years. Here is the story:

"A mythic dragon or serpent called Wainaba ruled the country for four hundred years. The monster was slain by a man called Angabo, the predecessor and father of the Queen of Sheba on the throne of Abyssinia. This serpent lived in Tamben, a district to the south of Aksum, and when it became known that it was coming to Aksum, Angabo promised the Aksumites that he would kill the monster if they would agree to make him king. To this they assented, and Angabo made plans to kill the serpent. He worked magic on the road by which it would come, and he hid a magical object in the form of an iron instrument, or weapon, under the surface of the road, presumably with the view of wounding the serpent. Wainaba set out on the road for Aksum, and as he proceeded on his way he shot out fire from his body on the right hand and on the left, and passing on between the flames he came to Aksum and died. He was buried in May Wayno where his grave is to be seen to this day."

From this version of the story about Wainaba, there are at least two possibilities regarding age. One is that there was a dynasty serpent kings that included individual kings, whose rule total four hundred years. In this first possibility, there would have been several kings whose time of rule together made up the total of four hundred years. As such, the ages of those serpent kings may be closer to those of ordinary humans of the time, which for Nubians was usually about 120 years (according to Herodotus, of whom we would be speaking much of, shortly). In this first possibility, I would speculate that the nagas that constituted the dynasty would have had reptilian ancestors but who also have more of the surface Earth human genetics. Of the second possibility, we would be considering one ruler, one single individual, who ruled continuously for the entire four-hundred-year period mentioned in the story, or close to it. In this second scenario, we would be considering the possibility of the 'real naga' scenario, that is, the Thulsa Doom kind of naga (see section 2.4 in chapter 2) where you have a sort of 'semi-divine' or 'demi-god' type entity that is in fact a close cross between Earth humans and the extraterrestrials of the serpent cult (i.e., not the 'all the way down the line' kind of ET descendant), producing individuals that can live for hundreds or even thousands of years which would have been longer than the average lifespan of 120 years in the Nubian

region at the time. To resolve these two scenarios to determine which one of the two was actually the case would require more information about the Abyssinian/Ethiopian Wainaba story, which I currently do not have.

As an aside, I find it to be cool that in the traditions and histories of many Africa lineages and dynasties, there was a place for magic and the spiritual. This is true in the Abyssinian case, where Angabo was shown in the story to resort to magical means in order to defeat the reptilian Wainaba. It was true in the case of Dinga, the descendant of Solomon, and his son Maghan Diabé who started the lineage of kings of the Ghana empire. It was true in the struggle for leadership following the demise of the Ghana empire, when Sundiata Keita (Sundiata means Son-Lion, the lion king) and his nemesis Soumaoro Kanté competed for who would become the next ruler of the region, which then became the Mali empire, and it was also true of the affordances of the magical prowess of Okomfo Anokye, who was able to unite various Akan groups into the Asante Confederation, that also ended up becoming an empire. So, the moral of these examples is that Africans have been a spiritual people since time immemorial. It is part of who we are. At the very core of the African is the reality of spirit. It would be a shame not to nurture this aspect, which is arguably among our strongest 'core competencies'.

At this point, given that much of this book has been devoted to exploring associations with the number seven, it is also fitting to delve more deeply into the importance of the deity Ammon to the lives of black people in Africa to discover just how deeply connected the history of this temple and its cult was intertwined with black people in Africa in ancient times, and how it *still* is connected to them today. To that end, we shall start with some quotes from the Ancient Greek historian Herodotus:

"Now all who have a temple set up to the Theban Zeus or who are of the district of Thebes, these, I say, all sacrifice goats and abstain

from sheep: for not all the Egyptians equally reverence the same gods, except only Isis and Osiris (who they say is Dionysos), these they all reverence alike: but they who have a temple of Mendes or belong to the Mendesian district, these abstain from goats and sacrifice sheep. Now the men of Thebes and those who after their example abstain from sheep, say that this custom was established among them for the cause which follows:—Heracles (they say) had an earnest desire to see Zeus, and Zeus did not desire to be seen of him; and at last when Heracles was urgent in entreaty Zeus contrived this device, that is to say, he flayed a ram and held in front of him the head of the ram which he had cut off, and he put on over him the fleece and then showed himself to him. Hence the Egyptians make the image of Zeus into the face of a ram; and the Ammonians do so also after their example, being settlers both from the Egyptians and from the Ethiopians, and using a language which is a medley of both tongues: and in my opinion it is from this god that the Ammonians took the name which they have, for the Egyptians call Zeus Amun. The Thebans then do not sacrifice rams but hold them sacred for this reason; on one day however in the year, on the feast of Zeus, they cut up in the same manner and flay one single ram and cover with its skin the image of Zeus, and then they bring up to it another image of Heracles. This done, all who are in the temple beat themselves in lamentation for the ram, and then they bury it in a sacred tomb"

There are two points of note here. The first is about the people that Herodotus calls "the Ammonians". In this quote above, Herodotus describes the Ammonians as "being settlers both from the Egyptians and the Ethiopians". In Herodotus' work, when we read 'Ethiopian', we think not of the Abyssinian but rather of the Kushite (Nubian) black people that were his contemporaries. Herodotus spoke of the Egyptians, the Ethiopians and a third group of people known as the Colchis (who were located on the coast of the Black Sea) as all being black in his book *History*. He said:

"For the people of Colchis are evidently Egyptian, and this I perceived for myself before I heard it from others. So when I had come to consider the matter I asked them both; and the Colchians had remembrance of the Egyptians more than the Egyptians of the Colchians; but the Egyptians said they believed that the Colchians were a portion of the army of Sesostris. That this was so I

conjectured myself not only because they are dark-skinned and have curly hair (this of itself amounts to nothing, for there are other races which are so), but also still more because the Colchians, Egyptians, and Ethiopians alone of all the races of men have practised circumcision from the first."

Circumcision is a practice that is still undertaken today by Jewish people, and that was undertaken in the ancient time by Ancient Egyptians and Ancient Hebrew people. The Ammonians then, are black African people in the hinterland of the continent, who were neither physically present in the lands we know of as Kemet/Egypt or as Nubia/Kush during Herotodus' time. What gives them the name 'Ammonians' is their connection with the Egyptian/Nubian deity Ammon/Amun. Wherever black people were in power, as evidenced by their presence as leaders during certain periods of the Old, Middle, and New Kingdoms they revered Ammon/Amun and elevated this deity as a state deity. I have argued in Appendix 3 of this book that the group I call the Ammonites are a much wider group that form parts of the populations of many African nations than may be apparent today, and I show many of the people of Africa today that can be called Ammonites, or people that follow the traditions of Amun. Amun has always been important to black people. In another quote by Herodotus, this time speaking of the Nubian civilization of Meroe, he tells us that:

"and after this you will come to a great city called Meroe. This city is said to be the mother-city of all the other Ethiopians: and they who dwell in it reverence of the gods Zeus and Dionysos alone, and these they greatly honour"

Again, we see Zeus in reference to Amun, and Dionysos in reference to Asar. So, the Asar-Aset-Heru and the Amun-Mut-Khonsu trinities show the spiritual traditions that have been of great importance to black people. Both traditions have strong connections with the Sirius star system and the guardians in those systems. The Asar-Aset-Heru traditions ultimately point back to the Abgal/Nommo, those amphibian beings that interacted with the Dogon. The Amun-Mut-

Khonsu traditions point back to the feline beings, especially the lion beings. They are another group of guardians who even predate the Abgal/Nommo as guardians. **In terms of correspondences (in general), the "DiaMo" group of Ancient Egyptians and resultant black peoples align more with the Amun-Mut-Khonsu tradition. The "DiaLa" group of Ancient Egyptians and resultant black peoples align more with the Asar-Aset-Heru tradition. Where there were black rulers, the Amun-Mut-Khonsu leaders or majority rulers displayed influences that came more from the ancient priesthood. The Asar-Aset-Heru leaders and majority rulers displayed influences that came more from the pharaohs, the "Divine Kings", and their derivatives.** *The reader can consult Appendix 3 for more associations and correspondences for these two groups.*

Moving on. In the Ancient Kemetic Pyramid Texts (Unis texts), there is a spell for bringing out the Sun, where we find the invocation of Amun, along with the primordial Kemetic deity Atum. The text says:

"BRINGING THE SUN
301 RECITATION. You have your bread-loaf, Nu and Undersky, you pair of the gods, who joined the gods with their shadow;
you have your bread-loaf, Amun and Amaunet, you pair of the gods, who joined the gods with their shadow;
you have your bread-loaf, Atum and Dual-Lion, who made their two gods and their body themselves—that is Shu and Tefnut, who made the gods, begot the gods, and set the gods." (Allen, 2015, p. 59)

The first point of note here is the appearance of Amun in these texts. Amun was a force in the Old Kingdom of Ancient Kemet, which lasted according to Allen (2015) from the third dynasty until the eighth dynasty (2650 BC - 2100 BC). We can expect then that the black culture of the Ammonite/Annu people was very much represented during this period at least. There was once again a resurgence of the culture and spirituality of the Ammonite and other black peoples in the

eleventh dynasty, in the twentieth dynasty and finally in the twenty-fifth dynasty, all of which had one thing in common. During all of these times, there were black pharaohs who drew on the spiritual power and authority of Thebes/Waset, the ancient center of black spirituality and civilization on the African continent.

The second point of note is the mention of Atum, in connection with felines and in particular the lion. In The Ancient Egyptian Pyramid Texts, Atum is defined as the "Primordial source of all the elements and forces of the world" (Allen, 2015, p. 350). Thus with the connection of Atum with lions, we can think of Atum as embodying the Creator forces of this galaxy, represented among them by a group of feline beings that have variously been called the 'Elohim'.

Returning to Herodotus, it is from his records that we learn that the oracles of old in the Ancient Greek world were in fact Ammonites, or the priestesses from the temple of Ammon/Amun. These priestesses went from Nubian temples of Amun to Libya (i.e., Berber regions) and further afield, to the famous oracles in Ancient Greece (Delphi, Dodona, Didyma, etc.). The amazing fact here is that the nature of these oracles is identical to the oracles Akan people have consulted for centuries. As they migrated from one place to the next, the Akan people carried their oracles with them. The oracle Tano is an ancient deity of the Akan people. The oracle of the Akan people today was the same oracle consulted in the temples of Ammon/Amun in ancient times. Here, however, I shall quote Herodotus on his historical information in regard to the temples of Amun:

"As regards the Oracles both that among the Hellenes and that in Libya, the Egyptians tell the following tale. The priests of the Theban Zeus told me that two women in the service of the temple had been carried away from Thebes by Phoenicians, and that they had heard that one of them had been sold to go into Libya and the other to the Hellenes; and these women, they said, were they who first founded the prophetic seats among the nations which have

been named: and when I inquired whence they knew so perfectly of this tale which they told, they said in reply that a great search had been made by the priests after these women, and that they had not been able to find them, but they had heard afterwards this tale about them which they were telling. 55. This I heard from the priests at Thebes, and what follows is said by the prophetesses of Dodona. They say that two black doves flew from Thebes to Egypt, and came one of them to Libya and the other to their land. And this latter settled upon an oak-tree and spoke with human voice, saying that it was necessary that a prophetic seat of Zeus should be established in that place; and they supposed that that was of the gods which was announced to them, and made one accordingly: and the dove which went away to the Libyans, they say, bade the Libyans to make an Oracle of Ammon; and this also is of Zeus. The priestesses of Dodona told me these things, of whom the eldest was named Promeneia, the next after her Timarete, and the youngest Nicandra; and the other people of Dodona who were engaged about the temple gave accounts agreeing with theirs."

Clearly, a lot has been said about Greek scholars going to Africa to learn from the Ammonite priests in Kemet, and then returning to Greece to set up schools. Unless one does some digging of their own, one may not realize that the very inception of the Greek traditions of philosophy and science were influenced by Greek aspirants who went to study in places like Waset/Thebes and others, and who upon returning to Greece set up their own schools of thought. I speak of the likes of Thales of Miletus, along with others like him such as Anaximander and Anaximenes. During my travels in the parts of what is today Turkey which were once part of Ancient Greece, among the places I visited was Miletus, and I learned in regard to that place that Thales, among others, had travelled to Ancient Egypt. He was not the only one. There were others, such as the great Greek philosopher Aristotle, as well as Archimedes, and many others, who all learned from the Ancient Egyptians. There should be nothing strange about this. It is like me, a direct descendant of Kemetic (black) pharaohs and priests (both lines), traveling to China, to India, to the UK, to the US, and other places, including places in Africa, in search of intellectual and spiritual knowledge. Yet it might seem

strange for some to think that the Greeks learned from the Ancient Egyptians, even though they did. Of course, that is why we do research, to reveal these truths.

Returning to Herodotus and the story of the oracles, another fascinating facet of the Ancient Greek people learning from the Ancient Kemetic and Nubian people that is perhaps less well-known is that the people of the Ancient Greek region not only benefited from ideas regarding mathematics and philosophy but also benefited from the spiritual technologies of the black peoples of Africa. Herodotus tells this incredible story of Croesus, at the time a prince of Lydia (east of Ionia, or Ancient Greece), who, scheming to overthrow the Persian king Astyages, decides to consult with oracles (we can presume that they were all of the Ammonite sect) in order to determine whether he could get an edge through spiritual means. But being one with a trickster mind, he began his rapprochement with the oracles by playing a trick on them, to see which of them would pass his test:

"but after this period of time the overthrowing of the rule of Astyages the son of Cyaxares by Cyrus the son of Cambyses, and the growing greatness of the Persians caused Croesus to cease from his mourning, and led him to a care of cutting short the power of the Persians, if by any means he might, while yet it was in growth and before they should have become great. So having formed this design he began forthwith to make trial of the Oracles, both those of the Hellenes and that in Libya, sending messengers some to one place and some to another, some to go to Delphi, others to Abai of the Phokians, and others to Dodona; and some were sent to the shrine of Amphiaraos and to that of Trophonios, others to Branchidai in the land of Miletos: these are the Oracles of the Hellenes to which Croesus sent messengers to seek divination; and others he sent to the shrine of Ammon in Libya to inquire there. Now he was sending the messengers abroad to the end that he might try the Oracles and find out what knowledge they had, so that if they should be found to have knowledge of the truth, he might send and ask them secondly whether he should attempt to march against the Persians. 47. And to the Lydians whom he sent to make trial of the Oracles he gave charge as follows,—that from the day on which they set out from Sardis they should reckon up the number

of the days following and on the hundredth day they should consult the Oracles, asking what Croesus the son of Alyattes king of the Lydians chanced then to be doing: and whatever the Oracles severally should prophesy, this they should cause to be written down and bear it back to him. Now what the other Oracles prophesied is not by any reported, but at Delphi, so soon as the Lydians entered the sanctuary of the temple to consult the god and asked that which they were commanded to ask, the Pythian prophetess spoke thus in hexameter measure: "But the number of sand I know, and the measure of drops in the ocean; The dumb man I understand, and I hear the speech of the speechless: And there hath come to my soul the smell of a strong-shelled tortoise Boiling in caldron of bronze, and the flesh of a lamb mingled with it; Under it bronze is laid, it hath bronze as a clothing upon it."

Such was the way of Croesus, attempting to use guile and trickery to get the better of the oracles so as to test to find out whether or not they were genuine. However, the spirits at the oracle could see past physical shenanigans, so it was Croesus that ended up being shocked and surprised to learn that there was indeed a genuine oracle that had seen through his scheme:

"48. When the Pythian prophetess had uttered this oracle, the Lydians caused the prophecy to be written down, and went away at once to Sardis. And when the rest also who had been sent round were there arrived with the answers of the Oracles, then Croesus unfolded the writings one by one and looked upon them: and at first none of them pleased him, but when he heard that from Delphi, forthwith he did worship to the god and accepted the answer, judging that the Oracle at Delphi was the only true one, because it had found out what he himself had done. For when he had sent to the several Oracles his messengers to consult the gods, keeping well in mind the appointed day he contrived the following device,—he thought of something which it would be impossible to discover or to conceive of, and cutting up a tortoise and a lamb he boiled them together himself in a caldron of bronze, laying a cover of bronze over them. 49. This then was the answer given to Croesus from Delphi; and as regards the answer of Amphiaraos, I cannot tell what he replied to the Lydians after they had done the things customary in his temple, for there is no record of this any more than of the others, except only that Croesus thought that he also

possessed a true Oracle. 50. After this with great sacrifices he endeavoured to win the favour of the god at Delphi: for of all the animals that are fit for sacrifice he offered three thousand of each kind, and he heaped up couches overlaid with gold and overlaid with silver, and cups of gold, and robes of purple, and tunics, making of them a great pyre, and this he burnt up, hoping by these means the more to win over the god to the side of the Lydians: and he proclaimed to all the Lydians that every one of them should make sacrifice with that which each man had. And when he had finished the sacrifice, he melted down a vast quantity of gold, and of it he wrought half-plinths making them six palms in length and three in breadth, and in height one palm; and their number was one hundred and seventeen."

Such were the lengths that prince Croesus was prepared to go, to "buy" the oracle at Delphi. The story does not end there (the reader can find the rest for themselves). Croesus continues to make incredibly grandiose overtures to the oracle at Delphi while also posing his questions of personal interest, of which he always got an answer. Over the course of this exchange, the oracle became his most trusted source of information on whether the attack on the Persians would be successful, and on which peoples and which forces to ally with in preparation for the attack. Given the mindset that Croesus exhibits in this example, I cannot help wondering which other princes and kings of the ancient time consulted such Ammonite oracles, even in cases where the targets were black peoples and nations themselves. I visited the ruins of one of these ancient oracles during my travels in Western Turkey, on the same trip where I visited Miletus. This time, the site was the temple of Didyma, another Ammonite temple dedicated to Apollo. Being the son of Zeus, Apollo's equivalent the Kemetic tradition would be Khonsu, since the equivalent of Zeus in Kemet and Kush was Amun. I took a photo of one of the pylons, which I show below. The photo surely shows the pythian element, in addition to what looks like a water entity, perhaps a merman or amphibian, with a woman (the priestess?) sitting on its back.

5

AKAN LORE CONCERNING THE NUMBER SEVEN

5.1 Divine Kingship (Asar-Aset) and Sacred State (Amun-Mut) of the Akan

From the last section of chapter 4, that is, section 4.12, we learned from Herodotus' *History* that since ancient times, the two sects that have been most important to black people in Kemet and in Kush have been the Asar-Aset-Heru sect and the Amun-Mut-Khonsu sect. Now, even before Herodotus' time, we have the evidence from Ancient Kemetic records that the sect of Amun-Mut-Khonsu was strong in Kemet whenever Kemet was united, or close to being united. Each time Kemet was united, it was led by black pharaohs. This occurred during the Old Kingdom period (especially third to fifth dynasties), the beginning of the Middle Kingdom period (eleventh to thirteenth dynasties), and close to the end of the New Kingdom period (twenty-fifth dynasty). In addition, the Amun-Mut-Khonsu sect was very strong during the twentieth dynasty, also led by a black dynasty, although Kemet was not united in the lower and upper territories at the time. The Asar-Aset-Heru sect has determined the manner of government in Kemet since the Old Kingdom period.

When we consider the information from Kemet showing that whenever there was a strong presence of black pharaohs (i.e., Asar-Aset-Heru sect), the sect of Amun-Mut-Khonsu was dominant as the national or state religon/spirituality, and also the information from Herodotus on Nubia-Meroë informing us that the Zeus (i.e., Amun-Mut-Khonsu) and Dionysios (i.e., Asar-Aset-Heru) sects were the most important in Nubia, then we can surmise that for the black peoples of the ancient time, these two sects predominated. Not only that. We can also surmise that over a period of at least two and a half thousand years (a conservative

estimate – it is more or less like the last 6000 years, if we include the Naqada/Napata period), from the time of the Old Kingdom in Kemet until the time of Nubia-Meroë in Kush, that these two sects have formed the pillars of the pharaohs and the priesthood among black people of the region.

Therefore, the derivative peoples of Kemet and Kush who settled further into the continent of Africa since the ancient time, one would reasonably expect, would also uphold a culture that reflects the strong influences of the two sects, as it was in the ancient time.

This is in fact the case, and this conclusion is in large part what this book I am writing is about. The cultures of certain black peoples of sub-Saharan Africa directly derive from those of Ancient Kemet and Kush. We can also see in these cultures, that are connected to what I am calling the "DiaMo" and the "DiaLa" bloodlines (see Appendix 3) the preservation of important aspects of the culture of Kemet and Kush. One of those cultures, and a great example, is the Dogon culture. Earlier in this book, I showed how the Dogon people of present-day Mali have preserved the Iroquois/Crow system of matrilineal inheritance, which was identical to that of Kemet and Kush. We also know that the Dogon have a great deal of "priestly" knowledge. Detailed knowledge about astrology, and about the Sirius star system. They know much more than that. Hence, with their preservation of the matrilineal system of inheritance and governance and with their preservation of the religious and the spiritual knowledge of the ancient black peoples of Kemet and Kush, the Dogon are one prime example of derivative African people of the ancient cultures of the ancient regions. It would not surprise me at all to learn that ancestors of the Dogon priests were those that administered the ancient temples at Waset/Thebes and Naqada, centers of the longest continuation of black spiritual influence and culture in the ancient world on the African continent.

Beside the Dogon people, the Akan people are another prime example of derivative African peoples of the ancient regions. In present-day Africa, the Akan people are the single largest group of black people that still maintain the ancient matrilineal (Asar-Aset-Heru) system of inheritance and governance which harkens back to ancient Kemet and Kush. In their well-known system of government, authors such as Eva Meyerowitz have demonstrated the isometric nature most aspects of Akan traditional government and statecraft and their parallels in Ancient Kemet. The book on this subject is titled *Divine Kingship in Ghana and Ancient*

Egypt. With this system of government, because we now know much about how Ancient Kemet was ruled since the medu (hieroglyphs) were deciphered, it became possible to do the one-to-one matchings equating the two systems of government. In this regard, the Akan people, black people in Africa and around the African Diaspora have Meyerowitz to thank for going into the heart of Akan territory to retrieve this information, publish it, and make it widely available.

However, there is a little secret that is not very well known. Among the Kemet and Kush ancient black people, we have much evidence of their ways of government because of the historical artifacts they left behind, including statues, the contents of tombs, pyramids, and descriptions of the ways of rulership. Much less has been highlighted of the ways of the Kemetic priesthood. Of the bits of evidence I have so far been able to access, one astonishing connection came once again from the Ancient Greek historian Herodotus. Herodotus is an interesting case because being one of the various Greek scholars and seekers of knowledge who visited Kemet, he actually had a chance to visit a temple of Apollo in Thebes. Apollo is the Ancient Greek equivalent of the Kemetic Khonsu, since he is the son of Zeus, whose equivalent in the Kemetic/Kushite culture is Amun. Herodotus confirms in his book *History* that he had visited one of the Theban temples, "...which offerings were both remaining even to my time at Thebes in the temple of Ismenian Apollo".

The astonishing connection comes from what Herodotus tells us of the oracles of Amun, including the fact that they sacrifice goats and not sheep. With this information, we can make a connection to the very heart of the sacred practices of the Akan sacred state. This single line, mentioned in Herodotus' History, is valuable indeed, "Now all who have a temple set up to the Theban Zeus or who are of the district of Thebes, these, I say, all sacrifice goats and abstain from sheep." Notice the double emphasis on 'all'. These are temples of Ammon/Amun. All of them, sacrifice goats. That is the part to remember, which I shall detail momentarily. For this, we truly have Herodotus to thank. He actually went there, visited the temples, and reported about the experience. It has been difficult for me to get other records from the ancient time on the Kemetic priesthood from individuals who share from actual experience.

Okay, so what I am saying here? Here, I am claiming that the sacred spirituality of the Akan people of West Africa, especially

involving their state deity Tano, is *the same* as that which was practiced in the Ammonite temples of Kemet (Waset) and Kush (Meroë), which includes both regions and metropolitan areas that went by the name Naqada/Napata. This is in line with Herodotus, who said "all". *This is major, and it deserves recognition.* That there are strong similarities between the Akan sacred state and that of ancient Kemet is not new. Eva Meyerowitz wrote an entire book on it, titled *The Sacred State of the Akan*. What she did in her other book *Divine Kingship in Ghana and Ancient Egypt* to detail influences of the Asar-Aset-Heru sect on the governance system of the Akan people, she also did in *The Sacred State of the Akan* to detail both the influences of the Amun-Mut-Khonsu sect on the religious and spiritual life of the Akan state and its people and to a lesser extent, the connections with the Asar-Aset-Heru sect. I believe this book is the first time such confirmation is being done, beyond the work that Meyerowitz pioneered. Meyerowitz got much of her information on the Akan people from the Bono Akan, one branch of the Akan people who have been led by the Oyoko clan. For that, we are truly thankful to her. The connection with divine kingship, Akan and Kemet is studied and well-known now. The connection between the Akan sacred state, Kemet and Kush is arguably less well noticed. If as we now know the Akan system of government and statecraft is virtually identical to that of Ancient Kemet, and if, as we also know, whenever Ancient Kemet had a strong presence of black pharoahs (including all the times both upper and lower Kemet were unified), the spirituality of the sacred state had a strong presence of the sect of Amun, then one would expect that the Akan sacred state too would have a strong presence of the sect of Amun. It would not make sense for Akan culture, if it has preserved relatively intact the ancient systems of Kemet and Kush, to reflect the practice of divine kingship while leaving out the practice of the sacred state. In fact, we find that not to be the case.

I am asserting that the Akan deity, Tano, was the same deity worshiped by the Ammonites in all their temples all over Kemet and Kush, wherever there were temples of Amun, as Herodotus tells us. Not only that. Tano was/is the same deity as that of the Nile. This is one of the secrets as to why the Akan always wanted to live close to rivers. As the Akan and other black people left the Niger area, they went in search of areas with rivers to restart their ancient culture. The Akan people migrated, carrying the shrine of Tano with them. They first settled in regions around the Niger river. As they migrated further south, they settled close to other rivers. Several other DiaMo peoples also did the same. For

example, the Igbo and Ijaw of Nigeria settled in the Niger delta. In Southern Africa, the Luba people (the Baluba), settled around the Congo River. And so on.

So, we have Herodotus to thank, for telling us about the goats, and about the sheep. Both of these are highly significant. Let us begin with the sheep. It is well known that the symbol of the ram was associated with Ammon/Amun in Kemet and in Kush. That part is well studied. What is scarcely known except within Akan circles (and even then only among those that are close to the ritual context of the sacred state), is that Tano, one of the most important nature spirit deities of the Akan, a river deity, is symbolized by the goat. In Meyerowitz (1951), it is stated that "Tano is symbolized by the ewio antelope and the goat" (p. 137). Meyerowitz tells us further that Tano is a child of the Earth Goddess (i.e., the planetary spirit). This is some of what we can learn about the Earth Goddess:

"The Earth Goddess Asaase Afua, a daughter of Nyame, is the goddess of fertility and procreation, of everything that grows on this earth and of everything contained within it. (In Bono she was the Mistress of Gold.) Her sacred day is Friday, her sacred number eight, her star Venus, and the animal that symbolizes her the goat. The name for the goat is aberekyi in Asante, which is really a nickname used to distinguish it from the sheep, for the term for sheep (oguan) also includes the goat unless otherwise stated. The Fante word for goat, aponkyeɛ explains what the animal really stands for; it means 'If [mankind wants] to survive, do not shake [me or it] off'—in other words, it points out that sex is needed for physical survival. That is why the goat is regarded as 'peculiar' by some, and by others as outright obscene or filthy; but the life-preserving power with whom it is associated is venerated and in the past warriors sacrificed goats before they went into battle." (p. 76)

In the quote above, the part I would like to draw attention to is the connection with Venus. When one studies the Akan sacred state carefully, one finds fascinating parallels between the principles applied in internal alchemy and tantra as detailed in the Alchemy of Night Enchiridion that occur between a man and a woman at an individual level, and those feminine and masculine principles that interact even at the level of the state. To that end, there are solar and lunar elements in Akan statecraft/government as well as in the religion and in spirituality of the sacred state.

Spirituality has male and female components, and spirit beings are androgynous/bisexual in the orientation of their energies. This means that a spirit being can express both its feminine side

and its masculine side. The understanding of Tano as a spiritual entity is as a consequence quite deep and complex. On one hand, Tano is seen as a female entity, being associated with rivers and with water. On the other hand, Tano has a male aspect, being the honhom, or the manna (breath of life) of this being. This is an intriguing aspect that is encountered in the study of nature spirit entities, another example being 'Mami Wata' (another nature spirit entity, not of rivers, but of the sea) also has both female and male aspects, a fact that may be a surprise to some. In this regard, this is what more we can learn about Tano:

"The clerk of the Tuobodomhene, when translating, always referred to Tano as she, her shrine', 'her day of birth', etc. My interpreter on the other hand, always used masculine pronouns when translating. When I pointed out to him that he could not deny that Tano was regarded as a mother, he said: 'O yes, we say so when we think of the god as a river flowing through the land (but his spiritual power is male'; and he quoted the saying: 'No need to make a god of that which receives — meaning a woman. In other words, the material side of the god— his identification with the river and the land -is female, and the sacred fish are "her" children, as it is only logical in a matrilineal society; but on the spiritual side, the soul or kra is male. Therefore his spiritual children, the lesser Tano gods, are 'his' offspring, for their mana or honhom comes from him in his male aspect. At Takyiman, Tano, as the God of Government, or state god is more predominantly male, and it is there that his solar aspect, also in the destructive sense, is most pronounced. His day of birth is Tuesday, the day of Abena {the spirit of the planet Mars), the God of fire and war. There the goat, symbolizing the Earth Goddess goddess of procreation, is his friend, and to whom, according to one legend, he owes the river whose spirit he has become. At Tanoboase, his day of birth is Saturday, the day of Amen, the most ancient God" (p. 138)

The last line is of course an explicit association between Tano and Amen/Ammon/Amun, as I have already intimated. There are several esoteric concepts in the quote just given. One I would like to dwell on for a moment is the concept of honhom. An English translation of the word 'honhom' gives, among other meanings, "a spirit; the Spirit of God; Holy Ghost" (Christaller, 1933, p. 185). The life-giving principle of the honhom is what bequeaths life to Tano's children.

In reference to the 'Throne of the Sun God' quote regarding the site of temples spoken of in the quote given from Williams (1974) in section 4.12 about Napata, we can now make a direct connection with the Amun sect by taking a closer look at the national or state spirituality of the Akan people. This will give a

peek into the practices of the Sun-god of the ancient temples of Amun, which I imagine was the same practice in the temples of Lemuria:

"Nyankopon, the personification of the male aspect of the supreme Mother-goddess Nyame, was chosen centuries ago to be the Sun-god, the ancestor and father-god of kings. Nyankopon means 'the alone great Nyame' because the solar kra came to be envisaged as greater than the lunar kra of the goddess (Cult Type III). Like Nyame he still shows traces of having once been a clan and Sky fertility-god. He is still Nyankopon Kwaame (He of Saturday) because as a Sky fertility-god his birthday was on Saturday. Once of his epithets is Odaa Amen, of which the meaning has been forgotten. It may be translated either as 'He who rests on Saturday', that is to say, does not show his power on this day (as a sun-god) or 'He who is an adjunct of Amen.' The sense in the latter case may have been that Nyankopon, the shining sun, was an adjunct or successor of Amen, the most 'ancient god,' whose planet was Saturn. Nyankopon's secret strong name is Amen" (Meyerowitz, 1951, p. 85)

And now for an incredible account of why goats are sacrificed, which is an account shared colloquially in Ghana and in Ivory Coast in relation to Akan practice of spirituality in regard to Tano (i.e., spirituality of the ancient temples of Ammon/Amun), and to Bia. Tano Akora is just another name of Tano, and Bia is a river in present-day Ivory Coast, on the banks of which settled other groups of Akan people. This account brings to the fore the importance of the revelation obtained from Herodotus in reference to the importance of goats and sheep at all the temples of Amun during his era, when he visited Kemet at the time, and which is also true today, among all the places on the African continent that the Akan people still hold their indigenous culture:

"In one tale about the origin of death, Nyame sent his servant—a goat—to give humans the message that although death would come to them, they would not remain dead. They would come to live with Nyame in the heavens. On the way, the goat stopped to eat some grass. Annoyed by this delay, Nyame sent a sheep with the same message. Unfortunately, the sheep got the message wrong; it told people that death would be the end. When the goat finally arrived, the people told it that they had accepted the sheep's message. In this way, death came into the world." (Lynch, 2010, p. 76).

So, in this quote above, we find the importance of both the goat and the sheep, to the spiritual cosmogony of the Akan people, just as they were to the people of Thebes/Waset during Herodotus' time. This is so because the Akan culture of the present day is a descendant of the cultures of Ancient Kemet. The goat refers

particularly to Tano, the river deity of the Akan people, and more generally to Asaase Afua, the Earth planetary spirit. The sheep refers to Amun, and in general to the Ammonite priesthood/spirituality.

So here, we have succeeded in connecting the ancient with the modern. The implications of this are that just as we can look at Akan traditional culture and statecraft today to get a sense of a modern rendition of the Ancient Kemetic system of rule, if we would like to witness and learn about a modern rendition of the ancient priesthood of Amun, one group to definitely focus on are the Akan people. The Dogon are another. Beside these two, the Luba people of Southern Africa (apart from the fact that the dog/Anubis and the goat/Amun were important to them), had a system of inheritance and government that is very close to that of the Akan and the Dogon, with some slight variations. This goes to show that they were once matrilineal people who inherited the matrilineal system of inheritance and government of Ancient Kemet and Kush. Murdoch (1959) provided the information on their former matrilineal status:

"This arouses a suspicion that all the Luba peoples may once have had a similar social system, a suspicion confirmed by evidence that succession to the Luba kingship was formerly matrilieal" (p. 287)

What Murdoch refers to her is the system of divine kingship of Ancient Kemet wherein a divine king, upon the death of an incumbent, is chosen by queenmother from among qualified males of the matrilineal clan or family. The Luba system, which I shall share shortly, is extremely close to that of the Akan. There are some minor details that people familiar with the Akan/Kemetic /Kushite system of government would immediately be able to pick up. Reading about it, it is almost the Akan system, except those minor (but significant) details. Here it is:

"The ruler possessed the attributes of divinity, and no one might observe him eat or drink, on pain of death. He appointed provincial governors and lesser district chiefs, who supplied troops for his army and levied tribute in ivory, salt, copper, slaves, and produce. They resided in the capital town, where they exercised additional functions. The four highest among them formed an advisory council called the Kannapumba. Ranking even above them, however, was the Lokohesha, or Queen-Mother. Always the daughter of a former king, she remained unmarried, possessed independent tributary territories for her support, maintained her own court, and shared supreme authority with the

monarch. When a king died, the Queen-Mother and the Kannapumba constituted an electoral college to choose his successor from among his own sons or those of former rulers" (Murdoch, 1959, p. 286)

Akan people must be shaking their heads, as I did when I first learned this. As African people, we need to know more of our history. There is more that unites us than separates us, as the descendants of former kingdoms of Kemet and Kush. Murdoch adds further details to demonstrate that the Luba are not the only ones that are formerly matrilineal. Similar to the Akan and to the Dogon (and many others in Africa), several of the other African groups related to the Luba also practice a modified form of the Iroquois/Crow matrilineal system. Theirs sits squarely beneath a topmost patrilineal layer. It is explained in this way:

"The southern kinsmen of the Lunda are also matrilineal, as are the subject peoples of the Yeke state. Moreover, in every tribe of the Mongo province, without exception, the sources report unmistakable survival of the matrilineate. The social systems of the Ekonda, Mbole, Mongo, and Nkunda in the west, which are especially well described, provide structural evidence of a still more conclusive character. When we subject the social organization of these four seemingly patrilocal and patrilineal peoples to close scrutiny, we observe several surprising facts. All of them, for example, have kinship systems of the classic Crow pattern, which elsewhere in the world is associated almost universally with matrilineal descent." (Murdoch, 1959, p. 287)

There is more. Much more. But let us now move on. Before we leave Herodotus for good in this book, I would like to return one more time to this Ancient Greek historian to glean some more insights into his views of what the ancient world was like back then. This time, the focus will be on what Herodotus had to say about the knowledge of the people of Ancient Kemet. It is clear from his own words that at least at the time he made the statements that Herodotus held the culture of Ancient Kemet in higher regard even than his own. This higher regard, not being arbitrary, was based on the knowledge of the people and the culture of Kemet:

"With regard then to the rearing of the children they related so much as I have said: and I heard also other things at Memphis when I had speech with the priests of Hephaistos. Moreover I visited both Thebes and Heliopolis for this very cause, namely because I wished to know whether the priests at these places would agree in their accounts with those at Memphis; for the men of Heliopolis are said to be the most learned in records of the Egyptians. Those of their narrations which I heard with regard to the gods I am not earnest to relate in full, but I shall name

them only, because I consider that all men are equally ignorant of these matters: and whatever things of them I may record, I shall record only because I am compelled by the course of the story. 4. But as to those matters which concern men, the priests agreed with one another in saying that the Egyptians were the first of all men on earth to find out the course of the year, having divided the seasons into twelve parts to make up the whole; and this they said they found out from the stars: and they reckon to this extent more wisely than the Hellenes, as it seems to me, inasmuch as the Hellenes throw in an intercalated month every other year, to make the seasons right, whereas the Egyptians, reckoning the twelve months at thirty days each, bring in also every year five days beyond the number, and thus the circle of their seasons is completed and comes round to the same point whence it set out. They said moreover that the Egyptians were the first who brought into use appellations for the twelve gods and the Hellenes took up the use from them; and that they were the first who assigned altars and images and temples to the gods, and who engraved figures on stones; and with regard to the greater number of these things they showed me by actual facts that they had happened so. They said also that the first man who became king of Egypt was Min; and that in his time all Egypt except the district of Thebes was a swamp, and none of the regions were then above water which now lie below the lake of Moiris, to which lake it is a voyage of seven days up the river from the sea: 5, and I thought that they said well about the land; for it is manifest in truth even to a person who has not heard it beforehand but has only seen, at least if he have understanding, that the Egypt to which the Hellenes come in ships is a land which has been won by the Egyptians as an addition, and that it is a gift of the river: moreover the regions which lie above this lake also for a distance of three days' sail, about which they did not go on to say anything of this kind, are nevertheless another instance of the same thing: for the nature of the land of Egypt is as follows"

I find the information in this quote to be hilarious on the reckoning of the knowledge of the people of Ancient Kemet regarding the calendar year vis-à-vis that of the peoples of Ancient Greece at the time of Herodotus. This is because it is evident to me that Herodotus at the time sees that Ancient Kemet is more advanced in its information about the world than are the Ionians (i.e., the Ancient Greeks and associated peoples). This would explain why Ancient Greek people went to Ancient Kemet to learn from them. That was not what I was taught as I grew up. Hilarious because during my conventional education through the modern school system, I repeatedly came across information in just about every course about the start of knowledge being by the Greeks. This was particularly the case in my study of mathematics, although I must also admit that I had at least one mathematics professor who was interested in one other fairly

ancient culture of the last 2000 years (not Ancient Egyptian) other than the Ancient Greeks for information on the origins of mathematics. I also remember reading a book on world history by a European author, my first foray into attempting to learn the history of other cultures. The author of that book authoritatively declared that two of the most interesting ancient cultures in terms of advancement and knowledge of the ancient world were the Ionian culture and that of Ancient China! She did not even mention Ancient India!! Now, after all these years, I realize that each individual who really aims to know these things must be prepared to make the effort to learn for themselves if necessary. There are truly ancient sources of information available to the public, for those who can find them. As an aside, the Igbo people of Nigeria have an identical traditional calendar to the one Herodotus was describing was the norm in Ancient Kemet.

Our final visit to Herodotus before we move on is on his view of who constitute the Ancient Egyptians. It would appear from Herodotus' view that he thought the Ancient Egyptians were actually black people from deeper into Africa who moved to occupy the Delta area from Upper Egypt, and that Thebes/Waset, that ancient place of black civilization, has gone by the name Egypt (think Kemet) since the most ancient times. This is confirmation of what I discussed in the last section of chapter 4 (i.e., in section 4.12) as well as in the early part of this section in regard to the Naqada/Napata culture. Importantly, it would appear that Herodotus thinks that Ancient Egypt was Egypt in the Theban area and further inland before it became known as Ancient Egypt around the Nile Delta area. A suggestion that would imply that civilization came from further within the continent rather and toward the delta, rather than from the delta into the hinterland. It is also not too surprising to read this view by Herodotus given the view in Ross (2013) that there have been settlements and civilizations in Nubia since at least 10,000 BC. Here is Herodotus' view:

"If we desire to follow the opinions of the Ionians as regards Egypt, who say that the Delta alone is Egypt, reckoning its sea-coast to be from the watch-tower called of Perseus to the fish-curing houses of Pelusion, a distance of forty schoines, and counting it to extend inland as far as the city of Kercasoros, where the Nile divides and runs to Pelusion and Canobos, while as for the rest of Egypt, they assign it partly to Libya and partly to Arabia,—if, I say, we should follow this account, we should thereby declare that in former times the Egyptians had no land to live in; for, as we have seen, their Delta at any rate is alluvial, and has appeared (so to speak) lately, as the Egyptians themselves say and as my

opinion is. If then at the first there was no land for them to live in, why did they waste their labour to prove that they had come into being before all other men? They needed not to have made trial of the children to see what language they would first utter. However I am not of opinion that the Egyptians came into being at the same time as that which is called by the Ionians the Delta, but that they existed always ever since the human race came into being, and that as their land advanced forwards, many of them were left in their first abodes and many came down gradually to the lower parts. At least it is certain that in old times Thebes had the name of Egypt"

This view is interesting to note, because it brings us to a discussion of the peoples that made up the lands of Ancient Kemet and Nubia and how they came to be. According to Eva Meyerowitz in her book *Divine Kingship in Ghana and Ancient Egypt*, in reference to the Egyptian goddess Hathor (Kemetic Hut-Heru), claims that "Hathor was brought forth as a black or a reddish-black child, a reference whose meaning is clear only if we relate it not to the goddess but to the people she represented" (pp.31 – 32). It is time to explain what the reddish-black reference means, and what the 'red line' and the 'black line' of Akan (and some other African) royalty means.

The 'red line' refers to the Ammonites. These are ancient peoples of Kanaan, Kemet, and Kush (see Appendix 3). They were the 'Ancient Egyptians' of the pre-dynastic time. They were also those we can call the 'Ancient Hebrews' from the Christian Bible. The symbol of these people is the feline, primarily Lion, but also the leopard. This group constituted one line of royalty in Kemet and Kush, meaning that members of theirs have held positions as pharaohs. It is the group I have been referring to as the DiaMo. They have a very strong connection to the Amun-Mut-Khonsu sect. The 'black line' refers to the Horites, the children of Horus/Heru. Those associated with the falcon, but also with the serpent. They too, were 'Ancient Egyptians'. More of them were pharaohs than those of the Ammonite group, especially during their high period of the Old Kingdom of Ancient Kemet. Hathor (a form of Aset) is termed as a 'red-black' child, because she is represents both lines. She represents the DiaLa, as well as the DiaMo. We are told that the Horites came into the lands of Kemet and Kush (presumably from other areas such as Kanaan and Punt), and established rulership there.

"Hathor's people, according to texts, came from Punt; the original Punt is believed to have been situated along the Southern Arabian Coast, the second in Nubia, in the desert east of the Nile. In the first Punt Hathor's

people, red-skinned, may have incorporated in their clan a subject race, a small swarthy people whom the Greeks in a later age called the Eastern Aethiopians;... In the second Punt, the falcon clan people absorbed 'negroes' into their society, for in a Denderah text, Hathor is called '...in this thy name: Negress'. The Falcon people who worshiped Min-Horus, and who came from Punt, called their god 'Strong Horus who subjected the "negroes" and who is first in Nubia. At the annual festival of Min, a 'negro' used to recite ritual formulae so that the worshipers of Min should never forget their past victories. Hathor according to a Denderah text, flew from Punt to Egypt in the shape of a female falcon. But as the 'Lady of Punt' or from Punt, she was envisaged as a lioness. The falcon, in which she was incarnate, was emblematic of her clan; the lioness indicated to the Egyptians that Hathor came from Punt, since Punt in Nubia was ruled by a royal lineage of a lion clan. Hathor's people must therefore have been composed, in accordance with the law of exogamy, of people whose mother was of the falcon clan and whose father was from the lion clan or some other clan in the confederation" (p. 31)

The first Punt are of the DiaMo people. The second Punt are of the DiaLa people. Min-Horus is a combination of Min/Amun and Horus/Heru, so it is a conflation of the Amun-Mut-Khonsu and Asar-Aset-Heru sects, hence 'red-black'. The royals of the Akan people know of the 'red' and 'black' lines, because they have also preserved that aspect as part of their Kemetic/Kushite heritage. Curiously, the Luba of Southern Africa whom we spoke of in earlier paragraphs of this section have also preserved the culture of the two kingly or pharaonic lines: a red line, and a black line. This should not surprise us, given the strong similarities pointed out earlier between Akan and Baluba systems of government. In Reefe (1981), we learn that there was the red line king was known as 'Nkongolo Mwamba', while the black line king was known as 'Mbidi Kiluwe'.

To this day, the Akan people of West Africa have preserved the bloodlines of the red line (DiaMo – Asona, among the Akan people) and the black line (DiaLa – Dako/Oyoko, among the Akan people), both of which have been intermixing for generations upon generations now. Being born into the Akan people, and after doing all of this research into the hidden histories and connections, I have now come to learn and to realize, using both intellectual and spiritual means, that I embody both the bloodlines of the DiaMo (Amun-Mut-Khonsu) and the DiaLa (Asar-Aset-Heru) lines. Fate would have it that both my parents have a mother that was of the Asona (led by DiaMo) and a father that was of the Oyoko (led by DiaLa). Both of my parents descend from royal families, on my father's side, the Fante people, and on

my mother's side, the Akyem Abwakwa people. Through my own mother's line, there can be a trace to the Ammonite ancestors (priests, and at least one pharaoh). Likewise, certainly through my parents and grandparents, I trace the Oyoko lineage, but if we should do it the correct Akan matrilineal way then through two of my four great grandmothers (the other two great grandmothers being Asona), there is also a direct line through the Oyoko lineage to the Asarian ancestors. With the matrilineal tradition of the Akan tracing descent through the mother's line, it would mean that technically I belong to the Asona side of the divide.

I find it ironic but fitting then, that an Asona clan member should be making these revelations for the benefit of all black people, and especially of the Akan. The Asona or Ammonite Akan people have been known to follow the ways of wisdom (the ways of Ma'at). In the past, the Asona Akyerekyere people (translated as 'the teachers' people) from Kankyeabo/Kandiama (in what is now Gonja territory in Ghana) and originally from the Dia kingdom were the teachers at Akrokyere (translates to mean "teachers town") in Adanse, in present-day Ghana. The Akyerekyere people, the priests and wise people, had leaders with names such as Asare-Adekyee (Asar/Asare, the Bringer of Light), and Asare Niansa (Asar/Asare the Wise). The Akyerekyere people built stone homes in Akrokyere (just like the stone structures of the Mwenemutapa kingdom of ancient Zimbabwe – see Appendix 3). This points to the fact that the Ammonite people built stone structures such as pyramids in the ancient time, evidence of which can be seen in Nubia, which has more pyramids than Kemet. And so, in this modern time, I continue the tradition of the Asona wise men and women, by carrying out the research to teach black people their history, traditions, culture and spirituality. I also have the warrior/fighting and the enterprising spirit of the Oyoko/DiaLa people (the ways of Nebet-Hut and Set). DiaGbon and DiaMo are also enterprising. The DiaLa hold the naga bloodlines to be found among the royalty of Africa. The same bloodlines that flowed through the Kandaces of Nubia-Meroë and through the Pharaohs of Kemet (during the parts of the Old Kingdom I have indicated) also flow through present-day Africans who are descended of the royal houses. Of course, the concentration of the naga blood would depend on the strength of the connection. In this case, the nagas are those of Enki/Ptah's group (Asar-Aset-Heru sect) who set up the ruling bloodlines by mixing with surface Earth humans. Among the Akan, the "Bosommuru ntoro" of the Akan Dako/Oyoko clan (the python genetic connection along the father's line) denotes this bloodline.

Another example is the Cissé clan of the Mande people, that has a similar connection with cobra and python. Maghan Diabé Cissé, founder of the Ghana empire, also had the naga bloodline as one of his bloodlines. The DiaLa are warriors and are also enterprising people (see Appendix 3 for more correspondences). As such, not only am I a follower of the ways of wisdom, but my "DiaLa side" can also "go to war" as and when I need to. Kwame Adapa is a Spiritual Warrior-Sage.

To further frame these bloodlines, I shall give some more information on the ruling bloodline family that became known as the falcon clan. This has been the same since the time of ancient Kemet in the Old Kingdom. The original ruling families of ancient Kemet in the Old Kingdom at the time of first unification (at that time, it was mainly Waset/Thebes and Memphis that were the main centers) were Ammonites, same as the leaders of Kush/Nubia have always been. See who they were (i.e., their pharaonic names) in Appendix 3.

The people of Kemet then, at the early time (dynasties 1 & 2), were led by pharaohs who were "priest-kings". The Hathor people then came through, as was told in the flight of the falcon from Punt to lower Egypt. It has been through the female/matrilineal line, going all the way back to Hathor (Hut-Heru) that the Asarian kings (Asar-Aset-Heru sect) have ruled (dynasties 3 – 5), just as it was with their Ammonite peers before them. Since the Asarian bloodline left ancient Kemet, it settled in various places such as the Ndjadum (today's Chad) and the Tibesti mountain range.

Eventually, it set up a dynasty in Dia, which had the matrilineal system of rule and which also had the temples and shrines of Amun, or the Ammonite culture. All through the journey from Kemet to West Africa, wherever the ancient Kemetic matrilineal system remained and fell, the method the conquerors used was to marry a female of the bloodline family. Once the conquerors had children, they now did the inheritance through the father's line, thus becoming a royal patrilineal lineage instead of a matrilineal one. But the bloodline ruling families in Old Kingdom Kemet that were ancestors of today's Africans were two, the DiaLa, and the DiaMo, and the succession was originally done through the matrilineal system. This is the reference to the 'red line' and the 'black line' of Hathor, in relation to Punt, and to Hathor's people. The red line is of the Ammonite (Lion clan) people. The black line is of the Asarian (falcon clan) people (as well as certain Phoenician peoples also have the falcon as their symbol, some of

whom originally came from Atlantis and are now in the Middle East, but here we speak of/focus on the ruling lines of the black people associated with Africa).

The ruling bloodline within this Hathor house has two aspects: the naga/reptilian aspect of the bloodline of Hathor comes in part through Enki's line, who is part "Usumgal", through Anu, Enki's father, according to Parks (2005), and who is also part Abgal/Nommo (Parks, 2007; Parks, 2010). There is also another Naga line through Enki's partner, who is almost fully Abgal/Nommo (Parks, 2007), but also has Amasutum (female reptilian priestess) ancestry. Among the Akan (Dakon/Okoko), the "Bosommuru" ntoro (Nibiru) refers to Usumgal, a family of royal reptilians and leaders of the Annunaki, with the top Sumerian/Mesopotamian deity Anu at the top of the Usumgal hierarchy. There are other Usumgal beside Anu and Enki (Parks, 2005; Parks, 2007; Parks, 2010; and much more about the Usumgal and their origins, in Parks, 2018). The Annunaki legions themselves are mostly Sirian. Enlil is not Usumgal, according to Parks (2007), but of a 'lesser' line as deemed by the Usumgal. The Nommo aspect of the Hathor bloodline comes from... the Nommo, those Sirian Guardians that the Dogon met. Both Enki and his partner have Nommo ancestry, and according to Parks (2007) she has more.

So, all the Asante, Akwamu, Akyem, Baule, Bono, Mfantse, Wassa and other branches of the Dakon/Oyoko royals, wherever they are, if the line is unbroken, are ultimately members of one big family. The family of Heru/Horus. House of Heru. Hut-Heru. Hathor. And within it, the ruling bloodline. This is the naga and Nommo (combined) bloodline of the Asar-Aset-Heru sect.

So now, when we consider books written by other Akan scholars such as *The Africans who Wrote the Bible* by Nana Banchie Darkwah, and *The Movement of the Akan from Kanaan to Ghana by AkanBa* by AkanBa we can see that other Akan royal bloodline members of the same overall royal family have been tapping into the same, one truth. The Akan people, by the derivations in this book, are shown to be descendants of the Ancient Ammonites (of whom are aso the Ancient Hebrews, or the Sephardic group). They are *also* descendants of the black pharaohs of Ancient Kemet (Pharaonic -- Old Kingdom). This is a fact (Diop, 1955; Diop, 1974; Diop, 1977).

So, since we have just discussed the Asarian lineage, what about the Amun-Mut-Khonsu lineage? Those Ammonite peoples are the ones you can truly and rightfully call the "people of God". The really ancient Egyptians/Hebrews. In Meyerowitz (1960), we are told that "Nyankopon and his son the king are symbolized by the Lion, or the leopard" (p. 137). We learn earlier in this section that Nyankopon is also associated with Amen/Amun, with the sun. This is the source of the Temple of the Sun of Kemetic and Nubian cultures, and also of the Solar Brotherhood of Lemuria. When the Rastafarians have talked about Jah-Rastafari, about the "Lion of Judah" (Solomonic), this is the energy/archetype/group they are invoking. When I have written about "Sirian-Guardians" in the past, even as far back as my first book, this was one group within the Sirian-Guardians I was referring to (the other are the Nommo). The Ammonites are connected with the Feline energy. In particular, the Lion archetype is a primary representative (not the only one) of the Creator Forces of this galaxy. This is also why Shu and Tefnut (the Dual Lions) are associated with the Amun-Mut-Khonsu sect. I should point out that the Feline energy is associated with subtle levels of reality well beyond the galactic level, all the way 'up' to the cosmic level of first abstraction from Source, and back to the Eternal Fields of Everness.

In a strange twist of the story, the Ammonites, who we can also call the 'Annu', are related to the legions of soldiers and followers of the Usumgal, the Annunaki (those Annu/Sirians that came to Earth, i.e., Mesopotamian Annunaki). The difference is that those that follow the Usumgal hierarchy (with the exception of a few that allied with Enki and his faction) have chosen to turn their backs to the Pleiadian and Sirian Guardians (the Avian, the Feline, and the Nommo, mainly). They how chosen not to follow the ways of the Creator Forces of this galaxy, in favour of conquest and empire building. In reality, the Asar-Aset-Heru line also has a Sirian-Guardian lineage, because the Nommo/Abgal ancestry is included there.

The third group spoken of in Appendix 3 are the DiaGha. These are the true indigenes of Africa. At one time, they covered much of Africa, before the increase of the Asarian and Ammonite peoples. They are the Guan peoples of West Africa. But not only West Africa. Among these indigenes of Africa can be found many peoples, even those as far south of the continent as the Khoi San people. And there are others. Some of the original "African (physical) Immortals" belong to this group. Their story is told in the book *Indaba, my Children*. They are those that Credo Mutwa

called "the Second People" in his book *Indaba, my Children*. Extremely powerful group, spiritually. The shamans of Africa. Powerful spiritually because being indigenous, they are connected to the Earth. Connected also to the Ancient Earth human, and by extension to the Guardians, especially the Avian Guardian beings (the ones the Native Americans call Katsina) from the Pleiades Star system, but also to the Nommo Guardians of the Sirius Star system, who were dealing with this group even from a very early time. If you get to read out *Indaba my Children*, in the earlier chapters be sure to pay attention to the story about Gorogo, chief of the wise 'frog people' (i.e., Amphibians/Nommo) who Amarava (Polynesians, now in Africa) and her African descendants interacted with at length, and also had children. This group are called 'the Second Race', because they came after the Ancient Earth human, the original human that was placed on this Earth. There is a story in *Indaba my Children*, that details the creation of this black race bloodline by mixing this Ancient Earth human (closest group today are certain Polynesian peoples, but also certain Native American peoples as well) with an earlier version of black people:

"The Wise Men of the Tribes also relate
That Amarava did not give birth to her young,
But that like the earliest Amarire people,
She laid crystal eggs that hatched in a month
And adulthood was reached in the space of two years.
On reaching puberty their parents turned them out,
In carefully chosen pairs to fend for themselves;
Soon they were grandparents to the ultimate power
Of no less than twice times ten million souls.
What did these new people –
These so-called Second people look like?
We have it from legend that they resembled exactly
The present-day Bantu – my children.
Some were as black as a much-used pot
Some were brown and even yellow-brown;
Some were tall as a stockade gatepost
And some were as short as our favorite thorn bush
There were types as thin as bulrush reeds
And others as fat as a proverbial thief's bundle
Some were idiots –
From dimwits they ranged
Down to utter nitwits;
Very few were truly wise!
In short my children, they exactly resembled
The puzzling muddle of present day humanity!
Gone forever was the uniform appearance

Of the First People who could have achieved perfection
If they had been properly governed.
Not in appearance alone they differed,
But also in mind and heart and soul;
Where there had been perfect equality,
We now encounter diversity." (Mutwa, 1999, pp. 61- 62)

This one quote captures the overall story of the DiaGha. There is much more in Mutwa's book. It is from the DiaGha people that Credo Mutwa got initiated into the information about the creation of reality, and about the first peoples of Earth, which form the earliest chapters of his book *Indaba, my Children.* That information was coming from the ancestral records and memories of the secret societies of these peoples. This African bloodline (quite a varied group, as the quote above attests to) are the reason why Mutwa opined that Africans came from the East, from a sunken continent. They are literally closest to Polynesians (some) and Native Americans (some) and ultimately to the Ancient Earth human, whom in the quote above, is represented by the Immortal Amarava, a 'red human' (Polynesian), representative of those I called in my first book the 'Lemurian elves', that is, Earth's 'Elder race'. The Polynesian archetype is one of the most powerful on Earth, in terms of spiritual vibration. Annu/Ammonite is another.

So, you find out that you are connected to ancient bloodlines, and even a direct descendant of some of those who once ruled the ancient land of Kemet. What does one do when faced with this information? For me, the first rank of importance I give to this information is that it is true, and truth has an eternal place in the scheme of things in this universe. Now beyond that, it is also important for Africans to know about their past. About their connections to their ancestral roots. This is not information I am uncovering to personally gloat about. Rather, it is information that is needed for healing. The ancestral lines need healing. Some African people today have lost faith in themselves, thinking that they and black people in general are 'good for nothing', cannot govern themselves well, or that they have never come up with anything great in the past. This is not true. The times were different back then, than they are today. In today's world, the people of European background (Western and non-Western powers) have the sway, and the Asians of different regions also have the sway. Anyone who understands the timings of the cycles of the universe knows that times and cycles change. In the current era, as black people around the world more and more come into

their own, they can be empowered by learning more about their past, including the far past, to inform their present lives, in order to forge futures for themselves. This way of thinking is in the very spirit of *sankofa!!!*

Go back and retrieve our past, not (only) to gloat about it, but more importantly to inform our present, heal ourselves and our ancestral memories, so that we can we reach forward into our common future.

So, to reiterate, I think that the main takeaway from learning about your ancestral roots, is to heal ancestral memory, in order to become empowered. Africans have been divided along artificial lines so much so that they have now become more important than the blood running through our veins. Empowerment means black people once again believing in themselves. It means exploring our own cultures and being proud of them, even as we participate globally. It means knowing our histories. Our spiritual traditions. Our philosophies. It does not mean becoming insular. Rather, it means going beyond 'Wakanda' as a dream of some fantastic possibility that never existed, to knowing that something grander and more meaningful existed, and it did for millennia. It means knowing that indeed, if one does their own research, as I have done, and as many others before me have (including some Africans that are/were on the continent, and *many* in the African diaspora), one will learn that just as the Indian subcontinent has as the classical civilizations Kumari Kandam for the Dravidians of the south and the Vedic period (with Sanskrit as its classical language) for others, and as China has its classical civilization of the Xia era, and earlier, the DiaLa and the DiaMo black peoples and many others in sub-Saharan Africa also have their classical civilization, some of which influences have survived right up to

the present day. The descendants of the same people that once lived great lives are here today. It is up to them to decide their own future.

And now, back to the Amun-Mut-Khonsu and Asar-Aset-Heru story of this section. The DiaLa and the DiaMo bloodlines that I am associating with these two sects are only two out of several bloodlines that make up the black races of sub-Saharan Africa. There are some African bloodlines that I have purposely not delved into in Appendix 3, as I was primarily interested in investigating and also in detailing bloodlines related to the guardian groups. And of these, I did not cover every sub-Saharan African group. I have selected to leave room for others to do their own investigations.

5.2 The number seven in Akan religious and secular life

For the remainder of this book, I shall delve into different textual sources on the Akan people of West Africa in search of instances and clues pertaining to the number seven. This is in line with what we have seen in the earlier chapters and sections of this book in connection with the number seven, the nagas, the serpent cult, and esoteric knowledge. There are some source texts on the Akan that come from anthropological studies of the colonial and early post-colonial period. Two main authors whose works I shall delve into for this exploration are Robert Sutherland Rattray (who did much of his work among the Asante of Ghana), and Eva Meyerowitz (who did virtually all her work among the Bono of Ghana). Both Asante and Bono are major Akan groups. The methodology takes the form of a simple document analysis and as such the work in these next sections is a form of qualitative research in which different documents are analyzed.

Therefore, in the sections that follow, I explore some historical texts on Akan cultural, religious and secular practices to learn more about ways that the number seven may have appeared among the Akan people. Seven is not the only number that appears in the doings of the Akan people. There are other numbers as well (e.g., the number 3) that occur in different contexts. The number seven on the other seven on the other hand is almost ubiquitous, appearing in different contexts across Akan religious and secular life.

5.3 Occurrences of number seven in *Religion and Art in Ashanti*

Seven pieces of items such as strips of skin of animals such as lion, leopard, hyena and honey-badger (Rattray, 1927, p.15)

Seven cowrie shells (Rattray, 1927, p. 19) used to make 'suman', also known as magic talismans, the number seven being important in the initiation of a medicine man, e.g.,
seven days required to wash in a spirit bath made of herbs (Rattray, 1927, p. 41)

Visiting a grave site for seven successive nights (Rattray, 1927, p. 41)

Seven eggs and other items used in a libation prayer offering to the ancestors and tutelary spirits (Rattray, 1927, p. 45)

Seven Ashanti kings whose skeletons formerly rested at Bantama, in the heart of Asanteman (Rattray, 1927, p. 116)

Seven golden disks on each of the coffins of the seven great kings of Ashanti (Rattray, 1927, p. 145)

The notion of seven kra (similar to the Egyptian/Kemetic notion of 'Ka') (Rattray, 1927, p. 153; 318)

The seventy-seven priests who appeared at the bedside of a deceased Ashanti king (Rattray, 1927, p. 107)

The seventy-seven drum proverbs or sayings of the fontomfrom drums (Rattray, 1927, p. 285)

5.4 Occurrences of number seven in *Ashanti*

Seven queen mother's blackened stools in the Adae ceremony (Ashanti, 1923, p. 105)

Seven men who came out of the ground, led by a worm that bored its way up, and were with several women, a leopard and a dog (Ashanti, 1923, p. 123)

Seven clans of the Ashanti, and the Akan in general (Rattray, 1923, p. 131)

5.5 Occurrences of number seven in *Ashanti Law and Constitution*

Seven clans of the Ashanti, and the Akan in general (Rattray, 1911, p. 64)

Seven ceremonial swords (afona) associated with shrines of the tutelary spirits, with kra and ntoro (Rattray, 1911, p. 252)

The 'nkontwuma', a spiritual tool or device for deciding/divining difficult cases, that consisted of seven strips of otwe (deer/duiker) skin, from a duiker that "talked" (i.e., cried out) when wounded (Rattray, 1911, p. 395-396)

The seventy-seven streets that once existed at Asantemanso, Kumawu, Kumasi, and elsewhere (Rattray, 1911, p. 61)

The demise of Asante's greatest medicine man, Okomfo Anokye, who asked not to be disturbed for seven years, and seventy-seven days and nights, during which no ceremony should be done to mark his death (Rattray, 1911, p.279) [my emphasis: sounds to me like this has some similarity with the curse of Bida the seven-headed snake, from the accounts in section 4.2 above]

5.6 Occurrences of number seven in *Divine Kingship in Ghana and Ancient Egypt*

The first confederate of states of the Asante, led by Osei Tutu, comprised seven autonomous states (Meyerowitz, 1960, p. 27)

The same was true of Bono Manso, founded as the capital of seven dominant Akan clan settlements (Meyerowitz, 1960, p. 63)

"Odomankoma's title Nna-mmere-son, literally 'seven-days-times', refers on the one hand to the seven circumpolar stars (nsoroma-son) the Bear (Arcturus) which indicate the hours of the night and the seasons. On the other it signifies the seven planets of the ancients: Sun, Moon, Mars, Mercury, Jupiter,

Venus and Saturn, and thus the seven-day week" (Meyerowitz, 1960, p. 59)

"The seat or throne of Ptah would appear to have been the Pole star, a hypothesis put forward by St. Clair in Creation Records, and confirmed by Akan religious thought, for the craftsman creator god Odomankoma is the divinity of the Pole star and is evidently in every respect the same god as Ptah (see below). This would also explain why Ptah became the measurer of time, the 'Lord of the Years', for the seven circumpolar stars revolving round the Pole star indicate the hours of the night as well as the seasons." (Meyerowitz, 1960, p. 65)

"In ancient Bono, the king's day began when the sun rose behind the ruler's head. He slept in a bedroom on the top floor of his three-storied palace, the window of which faced east. The bed was built like a seven-step pyramid; each step was covered with material of a different colour of the rainbow. The rainbow was envisaged as a ladder by which the king could reach his father, the Sun-god, and the Royal Ancestors; or the Royal Ancestors could descend by it to visit him in his sleep. The counterpane and sheets were of yellow silk or brocade, embroidered with gold, symbolic of the sun. His unit tress and pillow were stuffed with gold dust that would renew his strength during the night." (Meyerowitz, 1960, pp. 88 – 89)

When the kra soup is ready the Atumfohene blesses it; after this the king, the queen-mother, and the great men and women of the state walk round it three times before it is removed from the fire. It is then poured over seven fufu balls, symbols of the seven kra-giving planets and the seven great clans which form the state, and is shared out among
the company. (Meyerowitz, 1960, p.145)

5.7 Occurrences of number seven in *At the Court of an African King*

Seven powerful priests of Tano and Ntoa sent by Bono Takyiman to Asante to support the Asante during the Asante-Gyaman war (Meyerowitz, 1962, p. 19)

The seven clan elders as leaders of the seven great clans of the Akan, who served as generals during wars (Meyerowitz, 1962, p.36)

SOURCES

Acharya, S. (1999). *The Christ Conspiracy: The Greatest Story Ever Sold.* Kempton, IL: Adventures Unlimited Press

Alex Collier's List of ET Races, retrieved from https://web.archive.org/web/20160205140620/https://www.alexcollier.org/alex-colliers-list-of-et-races/

Allen, J. P. (2015). *Ancient Egyptian Pyramid Texts.* Atlanta, Georgia: SBL Press

Arthur, G., F., K. (1999). *Cloth as Metaphor: (Re)-reading the Adinkra Cloth Symbols of the Akan of Ghana.* Accra: Af-oaks Printing Press.

Arwe, retrieved from https://en.sewasew.com/p/arwe-(%E1%8A%A0%E1%88%AD%E1%8B%8C)

Ashby, M., & Ashby, K. (2000). *The Rau nu Prt m Hru: The Ancient Egyptian Book of Enlightenment.* Florida: Sema Institute of Yoga/C. M. Books

Ashby, M. (2003). *Sacred Sexuality: Ancient Egyptian Tantric Yoga.* Miami, Florida: Sema Institute of Yoga/C. M. Books

Ashby, M. (2005). *The serpent power: the ancient Egyptian mystical wisdom of the enlightening life force.* Miami, Florida: Sema Institute

Ashby, M. (2008). *Glorious light meditation: the oldest meditation system in history: from ancient Egypt.* Miami, Florida: Sema Institute

Bailey, A. (1999). *A treatise on cosmic fire.* New York, NY: Lucis Pub Co; London, UK: Lucis Press

Bailey, A. (2012). *The light of the soul: its science and effect: a paraphrase of the 'Yoga sutras' of Patanjali with commentary by Alice A. Bailey.* New York, NY: Lucis Pub Co; London: Lucis Press

Berzin, A. (n.d.). *The Life of Nagarjuna,* retrieved from https://studybuddhism.com/en/tibetan-buddhism/spiritual-teachers/nagarjuna/the-life-of-nagarjuna

Bannerman-Richter, G. (1984). *Don't cry! My baby, don't cry! Autobiography of an African Witch.* Winnona, MN: Appollo Books

Blavatsky, H. P. (1888). *The Secret Doctrine, A Synthesis of Science, Religion, and Philosophy - Volume II: Anthropogenesis.* London: The Theosophical Publishing Company

Blumrich, J. F. (1979). *Kasskara und die sieben Welten. Weißer Bär erzählt den Erdmythos der Hopi-Indianer.*

Busia, K. (1984). *The Yoga Sutras of Patañjali: A translation by Kofi Busia*, retrieved from https://www.kofibusia.com/pdfs/YogaSutrasOfPatanjali.pdf

Chang, S. T. (1986). *The Tao of Sexology – The Book of Infinite Wisdom*. San Franciso: Tao Publishing

Christaller, J. G. (1933). *A dictionary of the Asante and Fante language called Tshi (Chwee, Twˇi): with a grammatical introduction and appendices on the geography of the Gold Coast and other subjects*. Basel: printed for the Evangelical Missionary Society

Churchward, J. (1931). *The Children of Mu*. New York: Ives Washburn

Churchward, J. (1933). *The Sacred Symbols of Mu*. New York: Ives Washburn

Churchward, J. (1959). *The Lost Continent of Mu*. London: Neville Spearman Ltd

Danaan, E. (2020). *A Gift from the Stars - Extraterrestrial Contacts and Guide of Alien Races*. Independently Published

Danaos, K. (2000). *The Magus of Java: Teachings of an Authentic Taoist Immortal*. Rochester, Vermont: Inner Traditions

Deane, A. (2002). *Voyagers 2, 2nd Edition*. NC: Wildflower Press

Delafosse, M. (1912). *Haut - Sénégal - Niger: (Soudan Français): 1. Série: Le Pays, Les Peuples, les Langues, l'Histoire, les Civilisations*. Paris: E. Larose

Delafosse, M. (1913). Traditions historiques et légendaires du Soudan occidental traduits d'un manuscrit arabe, *Bulletin du Comité de l'Afrique française: Renseignement coloniaux*. 293-306, 325-9, 355- 368.

Diop, C., A. (1955). *Nations nègres et culture: de l'antiquité nègre-égyptienne aux problèmes culturels de l'Afrique noire d'aujourd'hui*. Paris: Éditions Africaines

Diop, C., A. (1974). *The African Origin of Civilization: Myth or Reality*. New York: L. Hill

Diop, C., A. (1977). *Parenté génétique de l'égyptien pharaonique et des langues négro-africaines: processus de sémitisation*. Ifan-Dakar: Les Nouvelles Éditions Africaines

Doreal (2002). *The Emerald tablets of Thoth-the-Atlantean*. Indianapolis: Dog Ear Pub *Electronic Text Corpus of Sumerian Literature* (ETCSL), retrieved from http://etcsl.orinst.ox.ac.uk/

Eliade, M. (1958). *Yoga: Immortality and Freedom (Vol. 56)*. New York: Pantheon Books

Great Zulu Shaman and Elder CREDO MUTWA On Alien Abduction & Reptilians - A Rare, Astonishing Conversation 9/30/99 by Rick Martin, retrieved from
https://web.archive.org/web/20061027101204/www.metatech.org/credo_mutwa.html

Griaule, M., & Dieterlen, G. (1965). *Le renard pâle*. Paris: Institut d'ethnologie

Hall, J. (2019). *The Magical Sexual Practices of Ancient Egypt*. Winchester, UK: O Books

Hall, M. P. (1928). *The Secret Teachings of All Ages, An Encyclopedic Outline of Masonic, Hermetic, Qabbalistic and Rosicrucian Symbolical Philosophy: Being an interpretation of the Secret Teachings concealed within the Rituals, Allegories, and Mysteries of All Ages*. San Francisco: H.S. Crocker Company, Inc.

Hariharananda, A. (1983). *Yoga Philosophy of Patanjali*. Albany: State University of New York

La légende du Serpent, retrieved from
https://web.archive.org/web/20070208001728/http://www.diawara.org/soninkara/legende.php

Le Plongeon, A. (1886). *Sacred Mysteries among the Mayas and the Quiches. 11,500 Years Ago. Their Relation to the Sacred Mysteries of Egypt, Greece, Chaldea and India*. New York: Macoy Publishing and Masonic Supply Company.

Levtzion, N. (1973). *Ancient Ghana and Mali*. New York: Africana Publishing Press

Liao, R., & Liping, W. (2012). *Ling Bao Tong Zhi Neng Nei Gong Shu*. Independently Published

Lynch, P. A., & Roberts, J. (2010). *African Mythology A to Z*. New York: Infobase Pub

Mallinson, J. (2013). *Dattātreya's Discourse on Yoga*, retrieved from
https://www.academia.edu/3773137/Translation_of_the_Datt%C4%81treyayoga%C5%9B%C4%81stra_the_earliest_text_to_teach_ha%E1%B9%ADhayoga

Meillassoux, C. (1963). Histoire et institutions du" kafo" de Bamako d'après la tradition des Niaré. *Cahiers d'études africaines*. 186-227.

Melchizedek, D. (1999). *The Ancient Secret of the Flower of Life* (Vol. 1). Arizona: Light Technology Publishing.

Meyerowitz, E. L. (1951). *The sacred state of the Akan*. London: Faber and Faber

Meyerowitz, E. L. (1951). *Akan Traditions of Origin*. London: Faber and Faber

Meyerowitz, E. (1957). The Akan and Ghana. *Man*, 57(6), 83-88

Meyerowitz, E. L. (1960). *Divine kingship in Ghana and Ancient Egypt.* London: Faber and Faber

Meyerowitz, E. L. (1962). *At the court of an African king.* London: Faber and Faber

Meyerowitz, E. L. (1972). The Origins of the" Sudanic" Civilization. *Anthropos*, 161-175.

Meyerowitz, E. L. (1975). *The early history of the Akan states of Ghana*, London: The Red Candle Press

Monteil, C. (1953). La légende du Ouagadou et l'origine des Soninke, *Mélanges Ethnologiques.* Dakar: Mémoire de l'Institute Français d'Afrique Noire 23, pp. 359–408.

Morningsky R. (1996). *Los Angeles Workshop Transcript.* AZ: Robert Morning Sky

M'Tam School of Kem Philosophy and Spirituality, retrieved from https://www.theearthcenter.org/our-branches/mtam-schools

Mullin, G. (1991). *The practice of Kalachakra.* New York: Snow Lion Publications.

Murdock, G. P. (1959). *Africa: Its Peoples and Their Cultural History.* New York: McGraw-Hill Book Company

Mutwa, V. C. (1999). *Indaba, My Children.* New York: Grove Press

Mysterious Maya Snake Kings And Their Powerful Kingdom In The Jungle Reveal More Ancient Secrets, retrieved from
https://web.archive.org/web/20180731234354/https://www.ancientpages.com/2018/04/23/myster ious-maya-snake-kings-and-their-powerful-kingdom-in-the-jungle-reveal-more-ancient-secrets/

Nagas, retrieved from
https://web.archive.org/web/20160913120722/https://www.cambodiasit e.nl/nagaeng.htm

Nor-bzan-rgya-mtsho, Jinpa, T., and Kilty, G. (2004). *Ornament of stainless light: an exposition of the kālacakra tantra.* Boston: Wisdom Publications

Ogden, D. (2013). *Drakōn: dragon myth and serpent cult in the Greek and Roman worlds.* Oxford, UK: Oxford University Press

Parks, A. (2005). *Atlantis against Mu*, retrieved from
https://web.archive.org/web/20160206152229/http://www.antonparks.com/main.php?lang=en&pa ge=atlantis_mu

Parks. A. (2005). *Le Secret des Étoiles Sombres*. Lopérec: Ed. Nouvelle terre

Parks. A. (2007). *Adam Genesis*. Lopérec: Ed. Nouvelle terre

Parks. A. (2010). *Le reveil de Phenix*. Lopérec: Ed. Nouvelle terre

Parks. A. (2018). *Le livre de Nuréa*. Lopérec: Ed. Nouvelle terre

Probert, M. (1963). *The Magic Bag: A Manuscript Dictated Clairaudiently to Mark Probert by Members of the Inner Circle*. San Diego: The Inner Circle Kethra E'Da Foundation, Inc

Rattray, R. S. (1911). *Ashanti Law and Constitution*. Oxford: Clarendon Press

Rattray, R. S. (1923). *Ashanti*. Oxford: Clarendon Press

Rattray, R. S. (1927). *Religion and Art in Ashanti*. Oxford: Clarendon Press

Reefe, T., Q. (1981). *The Rainbow and the Kings: A History of the Luba Empire to 1891*. Berkeley: University of California Press

Reynolds, J. M. (2005). *The Oral Tradition from Zhang-zhung: An Introduction to the Bonpo Dzogchen Teachings of the Oral Tradition from Zhang-zhung known as the Zhang-zhung-snyan-rgyud*. Kathmandu: Vajra Publications

Ross, L. (2013). *Nubia and Egypt 10,000 B.C. to 400 A. D.: From Prehistory to the Meroitic Period*. Lewiston, N.Y.: Edwin Mellen Press

Shaw, F. (1905). *A tropical dependency*. London, UK: James Nisbet & Co

Stark, M. A. (2006). Textualized Places, Pre-Angkorian Khmers, and Historicized Archaeology. In N. Yoffee & B. L. Crowell (Eds.), *Excavating Asian History: Interdisciplinary Studies in Archaeology and History* (pp. 307 - 326). Tucson: University of Arizona Press

Temple, R. (1998). *The Sirius Mystery: New Scientific Evidence of Alien Contact 5,000 years ago*. Rochester, VT: Destiny Books

Thai and Khmer Nagas: A journey through the semiotics of the snake divinity, retrieved from
https://amaelcognacq.medium.com/thai-and-khmer-nagas-33a170c2888a

The Book of Wisdom of Solomon, retrieved from
https://www.coptics.info/Bible_Study/Bible/The%20Book%20of%20Wisdom%20of%20Solomon.pdf

The History of the Soninke (Serahule) and Culture, retrieved from
https://web.archive.org/web/20180507093815/mfsumareh.weebly.com/history-of-soninke.html

The Solar Brotherhood of the Seven Rays, retrieved from

https://web.archive.org/web/20130918000448/http://bibliotecapleyades.lege.net/sumer_anunnaki/reptiles/reptiles23.htm

Thomas, L. L. (1980). Crow-type skewing In Akan kinship vocabulary and Its absence In Minangkabau. *American Ethnologist*, 7(3), 549-566.

Timbuktī, Maḥmūd Kutī ibn Mutawakkil Kutī, Houdas, Octave Victor (ed. and tr.), & Delafosse, Maurice (ed. and tr.). (1913). *Tarikh el-fettach ou Chronique du chercheur, pour servir à l'histoire des villes, des armées et des principaux personnages du Tekrour*. Retrieved July 3, 2021, retrieved from https://gallica.bnf.fr/ark:/12148/bpt6k5439466q.image

Tompkins, W., M. (2020). *Selected by Extraterrestrials Volume 2 – My life in the top-secret world of UFOs, Think Tanks, and Nordic secretaries*. Independently Published.

Urban, H. B. (2010). *The Power of Tantra – Religion, Sexuality, and the Politics of South Asian Studies*. New York: I.B. Tauris & Co Ltd

Valerian, V. (1997). *Defending Sacred Ground*. VA: Leading Edge

Van Dam, V. (1991). *Starcraft*. London: Scoob

Van der Toorn, K. et. al. (1999). *Dictionary of deities and demons in the Bible*. Leiden; Boston: Brill; Grand Rapids: Eerdmans

Viyogi, N. (2002). *Nagas, The Ancient Rulers of India, Their Origin and History*. New Delhi: Low Price Publications

Wainaba, the Serpent Ruler, retrieved from
https://web.archive.org/web/20210705172712/https://www.oxfordreference.com/view/10.1093/oi/authority.20110803120336554

Wallace, V., Pundarika, K. (2010). *The Kālacakra Tantra: the Chapter on Sādhanā with Vimalaprabhā Commentary*. New York: American Inst. of Buddhist Studies

Walser, J. (2005). *Nágárjuna in context: Maháyána Buddhism and early Indian culture*. New York: Columbia University Press.

Williams, C. (1974). *The Destruction of Black Civilization: Great Issues of a Race from 4500 B.C. to 2000 A.D*. Chicago, Illinois: Third World Press

Wong, E. (1990). *Seven Taoist Masters: A Folk Novel of China*. Boston: Shambhala Publications.

Wong, E. (2000). *The Tao of Health, Longevity, and Immortality – The Teachings of Immortals Chung and Lü*. Boston & London: Shambhala

APPENDIX 1

A brief note on extraterrestrials

As I write this book, I take for granted that many if not most readers would be acquainted with the idea of the existence of extraterrestrials (ETs). However, I also deem it useful to take a break from the topics of discussion so far to introduce the topic of ETs to the reader who may be unaware of this subject. This is because the ET context will surface a number of times in this book. In a number of my previous books, I have explored the topic of ETs in greater depth, especially the groups known as the Reptilians and the Sirians. At the time of writing this book, the topic of ETs is still frowned upon or considered a fringe or a peripheral subject not having much serious consideration or study in mainstream circles. In short, just about everyone has heard about ETs, but many do not care about the subject, thinking it to be nothing more than science fiction. Remarkably, in the world that humans live in at this time of writing, the distinction between what is real and what is intended to serve the purpose of entertainment grows thinner and thinner. The subject of ETs has (arguably) been successfully relegated to the realm of fiction in the mainstream arena, mainly to be engaged with in cartoons, comic books, and movies. And yet, the phenomenon of ET existence is very real, an assertion I shall address in this section.

This state of affairs where the real is relegated to the fictional is not without reason. ET existence has been known for a long time in the history of mankind. Before modern education (itself based strongly on Western epistemology) assumed the dominant place it has today as the key source of information for modern people, there were other sources of information. Historical accounts of indigenous peoples, detailing knowledge of extraterrestrials, and meetings with them. Ancient artifacts depicting extraterrestrial existences (consider for instance those Sumerian tablets that

detail knowledge of ETs and interactions with them). There are several other sources that can be listed here. It would appear that ET beings have been interacting with Earth and its peoples for a long time. In ancient times, there were accounts of physical meetings and interactions with these beings, who were sometimes seen as gods. Among the people of Mesopotamia, of Kemet (Ancient Egypt), the Aztecs, and the Ancient Vedic peoples, there are stories of gods, some with shining bodies, sometimes coming to visit Earth people in their splendour, sometimes even with flying vehicles, and on occasion even arriving in "flying cities".

In modern times, it would appear that the ET beings would once again present themselves to Earth humans. Following the first atomic explosions carried out through the Manhattan project and subsequently the use of nuclear weapons in war against Japan in 1945, the door opened for some ET groups to initiate contact with modern Earth humans. It was as if exploding those atom bombs became a clarion call for our stellar neighbours who perhaps for the most part had contented themselves with observing the development of Earth humans from afar to now realize that surface Earth humans had crossed a technological threshold that necessitated contact. It was like saying to the galactic community, "hey, we're no longer kids. Did you see that? We exploded a nuke. We've got dangerous toys now". Surface Earth humans, following this event, now needed to be actively interacted with so that they would not destroy themselves along with the galactic neighbourhood. Exploding a nuke not only sends out intense radiation and heat, destroying everything in its path. It also messes with the space-time fabric, meaning that indiscriminately using nukes for experimentation can be extremely dangerous. Such actions can, among other things, poke holes in the space-time fabric, allowing beings and entities that were never meant to be in this space or time reality to find their way here and in some cases to cause havoc. It is even said that some malevolent 'Grey' ETs (the ones Zulu shaman Credo Mutwa called the 'Mantindane' or 'the tormentors'; see reference to 1999 interview with Rick Martin), managed to come into our space-time reality as a result of exploding nuclear weapons (Mutwa does not say that the Mantindane came here as a result of exploding nukes. I learnt this part from another source) and carrying out certain other dimensional experiments. So as a result, this modern contact between surface Earth humans and different ETs has become one of the most closely guarded secrets of our time, with levels of

classification that are unheard of by most people, and that are way above 'top secret'.

So, to put it simply, a number of ET races, both those that resonate more with the negative polarity, and those that vibrate more with the positive polarity, began to approach a number of countries on surface Earth before and during World War II, and shortly after the war ended. The USA was a primary destination for these visits. After all, it was the USA that in modern times succeeded in splitting the atom and turning the process into a weapon, thereby announcing to the galactic community that we had arrived at the nuclear age. In the US, when these visitations started, the personnel who were aiding presidents at the time classified this ET information to unheard of levels. They created a very secretive group of 12 individuals (the initial group) with very powerful links in the intelligence, business, military and industrial worlds who were initially meant to inform the president of the US on issues surrounding this new ET phenomenon, but who eventually chose to "go private" with their knowledge of these contacts. I shall not go into enormous detail about this particular aspect of the history. Certain individuals have already gone to great lengths to reveal this information to the general public. The initial extreme secrecy and public denial that followed meetings such as the one a former US president reportedly had with ET groups in 1954 (at what is now Edwards Air Force base in the US) eventually developed into a culture of unfathomably deep secrecy and denial not only in the US but in many other countries around the world as well. The subject of extraterrestrials had become taboo, lacking approval and support from "officialdom", and set up to invite derision and potential loss of credibility by individuals who consider themselves to be serious investigators and researchers.

Given this state of affairs, it should come as no surprise then that the serious study of extraterrestrials is all but completely absent in mainstream academia. The top scientific institutions of the world are still searching for extraterrestrial intelligence (SETI). It helps greatly to have the support and approval of 'officialdom', and of official sources. Where there is no such support, especially in a case where the key information has been made deeply classified, it is hard to do real research and hard to build knowledge as a community. There's little to no serious data there to study, given the scope of this topic! Or, so it would seem, at least from official sources.

But, that is another discussion. Here, I mean to point out that, as I see it, the conditions are currently not present for serious mainstream study of the ET phenomenon. As such, the subject has been relegated to the periphery. Meanwhile, the subject is like the big elephant standing in the middle of the room, that everybody sees, and yet the leadership is trying to hypnotize everyone that it is not there (i.e., all those UFOs that travel at incredible speeds. Yet, they have been described as being 'swamp gas'). Fortunately, even with relegation to the periphery of mainstream information, it is still possible to access first rate information outside of classified or official sources. Good quality information on this phenomenon is still out there, to be accessed by any who express an interest to. Sources that include whistleblowers with prior privileged access who can produce artifacts and documents and who can share intimate details of experiences in relation to this phenomenon. Such information, even when shared or given a platform (such as was the case with the Disclosure Project Press convening in 2001), simply does not get the attention, 'air time' and focus that would be required to give the subject enough credibility to be taken seriously by the masses. The mainstream media choose to ignore it in a big way for it to be taken seriously, or they present it in some form or fashion to underscore its peripheral and not-important nature, after which the "real news" is given.

This is the way the system is designed. It was even that way back in ancient times, certainly during the time of the Ancient Greeks, as was described to the world by their philosopher Plato. Plato, sharing the words of Socrates, gives the world the allegory of the cave. If the reader understands the allegory of the cave, the reader may understand why today's mainstream media would rather ignore or deride the ET topic than give it serious treatment. I devoted an entire book to writing about subjects concerning this allegory (the reader may refer to my book *Awakening to your nature* to learn much more about the allegory of the cave).

Really, it comes down to a metaphor I would borrow from the first Matrix movie. When the character Morpheus met Neo, the latter was offered two pills. There was a blue one, that would send Neo back to sleep, and there was a red one, which Morpheus said, if Neo selected, he would show Neo how deep the rabbit hole goes. As a result of this movie, there is now a term known as being "red-pilled". To be red-pilled, as I understand it, is to get the real, raw deal about something. To be given the truth, whether it is received well or not. Humanity en masse deserved to be red-pilled almost

80 years ago. It did not happen then, and it has still not happened now. Therefore, waiting for 'the government' to red-pill you would probably not happen. Given that the information on this ET phenomenon from official sources appears to be highly restricted and in some cases ostracized from mainstream sources, the logical recourse then, for those interested in learning about this important and most relevant phenomenon, then, is to resort to what lies in what I am calling the fringe, or at the periphery. That is the way I see it now, at this time of writing. This includes whistleblower accounts. This includes accounts from declassified documents. Encounters between ETs and indigenous people, as well as the indigenous knowledge base on the subject. This part is allowed by the "powers-that-be". It is also good to acknowledge that everyone is different, so each would resonate with different material, however we all can exercise our discernment, and the research approaches and skills that work for and on data. We all have different timings for our awakening, and awakening seems to happen in successive stages for most, and all-at-once for a very few. So, it is well to respect all of this on an individual basis.

And now, to finally write something brief about ETs! Basically, the point I would like to make, in regard to saying something brief about ETs, is that as with many things, a lot of the information we get out there that stands out as source texts on the ET phenomenon come with their own lenses. This is to say that these source texts are not necessarily "objective" (if there is ever such a thing). They come with their own colourings, strengths and weaknesses. I make this comment because I would like to highlight some very good sources of information I have come across over the past few years regarding, on the one hand, the Reptilian and Sirian side of the ET story, and on the other hand, the more human side of the story (Pleiadian, Galactic Federation etc.). On the Reptilian and Sirian side, apart from Robert Morning Sky's phenomenal work, one other author whose works I have enjoyed and now write about in some of my books are the works of French author Anton Parks. His work is very original. He writes a lot of the time from a first-person point of view, giving the memories of the being known to many as Enki. In his first interview with Nexus Magazine in 2007, he had this to say:

"It all began in 1981, when I was fourteen...I started getting "flashes." How to explain in simple words...they always came spontaneously, at any hour of the day. I was never able to control this phenomenon...At the beginning, the flashes appeared tentatively, and in the weeks that

followed the "visions" functioned wonderfully without my having to do a thing."

Anton Parks has not been sure whether he was this being Enki during an earlier incarnation, or whether those memories were given to him in some other fashion. In the same Nexus Magazine interview, he shares that "I don't know if I have a direct connection with this story and if I actually was the Sa'am [i.e., Enki] whose story I tell. Anyway, every time I had these flashes, I found myself inside his body!". Because he writes as someone who lived the experiences he shares, he provides intimate details about the society of the Reptilians and associated people more than I have seen in many places. A lot of his overall information and themes appear accurate even though written in story form. Having just written that, I should point out that one downside to Anton Parks' work is that in reading them you would learn much about the Reptilians, Sirians and also about a group of beings known as the Guardians (in his work, they are referred to as the 'Kadistu') but not much about other ETs, such as those of the humans that are more like us surface Earth humans. The Guardians are basically a select group of highly advanced ETs (spiritually and technologically highly advanced) that work on behalf of Source to support the evolution of all beings (be they balanced, negative, or positive polarity oriented).

On the human side, one awesome book in terms of information on ETs from the point of view of members of the Galactic Federation of Worlds is a book titled *A Gift from the Stars*, by Elena Danaan. This book crossed my path in the past few years. In this book, there is a section that effectively acts as an encyclopedia of who's who among ET races that have interacted with Earth humans. Here, unlike Anton Parks' works where one gets in-depth knowledge about certain groups of Reptilians, Sirians, and Guardians, in Danaan's book one gets a wide breadth of information about many star peoples, where they are from and what some of their agendas are here on Earth. Her book goes into great detail about ET culture, history, politics, factions and various agendas. Here too, I must point out that much as this information is a great affordance to surface Earth people, it also has a weakness that some can pay attention to if they so choose. In my view, the weakness is that the information is written through the lens of members of the Galactic Federation of Worlds. In particular, it is written from the standpoint of the Ahel, a group of Lyran humans found in many places in our galaxy including a large contingent in the Pleiades star system. One

specific group of Ahel, known as the Errahel, can be found around the Star System Erra in the Pleiades. The Ahel are thus one group of the humans that make up "the Pleiadeans", and who were themselves originally from the Lyran Star System. Thus, this book is basically an alien book, because Danaan also claims to be from the Pleiades. It was written by aliens (i.e., people from another star system) and given to Earth people. As such, the Ahel have their own lens, their own standpoints, colourings, and biases. These in my view come across in the book.

For instance, it would appear that some Ahel have some longstanding misgivings with members of another group of Lyran humans known as the Taal, a contingent of which are also found in the Pleiades. So, we hear a lot in this book about how the Taal people who were the original leaders of humans in the Lyran constellation (supposedly the cradle of human civilization in this galaxy) betrayed their people during the period of the Draconian Reptilian invasion that ended human civilization in Lyra. We learn about the betraying leaders secretly going into exile, relocating to the star Mirza in the Sirian system. We also learn at length about the Taal who settled in the Pleiades, which includes the positively oriented Taal found around the star Erra, as well as the supposedly negative-polarity Taal, the Taal-Shiar. Taal-Shiar (ah, it sounds like the secret agents of the "Romulans" from Star Trek, for those who may be familiar), a group of Taal who settled around the Alcyone star in the Pleiades and who are said to be in league with malevolent Reptilians and other malevolent groups, even some in this solar system. All of this is well and good is well in my opinion, and I appreciate this information.

In some regards, this book is not only wide in scope, but also deep in coverage of certain aspects. One of those aspects (to me) is how amazing the Ahel are. We learn a lot about the Errahel in particular, and this is great. Who best to speak about themselves than the people themselves. There are several pages on the amazing Ahel and in particular on the Errahel. Yet, there is very little said that is a downside or that gives us a balanced view of these people. I only found one line (yes, just one line, and this was in a main section about an entire sub-division of the Ahel!) about one group of Ahel that were exiled from the Lyran system. This group, judging from their location, it would seem that they are likely allied with an Annunaki colony in the Janosian system (Taurus Aldebaran). For those who know about the Annunaki, they are a group of Sirian-Reptilian people that have been associated with this solar system for a long time. Groups of them

have been in league with the Orion Reptilians. On Earth, the Annunaki have played the role of 'gods', and there is a long history of them that has been preserved among different Earth peoples. Danaan's book indicates that those Annunaki in the Janosian Star System were exiled from our solar system and that these were the people that the Vril society person Maria Orsic was channelling. I suspect that this group of Ahel, the Jadaiahil, are sort of comparable with the Taal-Shiar of the Taal people. It seems to me that there may be some sophisticated Ahel propaganda here to "look good" in the eyes of Earth people while making some other groups look bad. It is up to us surface Earth humans to discern what is true and what is not, what is useful and what is not. If you have a way to check things with your own Higher Self, then you can often find out what is true among some information and what is not. I still think the encyclopedic information on different ET races and what they are about is first rate, and in that regard I think that Fleet Captain Thor Han Eredyon succeeded in his mission to inform Earth people. But just like Christian missionaries brought Earth's indigenous people education and religion, it would be up to each individual to decide what to keep and what to release. Outside of hearing the other point of view (i.e., those Taal that settled in Mirza or Beta Canis Majoris), we only have information on one side. In any case, I think it is good to know these things that are revealed in *A Gift from the Stars*. There is so much information on different groups of Reptilians and Greys, and so many other beings/peoples whom I had never heard of.

For example, one of the points of data that I personally liked from Danaan's book is about a group of ETs known as the Kiily-Tokurt. This group is one I find extremely interesting. There is information on this group in Parks' works. There is also an individual known as Charles Hall who wrote the "Millennial Hospitality" series of books and who wrote about similar beings. In Hall's work, this group of beings that Danaan refers to as the Kiily-Tokurt are similar to those referred to as the "Tall Whites." Danaan's book gives a great synopsis of many ET races, including contexts for who they are, and why they may interact with people on Earth.

Over the past decades, there have been some key contactees as well as researchers who have informed Earth's people about what is going with the ET presence. For instance, before there was David Icke, there was Valerian, and his early Matrix books. Icke in collaboration with Credo Mutwa has done more than many to

educate the world about the Reptilian presence in particular. Valerian interviewed Collier, and that interview formed a major part of the book *Defending Sacred Ground*, that came out in the late 90s. Some of Collier's information, such as information on the Ciakar (those white-skinned, winged reptilian "royals") has been confirmed and extended in Danaan's book, however I would like to highlight some fairly recent information (released in 2016) that Collier provided on his website which I have not found anywhere else yet. In *Defending Sacred Ground*, we are told that of all the races that have interacted with Earth (and you can read about a lot of them in *A Gift from the Stars*) there are 22 groups that contributed to the genetic experiments that led to humans on Earth today. I am including that list of 22 ET groups that Collier released, as well as some context on them as an appendix to this book. We have Collier to thank for this information. With this list, it is now possible to learn some very detailed information about the exact groups that participated in the genetic experiments which resulted in today's surface Earth human races. I am starting that process of linkages in last column of the table on Collier's 22 races in Appendix 2. Collier most likely got the information on the 22 ET groups from his Zenatean teachers. Speaking of Collier's information, I once crossed paths with an individual many years ago in London who quoted Visais, one of Collier's ET teachers, to me. It happened at a restaurant in London. I was there with this individual, a co-worker who I hardly knew. There was chaos around us on this occasion, and this individual said to me, "the love that you withhold is the pain you carry." I looked at him, stunned for a moment, realizing that he had just quoted an ET. I happened to have learned a lot about ETs and as such I knew where this quote was coming from. So after a moment, I responded, "you realize you just quoted Visais to me." Needless to say, this individual was shocked beyond belief, judging from his physical body response. He was even more surprised than I was. He was speechless. He never expected that I would know this quote, yet alone respond the way I did.

APPENDIX 2

22 ET races that created Earth's human races

The purpose of this appendix is to link some of Collier's information with Elena Danaan's information, and with the information on the various Earth human groups that I provided in Chapter 4 of my book *The Guardians, Earth Humans, and Ascension*. See web link to Alex Collier's page in references section

#	ET Races	Type	Inhabited Star Systems	Notes
1	Ciakar	Reptilian	Alpha Draconis smaller star solar system Thuban-Anwar, Giansar, Grumium, Eltanin	All listed stars are within the constellation of Draco. Thuban-Anwar is the main home of these white winged reptilian royals. You don't want to meet these guys. Brutal race, and the pinnacle of the Draco. Their leader in this solar system is known as the "Pindar". Influenced many races on Earth and have bloodlines among various Earth royalty, especially those of the white race.
2	Vega/Lyrans	Human	Small star systems which orbit Sulafat, Alberio	Most likely a Taal colony of the Lyran constellation. Lyra is said to be the cradle of human civilization in this galaxy. The Taal were/are light skinned, dark haired human group among whose members were the original leaders/royalty of humans in this star system. Over time, the Taal settled in many other places in the galaxy and some developed different skin tones, including blue, brown, and red. Taal mostly influenced

				Indo-Europeans and are in fact said to very closely resemble some white people in appearance.
3	Orion	Human/ Reptilian	Small star systems that orbit Alnalim; stars named: Sysclopesus, Rigel, Betelgeuse	The humans in Orion include the Taal-Uruanna, a branch of brown-skinned Lyran Taal humans who battle the Orion reptilians as a group known as the "Orion Black League". The reptilians in Orion include the "Alliance of the Six", known also as the Orion-Draconian Empire, which comprises: Ciakar, Ebans, Grail, Indugutk, Kiily-Tokurt, and Maytra. With the exception of the Ciakar, the rest have a certain constitution of a Grey humanoid. This is one of the most powerful empires in this galaxy. They have influenced all of Earth's human races, especially some Asian groups. Although not mentioned by Collier, the Orion system also reportedly has some guardian races, including a contingent of an Avian race.
4	Cygnus Alpha	Human/ Aquatic/ Bird	Smaller star solar systems which orbit around the central suns: Deneb, Sadr, Gienah, Albireo	There are dolphin-type races in the Cygnus system that use sound technology. There are also humans from the Lyran system that settled there. Although Collier does not include reptilians in his table, there are reportedly reptilian (including greys) there, which he alludes to, and to which Danaan speaks to directly.
5	Arcturians	Human/ Reptilian	Smaller star systems around Bootes	There are reportedly 3 human-like races in the Arcturus system, including the Ohorai, a group of spiritually and technologically advanced human-like beings that provide assistance to various Lyran human

				groups around the galaxy. These human-like Arcturians are said to have influenced the Etruscan civilisation in Europe. The Arcturian system also has a reptilian race known as the Anak, who are part of the Draconian reptilian empire. For guardian races associated with Arcturus, Ashayana Deane describes meeting a "semi solid" guardian entity in-person. This brings to mind the guardian race that Anton Parks calls "the Ameli", a semi-solid or semi-etheric race found also in the Aldebaran system, and which frequently collaborates with the Abgal, the amphibians of the Sirius star system.
6	Pleiadians	Human	Small star solar systems which orbit Taygeta, Maia, Merope, Pleione, Alcyone	According to Danaan's information, there are four sub-races of humans in the Pleiadian system. Three of these races are migrated to the Pleiadian system from Lyra after war with the Draconian reptilians. The three migrants are the Taal, the Ahel, and the Noor. The Taal, we've already encountered a few times above: they look like your basic European with dark brown to black hair. Then there are the Ahel, who are blond with blue eyes. The Noor are also blonds but they differ from the Ahel by tending to be bigger and taller. The fourth race, the Alkhoru Noor, are Noor people that have succeeded in becoming ethereal beings. This same information asserts that those Pleiadians who live around the star system Alcyone are a group of Taal that are in league with the Orion and other

				reptilians, Sirius B Ashtar collective and others. This could explain why Anton Parks mentions a presence of reptilians in the Pleiades system. Apart from those around Alcyone, there are those humans in the Taygeta (Erra) system, which is where all four of the groups listed above are found. Not mentioned by Danaan but mentioned by Ashayana Deane and Anton Parks is that there were and are still groups of humans in the Pleiades who are aligned with the guardians found around Alcyone (Avian beings) and who look like Native Americans and Native Polynesians. This would explain why the Pleiades has such an important place to members of these two native Earth human groups. In addition to these two Earth groups, the Pleiadians also influenced the European Celtic people, the peoples of Atlantis, and certain African groups.
7	Zeta Reticulans	Reptilian /Plant	Small star solar systems that orbit between the stars Achernar and Canopus.	There are a number of Grey races associated with the Zeta Reticuli system. They include the Do-Hu (Dow), the Eben, the Solipsi Rai and the Xrog Shamtbahali. The Do-Hu have both reptilian and plant genetics. The Xrog are said to have been on Earth since the time of the Annunaki, as mentioned by both Parks and Robert Morning Sky. Greys eventually co-opted the Annunaki. Apart from the Eben who are friendly to humans and have non-reptilian DNA, the rest have had a history of malevolent interaction with Earth and other humans. Greys have

				influenced all of Earth's human races. Over the ages, they have been experts at human abductions.
8	Sirians	Human/ Reptilian /Aquatic	Muliphen, Murzim (smaller sister star) stars between Wezen and Aludra.	Many races in the Sirian systems. E.g., Taal humans from Lyra settled in the Sirius star system, around Sirius A. The Sirius B Ashtar Collective is comprised of humans (Lyran Taal mixed with Orion Greys) and different reptoids among others. The Ashtar Collective is part of the Orion-Draconian Empire, meaning they are ruled by the Ciakar. The Sirius star system also has the Abgal, amphibian beings that are also members of the guardian collective, and that were in touch with the Dogon people, but also with people in Lemuria, in Sumer, and in Kemet. The Sirius B system also has some blue and dark-skinned guardian human groups, as well as the felines around Sirius A. The Sirian guardians and Sirian-Reptilians have especially influenced the Polynesians, the Africans, the Native Americans, and the Asians, including those of the Middle East, India, and elsewhere.
9	Aldebaran	Human/ Reptilian	Small cluster of solar systems that orbit around the star Aldebaran	It seems the people of the Aldebaran star system call the system "Jada". The humans there are a group of Ahel originally from Lyra, a blond hair, blue eyed race. They are known as the Jadaiahil. There is also an Annunaki colony in this system. They are known as the Jadaii Annunaki. As mentioned above in the section on Arcturus, there is also a group of guardians in this system that Parks calls

					the Ameli. According to him, there were greys in this system in the past, which the Ameli drove off. The people of Aldebaran interacted with German people and influenced German culture. They also infused the Scandinavian Viking culture, according to some sources.
10	Andromeda	Human		Many star systems that orbit Almach and Mirach Central Suns.	The main group in the Andromedan constellation that has interacted with Earth humans are the Zenae/Zenatae, who are a Taal group that left the Lyra system, first for Vega, and then for the Andromeda constellation. In Collier's book, *Defending Sacred Ground*, it is mentioned that humans derive from a soul group known as the Paa Tal. We then find from Danaan's book that there is a human group known as the Taal, and that the Zenae are themselves members of this Taal group of humans. So, then I wonder whether the Paa Tal created the Taal race, and then decided to name the race after themselves, by calling this race the Taal? Would this also be why the Taal were the original rulers of the Lyran humans? It would appear that the majority of humans on Earth of European descent are in one way or another connected with the Taal group of Lyran humans. Another group around the star Mirach (around which revolve 919 stars, 130 of which have inhabited life) that is also important to the creation of Earth humans and that are mentioned in

				Alex Collier's book are known of as the Inextrians. The Zenae/Zenatae of the Andromedan group influenced the Japanese, certain Turkic groups, certain Hungarian groups, and certain people from Finland.
11	Mizarians	Human	Large star solar systems located between Alcor and Mizar.	
12	Mintakains	Human/ Aquatic	Orion – small stars around Central Sun	
13	Cassiopians	Insectual /Aquatic	Caph, Ruchbah, smaller stars. 19 solar systems	
14	Canes Venatici	Reptilian (benevolent)	Triple sun system; no name	
15	Pictorians	Animal/ Human/ Yeti/Sasquash	Double Star System near Kapteyn's Star	
16	Antarians	Humans	Solar systems lie in a binary star system	The main people on Earth that cultures from the Antares system influenced are the Ancient Greek people/culture, and by extension, the Turkish culture, for those eastern parts of Ancient Greece that are now part of Western Turkey. Of the Ancient Greek cultures, Sparta is the main culture influenced by the Antarean ETs. Those ETs are into fabulous musculature, and they have a warrior culture that has succeeded in large part against the reptilians. Some Antarean-influenced Ancient Greek peoples also

				influenced peoples in Spain and in Portugal.
17	Sagittaria	Human/ Feline	Very large star systems between Nunki, Ascella, Media, and Kaus Australis	
18	Nibiruan (Annunaki)	Human/ Reptilian	Bootes (Tarshem)	The Annunaki are a cross between humans from Sirius B, and Reptilians from the Orion empire. This crossbreeding created a new race of Sirian-Reptilians, and it was done as a way to bring peace between warring factions in Orion and in Sirius. Becoming their own sub-clan or sub culture, the Annunaki live on Nibiru, a mobile world, as well as on many other star systems. According to Danaan, "Annunakene" means "humanlike" which details the fact that these beings look somewhat like humans (but they tend to have more elongated skull structures). The Annunaki are now famous on Earth for having been the group that influenced cultures in Mesopotamia and elsewhere on the planet. Among other places, they were once living in this solar system, on the planet that is now the asteroid belt. On Earth, the Annunaki have in the past also interacted with the feline/Lion race of guardians and on other occasions they have both sided with and fought against various factions of Reptilians, including the nagas. After they left this solar system, they made their home in several star systems, including some in the Bootes system as well as

				their Janosian culture in Aldebaran. Janosian equates to the Roman god Janus. The Annunaki influenced the Romans as well as many cultures on Earth, in addition to those of Arab/Semitic peoples, the Mongols, the Japanese, and certain African groups. According to Danaan's material, the Annunaki left this star system but before doing so, they left behind an elite continent to act as controllers affiliated with the 'Military-Industrial-Complex' and who act as manipulators of mankind, a contingent that would no doubt compete with other factions such as certain groups of Orion Reptilians and the Draconians, who are all trying to achieve similar ends.
19	Tau Cetians	Human	Star solar system that orbits between Menkar and Mira	I like to think of the Tau Ceti people as resembling 'the Vulcans', a race of beings in the Star Trek universe who have pointed ears. It is said that the Tau Ceti humans also have pointed ears. Unlike the Vulcans of Star Trek however, the Tau Ceti people appear to be shorter in stature. This group has influenced the Slavic group on Earth, across all Slavic nations. According to Danaan, their planet in the Tau Ceti system is called 'Araman', which means 'exiled man'. They were among those humans of the Lyran constellation that became exiled or that left the system after wars began with the Draconian Reptilians. They are of the 'Taal' group of Lyran humans. The Tau Ceti are part of a larger group of humans descended from the

				Lyran constellation known as the 'Galactic Federation of Worlds'. I like to think of this group as the 'Europeans' of the Milky Way galactic community. This is because Europeans today can trace their genetic ancestry back to various members within this group. Basically, this is the group that brings together Taal, Ahel, and Noor varieties of Lyran humans who, because of those wars with the Reptilians, ended up as exiles in numerous star systems but were then able to once again come together to serve their common interests, especially as it involves protecting themselves from the Draconian and Orion Reptilians, and their allies. Various other groups discussed earlier such as the Antareans are full members while others (such as the Andromedans and the Pleiadians discussed earlier) are 'adjunct' members but also part of this group.
20	Capellians	Reptilian (Neutral Now)	Three star solar systems held by gravity of the Central Star Capella.	
21	Procyons	Human	Single and binary star solar systems – rich in mineral deposits	Procyon is home to a group of "guardian humans" (they look like the Native Peoples of North and South America" who have interacted with humans especially in South America for millennia. Among those peoples influenced are the Quechua peoples of various South American countries (Lemurian descendants of the Incas) as well as the fierce Mapuche Native

				Indian peoples of the highlands of Chile. There were other groups besides these two. In the Procyon system as well were Lyran 'blonds' of the Ahel and Noor varieties, who have been victimized by the Grey reptilians from Zeta Reticuli and Rigel, themselves aligned with the Nebu, or the Orion Reptilian "alliance of the six".
22	Hyades	Human	Binary star solar system near Aldebaran	The Hyadean system also has various guardian and human collectives. Among the guardians in this system are the Avian (Bird) race and some Reptilian Amasutum priestesses. So, this configuration of guardians there in the Hyades is similar to that in the Pleiades. The humans there are also similar in configuration to those in the Pleiades system: that would be the Taal, Ahel, and Noor groups of Lyran humans who became exiled from the Lyran constellation.

APPENDIX 3

A Map of African Peoples Connected to Kemet & Kush

In this appendix, I finally explain connections between various peoples that were in Dia/Dja, a kingdom contemporaneous with Wagadu (i.e., the Ghana empire), and the connections these peoples have with Kemet and Kush. Dia/Dja was an ancient kingdom that has served as a very important center in the histories of various peoples of West Africa. When one begins to go very deeply into the study of many West African peoples, they inevitably come across Dia, which is often alternatively spelt as Dja or as Dya. The people of Dia have gone by many names, such as Djadum/Ndjadum/Djado (i.e., Dia-Dum; today's Chad), Djenne (i.e., Dia-ni), Gyama/Gyaman (i.e., Dia-Man), Diara-ba (i.e., Dia-Ra-Ba), Dyula (Dia-Na; Dia-La), Diara-Konte (i.e. Dia-Ra-Kan-Te). Dia is seen as the 'parent nation' of many West African peoples – a place that preceded the great West African empires of Ghana, of Mali, and of Songhai. In fact, the ruling houses of Mali and Songhai all have connections with Dia. When ancestors of present-day West Africans left the Nile valley region, one settlement they eventually founded and stayed at for over two millennia was what became the kingdom of Dia. As such, Dia holds a place in just about every sub-Saharan black group (but not all) in West Africa.

Much of what we know about Dia comes from oral history accounts preserved by the royalty of different groups that researcher Eva Meyerowitz was fortunate to and able to interview. In my reflections on Dia, I have come to realize that understanding the mystery of Dia and its people can open doors to really understanding many of the peoples that migrated from Kemet (Egypt), who were aligned with Ptah/Enki, and his group (Asar-Aset-Heru sect) as well as those in Kemet, Kush and Kanaan who can be identified as Ammonites (Amun-Mut-Khonsu sect). The greater group of African descendants aligned with these two sects are to be found not only in West Africa today but also in certain other parts of Africa and beyond.

This deep dive into Dia, its meaning and a connection with its people is important because it gives an alternative lens through which to understand the interrelated and interconnected nature of many black peoples in Africa. Africans in particular are often seen as separated peoples. In fact, when one looks more closely, this is not so. Ordinarily, blacks in Africa (and in fact, people around the world) often tend to be categorized on the basis of language, and language groups. This makes sense, because language tends to carry culture. Through analysis of language, especially through etymology of words, it is possible to demonstrate some far-reaching connections among different peoples. In this regard, AkanBa, author of *Revelation – The Movement of the Akan People from Kanaan to Ghana*, is the standard tour-de-force work using this approach.

In this short section of the appendix, I shall adopt another approach to make linkages not only with the Akan but with many other people in West Africa and beyond. The main thrust of my approach, however, is founded on identifying a set of bloodlines if you will. Beneath the veneer of the different languages of various peoples in Africa, there are common elements of unity based more so on blood and on kinship than on language and even on culture. What I shall demonstrate shortly, is that the Akan, Gonja and Mande leaders are all members of one bloodline, a bloodline that once ruled Dia. They are literally kin. This is what brings them together, despite distance, different languages and arguably different cultures between them. My main argument in this appendix entry is that if we know the major bloodlines for the groups of black peoples in Africa and the Middle East, we can know much more about African blacks, especially how much we are actually the same.

Often, blacks in Africa distinguish ourselves based on the trappings of colonial cultures we are born into, or otherwise the trappings of the cultures and languages of the ethnic groups we are born into. Apparent differences that lead some of us to hating one another, harboring prejudices or failing to understand that underneath it all, the person from the other tribe is our brother or our sister, literally by blood. So, I hope this effort here will go some way to ending some of this disunity. The fragmentation of Africa based on ethnic lines is in my view based on a fallacy of differences in culture and language, when underneath it all, there is so much similarity even among the differences of language and culture and certainly on the basis of genetics and blood. It is our own ignorance that keeps us trapped in a mindset of disunity.

The exposition I present here was never meant to cover every African group. This was done on purpose. There are some African groups as well who do not have a connection with the bloodlines I have worked out that appeared in the ancient kingdom of Dia.

To arrive at this information, I have used spiritual methods. Some of these involve divination, and others involve my intuition. I am convinced that the information I am about to present is correct. In my book *Awakening to your nature as a spirit being incarnated on Earth*, I talk at length about three modes of gaining knowledge: via perceptions, via inferences and also via a third means known as 'correct witness'. Correct witness is where one "sees" or has information "revealed". It is a spiritual means of gaining information, through seeing, through visions, and through connections with one's Higher Self. In appendix 3, the structure of the information I present was first arrived at through 'correct witness'. I, as a seer, was able to tap into and access this information. It is an ability I have developed over many years now, which I use to verify my information. Thus, I verified the information in this section (and in much of this book, in fact), as a seer who is also guided by strong logic. However, the reader may be unable to independently verify or refute the information I am presenting here, unless they have their own forms of checking or verifying information independent of the data we get from our five physical senses. All I would say is that the scientific approach is not the only way to discover and to know things.

The scientific approach of the modern time is based on gaining knowledge through perceptions (that can lead to facts), and through inferences (logical derivations and deductions), and almost exclusively never on correct witness ('seeing' or 'revelations'). Of course, most rules have exceptions, and in this case one exception was the scientist Nikola Tesla, who started his scientific endeavours with 'seeing' or correct witness. Virtually all his inventions started off by 'seeing' or by having a vision, from which he worked backwards to the physical and logical details). I am doing the same here, with appendix 3.

Moving on. To start off, let us consider the building blocks, the starting premises. I am taking for granted the existence in the past of a place known as Dia, which was somewhere in the country today known as Mali. In fact, there is a small town in present-day Mali called Dia, in the Mopti region of south-central Mali. I do not assume that this place in present-day Mali was the site of the ancient Dia. The first assumption, then, is the existence in the

past of a nation called Dia. This assumption is based on historical and oral accounts. Moving on, the second assumption is that in this medieval black nation, there were different peoples who at the time could be identified by different bloodlines. These bloodlines, from the historical records, are: Diala/Diana (which I shall refer to in this work as DiaLa), Diagha/Dyoka/Adiaka (which I shall refer to in this work as DiaGha), and Diamo/Djamo/Dyamo (which I shall refer to in this work as DiaMo). Of these three, DiaLa and DiaMo are most commonly shared among the black peoples of Africa today. This last part of the information, and much of its details, were arrived at through 'correct witness'. These two shall therefore be a topic of lengthier discussion in the exposition below. A fourth group represented in the region of Dia were the Berber. Berber as a group have mixed in some contexts with some of these bloodlines.

These 3 bloodlines are by no means arbitrary. In analyses of the histories of the Akan, and the Gonja, all of Ghana, these bloodlines, or versions of them as shown in the first table below keep cropping up. In fact, one of the holders of the tribal histories of the Gonja people of Ghana, the Vaghala-Kora of Tuna told famed anthropologist Eva Meyerowiz that "Gonja, Guan, Bono, and Asante were all brothers. Of the Gonja, only the "old Gonja" came from Dia" (Meyerowitz, 1957, p.84). Here, the "old Gonja" being referred to are those known as Kandiama (Kan-Dia-Ma; i.e., the children/descendants of the Akan from Dia). This Kandiama group, a confederation of many Akan clans, was taken over by the Mande warrior Ndewura Djakpa, who, after defeating the Kandiama king, married an Akan princess from the Kandiama dynasty and then began a new dynasty. This new dynasty became the ruling house of Gonja that we have today. The reader can learn more about this history in Meyerowitz's book *The Early History of the Akan States of Ghana*.

To continue, of these four (3 bloodlines plus Berber), the Berber are not black like the sub-Saharan black people, but they have a darker skin hue than certain Europeans. Interestingly, sub-Saharan blacks and Berber people lived in relative peace for a long time (there were skirmishes now and then) before the advent of Islam. According to Lady Lugard (Shaw, 1905), sub-Saharan blacks sometimes ruled Berbers. The two groups often lived next to one another in peace. The deep reason why this peace was more or less sustained, is because the matrilineal Berbers and the matrilineal blacks were all 'on the same team' at one time. **What the sub-Saharan blacks and the Berbers have in**

common, is the Ammonite connection. The deep reason why the peace was broken, was that the Arab incursion into Berber lands brought the energy and the ways of the patrilineal (Mesopotamian) Annunaki into the lives of these two African matrilineal people.

Okay, so now let us now go one step deeper to unravel some more about these, let us call them three bloodlines, as well as some more information on the Dia nation:

Word	Variation(s)	Notes
Dia	Dja; Dya	(1) Asar-Aset-Heru derivation: Dia = TA.EA – the land of the people of EA/Enki/Ptah (2) Amun-Mut-Khonsu derivation: Dia = Dja; Ja; Egya; Fire; Light; Sun; Leo; Lion; Ja Rastafari; Representatives of Creator forces; Central stars in Milky Way galaxy
DiaGha	Gbon-Dja; GbonDya; DiaGbon; WanGara; Adiaka; Dyoka; Diaka; Degha; N'wa	Guan peoples; Indigenous Africans, now in West Africa, in Southern Africa, etc.; were not based in Kemet, meaning that they were not largely grouped there; strongest connection with the Earth, with Earth-based humanity, and with the Ancient Earth humans among the three bloodline groups; Connected with the Sirius star system, with the Pleiades star system, and very much with our solar system and Earth. Many different totemic associations with this group. Spiritually the most powerful among the three bloodlines.
DiaLa	Dyula; DiaNa; Diani; Wan-kore	Kings, queens and rulers of the Dia nation; Ancient Mande town of Djenne/Jenne (i.e., DiaNi); The 'Na'/Naa/Naba are the rulers; Kings/Queens; Direct descendants of Enki/Ptah, his family, and his group of different Neteru (find further details on this in section 5.1); Sirian-Reptilian people; their name is 'Nt'; 'Nta' was/is the name of Djakpa's Mande people; Strong connection to both Orion and Sirius star systems; Bantu (Ba-Nt); Mande (Ma-Nt) – Mande word for snake is 'saa/sah', which is the same word used in the Egyptian language to represent the Orion star system; The naga and Nommo bloodlines among the descendants of Kemet all over Africa (see details in

section 5.1); Dako/Oyoko (Bosommuru); cobra, python; Warriors, followers of the ways of Nebet-Het and Set; Followers of the ways of rulership (and of commerce), as descendants of the pharaohs; Builders of large nations and empires; Historically the greatest magicians and sorcerers among the three bloodlines; Also with strongest connection to Hermetism and to esoteric Christianity; Mainly represented in the early dynastic period of Kemet (Old Kingdom) of the time, especially those great pharaohs of the 4^{th} and 5^{th} dynasties, before their descendants migrated into the hinterland of Africa (Kemetic "exodus") to eventually form groups like the Mande and the Akan of the present time.

SOURCES ON ASARIAN SPIRITUALITY

[a] Traditional: *The Way of the Elders: West African Spirituality & Tradition*, by Adama Doumbia, & Naomi Doumbia; *Divine Kingship in Ghana and Ancient Egypt*, by Eva Meyerowitz; *The Sacred State of the Akan*, by Eva Meyerowitz

[b] Ancient Egyptian: *Rau nu Prt m Hru* (Kemetic Book of the Dead/Book of Coming Forth into the Light); *Osiris and the Egyptian Resurrection*, by E. A. Wallis Budge

[c] Gnosticism: The Gnostic Society Library - The Nag Harnmadi Library: www.gnosis.org/naghamm/nhlalpha.html

[c] Ancient Hebrew/Christian Bible: Books – all New Testament books, with the exception of Matthew, Mark, Luke, and Revelation, and especially Hebrews (This addition is especially for those Africans who are still 'making the transition' out of Christianity and into the traditional spirituality of their groups as well as generally to the Asarian and Ammonite).

PHARAOH AND SAGE ANCESTORS

Pharaohs – Nebka, Djoser, Sekhemkhet, Hudjefa II, Mesochris, Nebkara, Neferkara, Huni, Sneferu, Khufu, Radjedef, Khafra, Menkaura, Shepseskaf,

		Baufra, Thamphthis, Hordjedef, Userkaf, Sahura
		Sages – (Djehuti)

Now that we have an alphabet/key, or the building blocks, let us now construct a tapestry, that shows the interrelated nature of people in Africa, based on these three bloodlines above as well as the Berber people of North Africa:

Name	Bloodline Notes
Akan	A mixture of all three: DiaLa, DiaGha, DiaMo; although proportion sizes are comparable, overall the largest representation is actually from the DiaGha (Guan), followed by the DiaMo and then the DiaLa. Akan royalty practiced clan exogamy as they successively settled among DiaGha peoples. Proportions also differ from one Akan group to the other. Some examples: DiaGha – currently lead Ahanta, Efutu Kwahu, Nzema DiaLa – currently lead Asante, Akwamu, Baole, Bono, Gyaman DiaMo – currently lead Akyem, Akuapem, Denkyira, Fante, Wassa
Amhara	Largely Semetic (Punt), with a smaller proportion of Berber and a very small proportion of DiaMo; Led by the DiaMo
Baganda	DiaLa, and Yoruba current; Led by DiaNa
Baluba	Fully DiaMo
Bambara	Fully DiaLa The Kama-blo is a secret ceremony that brings together different peoples of Mande extraction or ancestry (including representatives from Akan and Gonja peoples) into one gathering every seven years at Kaaba or Kangaba (also known as Kanga) in Mande territory, Mali.
Basotho	Led by the DiaLa

Dagomba	Mostly DiaMo, with very small DiaGbon and even smaller DiaLa; Led by DiaLa The Mamprusi and the Frafra, who are related to the Dagomba, are fully DiaMo. All three groups are also related to the Gurmanche and to other Mossi.
Dioula	DiaGha, DiaLa, and DiaMo; Highest proportion is DiaLa The Dioula/Dyula are a merchant group (DiaLa bloodline likes business and commerce) that are Mande people who traveled further south to establish businesses and trade routes (supply chain routes) for the Mande empires. They can be found in present-day Côte d'Ivoire, Mali, Ghana, Guinea.
Dogon	Fully DiaMo The Dogon, the Oromo, and the Akan (as only 3 examples among many), all have notions of the One Infinite Creator, to whom they do not create any temples or representations or effigies, as one would to a 'sky god' (i.e., ET) or to a nature spirit. Among the Dogon, this being is known as 'Amma'. Among the Oromo, this being is known as Waaqa Tokkicha (sounds like the equivalent of the Native American Lakota/Sioux Supreme Being Wakȟáŋ Tȟáŋka) and among the Akan, the equivalent is Odomankoma. As an aside, the Blackfoot peoples of the US and Canada, an Algonquian group that are neighbours of the Lakota, are descendants of the Ancient Egyptians, according to Native American author Robert Morning Sky.
Ewe	Of the three, mostly DiaGha has representation
Ga	Mostly Yoruba current; Small proportion of DiaMo
Gonja	DiaGha and DiaLa; Mostly DiaGha; Led by DiaLa/Mande

	The Mande warrior/general Djakpa, of Diara-Konte, established the ruling house of the Gonja royal family when he took over the state from its Akan rulers (the Kandiama).
Guan	Almost exclusively DiaGha
Gurmanche	Mostly DiaMo, with a very small DiaLa proportion; Led by DiaLa
Hausa	DiaMo and DiaLa mixed with Berber; Biggest proportion is Berber, followed by DiaLa, then DiaMo; Led by DiaLa
Igbo	Mostly DiaMo The Igbo Ekpe leopard society in Nigeria and in Cameroun is an ancient secret society that has preserved some of the knowledge of Ancient Kemetic/Hebrew peoples of the "DiaMo", who are connected with lion/leopard feline energies of early Kemet and Kanaan.
Jola/Diola	Almost exclusively DiaGha
Kasena	Mostly DiaMo with a smaller DiaGha proportion; Led by DiaMo
Kusasi	Mostly DiaMo with a smaller DiaGha proportion; Led by DiaMo
Luo	DiaLa, with a small proportion of DiaMo; Led by the DiaLa
Mandinka	Fully DiaNLa
Mongo	Highest proportions are Yoruba current, then DiaLa, then DiaMo and then DiaGha/KhoiSan, in that order; Led by Yoruba current More is said about the Mongo in section 5.1, especially the fact that they appear to be originally matrilineal (DiaLa and DiaMo influences), with vestiges of that still surviving underneath the veneer of the patrilineal culture. The surviving matrilineal influence is true of the Mongo and neighbouring peoples (Ekonda, Mbole, and Nkunda)
Mossi	Overwhelmingly DiaMo, with very small DiaNa proportion; Led by DiaNa The Mossi capital, also now the capital of Burkina Faso, Ouagadougou, is a direct connection to Wagadu/Ouagadou, that is, the

	Ghana empire. The people of the Ghana empire were known as the Wagadu/Ouagadou. Ghana was the title of the king. Therefore, the Mossi are reminding us that they remember where they are from. They were DiaMo of Wagadu. Also, the suffix of Ouagadougou, 'gou', is the same as the Akan word 'kuro', which means town or city. There are variations of this suffix all across West Africa. As such, Bondoukou, Diebougou, Dormaa Ahenkuro, Ferkessedougou, Kissidougou, Satandougou, and Yamoussoukro, all towns or cities in various countries across West Africa have the suffix that indicates as such. Meyerowitz (1952) tells us of the Mossi, and their Gurma (Dagomba, Frafra, Gurmanche, and Mamprusi relatives): "Between the years 1200 and 1300 the N'Gwa or A'Gwa states north and north-east of the Northern Territories of the Gold Coast were one after the other conquered by the Bozamfari people from Zamfara in Northern Nigeria. N'Gwa proper, now called Gurma, whose capital was Biego (Bingo), was overrun in about 1200; Mamprussi (Djana or Tiana) [i.e., DiaLa/DiaNa], whose capital was Gambaga (Djamba), in about 1230, and four or five states in Mossi in about 1300." (p. 49)
Nguni	DiaMo and KhoiSan; Led by DiaMo
Oromo	Fully DiaMo
Senufo	Almost exclusively DiaGha
Shona	Fully DiaMo; Shona kings were titled Mwenemutapa (written in English as Monomutapa); Mwenemutpa means 'King or Lord of the Land'; Mwene = King or Lord (Shona Mwene and Akan Hene/Ohene mean the same thing); Mutapa = of the land; The root word 'ta' refers to land in the Egyptian language (e.g., Ta-Neter = land of the Gods, Neter = Gods; Ta-Meri/Ta-Mare = 'land beautiful' or beautiful land, the

	original name of the continent now known as Africa, which is why the Dagomba/Dogon people have a major city called Tamale, and the equivalent in the Akan languages being 'Asase-Tam'). In the Akan languages, this root word also appears in relation to land. E.g., Asase-tam = continent, Asase-taw = a plain or a level country, Asase-tamaa = a table-land or plateau; As an aside, the unspeakable torture techniques the Portuguese used against the Mwenemutapa Kings to force them to reveal the location of their gold were "tried-and-tested" techniques they also applied to Aztec and Inca peoples in Central and South America.
Songhai	Berber and DiaLa, with larger proportion being DiaLa; led by Berber
Soninke	Fully DiaMo From the story about Dinga, Soninke founder of the Ghana empire (the Soninke are an Ammonite group), that was given earlier in the book by Delafosse (1913), we learn a curious fact. Dinga's chief magician was Karabara Diadiané. From the last name of this extremely powerful magician, Diadiané, who was a founder of the Soudoro clan, we can deduce that he was DiaLa/DiaNa (Dia-Diané) and of the Mande.
Tigrinya	Led by the DiaMo
Tuareg	Fully Berber; They call themselves the Imazighen
Xhosa	Led by the DiaLa
Zulu	DiaMo and KhoiSan; Led by the DiaMo The Zulu people were famous past and present of course because of Shaka Zulu, and in more recent times, because of characters such as Chief Mangosuthu Buthelezi (founder of the Inkatha freedom party during apartheid times), and, among recent times in the spiritual community, the late Vusamazulu

Credo Mutwa, the high shaman (sanusi) of the Zulu people, the Lion Shaman, and one who has taught the world many things about our ancient past. My teacher of ancient African wisdom. Credo Mutwa has said in his book *Indaba my Children* that the Zulu have been influenced by many wise kings, one of whom was the Mthethwa King known as Oyengweni Dingiswayo. The rule of Dingiswayo brings to mind the rule of the wise DiaMo leaders of old.

APPENDIX 4

The Dogon account of first contact with the Nommo

We shall end this epic journey of a book with the Dogon account of their 'first contact' meeting with the Nommo/Nummo people of the Sirius star system. The Nommo are an amphibious (extraterrestrial) race who play to role of guardians or of monitors. They are part of a larger group known as the guardians. The group of beings known as the guardians are supremely advanced, spiritually and, in many cases, technologically as well. As guardians, their job is to be caretakers or 'shepherds' of *all* races that are evolving in a given galaxy. The guardians/monitors do this on behalf of the creator forces of that galaxy. Those creator forces are manifested (their consciousnesses expressing) as the central stars of each galaxy.

At the very root of this entire system of the incredible knowledge the Dogon people of Mali (not least what they know about the Sirius star system) is the fact that they ascribe their knowledge to meetings they had with otherworldly beings who physically appeared to them in technological craft and with whom the Dogon interacted. As such, it would be remiss of me to unravel the connection of African and other peoples to Sirius without also including this axiomatic portion of the paradigm the knowledge of the Dogon people.

Here is part of the translated account, from Griaule and Dieterlen (1965):

"The ark landed on the Fox's dry land and displaced a pile of dust raised by the whirlwind it caused...The violence of the impact roughened the ground...it skidded on the ground...It was like a flame that went out when it touched the earth...The Nommo was "as red as fire"... when he landed, he became white...As (the ark) landed, the weight of the ark caused the "blood" to spurt to the sky...[The Nommo is] 'the monitor of the universe, the "father" of mankind, guardian of its spiritual

principles, dispenser of rain and master of the water generally...The Nommo divided his body among men to feed them; that is why it is also said that as the universe "had drunk of his body" the Nommo also made men drink. He also gave all his life principles [internal alchemy and tantra??] to human beings."

ABOUT THE AUTHOR

Kwame Adapa is an intellectual and a spiritual being with diverse interests, currently incarnated in an early middle-aged male Akan physical body. He strives to achieve mastery of self, on the physical, emotional, intellectual and spiritual levels of experience while incarnated. Kwame has been writing about and sharing his thoughts and experiences for a decade and a half. Recently, he has been guided to reach a wider audience by sharing his experiences and thoughts with the world. Kwame continues to expand the limits of his knowledge and experience and he continues to develop himself spiritually. To this day, Kwame still practices the out of body projection skills he first learned in 2005, as well as other methods from internal alchemy. Get linked with Kwame:
Email – akwadapa@hotmail.com
Homepage – https://www.theakan.com
Facebook – https://fb.me/KwameAdapa
Instagram – https://www.instagram.com/Kwameadapa
Twitter – https://www.twitter.com/Akwadapa

OTHER BOOKS BY KWAME ADAPA

The Akan, Other Africans & the Sirius Star System: Egyptian and Sumerian gods in African culture – The traditions and the culture of the Akan people of West Africa are a treasure trove of clues to an ancient past, linking to extraterrestrials associated with the Sirius star system who influenced the ancestors of the Akan and other Africans.

Out of Body into Life: Journeys into spirit worlds and how to get there on your own – through out of body journeys, also known as astral projection, Kwame explores the regions that human souls go to after passing through death. He also found answers to who he is as a soul, what ancient civilizations lie within the Earth's caverns, about nature spirit entities that cohabit our planet and about the inhabitants of other star systems.

Dreaming Consciously: Extraordinary journeys and the exercises that created them – An account of over 60 non-ordinary lucid dreams and lucid projections of exploration in nature spirit worlds, extraterrestrial encounters and trainings with spiritual masters in dream realities.

These accounts are shared together with the psychic and energy exercises that helped create them.

The Guardians, Earth Humans and Ascension: Spiritually hacking your awareness and DNA – as a sequel to The Akan book, this book discusses the guardians and the Earth human experiment in significant detail, including but going beyond the Akan and other Africans, to human groups from across the globe. There is also a discussion of techniques to bring about spiritual ascension. These techniques ultimately come from the guardians.

Spiritual Tools for Awakening: A how-to guide – is a counterpart to *Awakening to your Nature as a Spirit Being Incarnated on Earth*. This practical guide offers insights and techniques that can serve as supports on the awakening journey of a spirit being. The guide is written to be broad to cater to the spiritual development interests and needs of different individuals while being specific in each section to include tangible suggestions that can bring improvement into the lives of individuals.

Awakening to your Nature as a Spirit Being Incarnated on Earth – in this unique book, Kwame Adapa details the journey of coming to the awareness of being a spirit being through successive incarnations and awakenings. This book also reveals the greater identities of a spirit being and discusses what it means to be integrated on different spiritual levels of being from the standpoint of Eastern, Indigenous and Western philosophical and spiritual traditions.

Thank you for reading my book!

Please allow me to thank you for choosing my book. I sincerely hope you found some of what I shared useful to you on your path and I know that you could have picked up another book on spirituality but chose to read mine so I thank you again.

If you enjoyed reading this book, and found some value in it, I would be most grateful to receive a five-star rating from you. It would only take less than a minute. Your feedback would also help me continue to write more books such as this one, to promote learning and knowledge. Thank you again!

Regards,
Kwame Adapa